On Images

Whether it was the demands of life, leisure, or a com___
that forced our hands, we have developed a myriad of artifacts—maps,
notes, descriptions, diagrams, flow-charts, photographs, paintings, and
prints—that stand for other things. Most agree that images and their
closed relatives are special becuase, in some sense, they look like
what they are about. This simple claim is the starting point for most
philosophical investigations into the nature of depiction.

On Images argues that this starting point is fundamentally misguided.
Whether a representation is an image depends not on how it is
perceived but on how it relates to others within a system. This kind of
approach, first championed by the Nelson Goodman in his *Languages of
Art*, has not found many supporters, in part because of weaknesses with
Goodman's account. *On Images* shows that a properly crafted structural
account of pictures has many advantages over the perceptual accounts
that dominate the literature on this topic. In particular, it explains
the close relationship between pictures, diagrams, graphs and other
kinds of non-linguistic representation. It undermines the claim that
pictures are essentially visual by showing that audio recordings, tactile
line drawings, and other non-visual representations are pictorial. Also,
by avoiding explaining images in terms of how we perceive them,
this account sheds new light on why pictures seen so perceptually
special in the first place. This discussion of picture perception recasts
some old debates on the topic, suggests further lines of philosophical
and empirical research, and ultimately leads to a new perspective on
pictorial realism.

John V. Kulvicki is Assistant Professor of Philosophy at Darmouth
College, New Hampshire

On Images

Their structure and content

John V. Kulvicki

CLARENDON PRESS · OXFORD

OXFORD

UNIVERSITY PRESS

Great Clarendon Street, Oxford OX2 6DP

Oxford University Press is a department of the University of Oxford.
It furthers the University's objective of excellence in research, scholarship,
and education by publishing worldwide in

Oxford New York

Auckland Cape Town Dar es Salaam Hong Kong Karachi
Kuala Lumpur Madrid Melbourne Mexico City Nairobi
New Delhi Shanghai Taipei Toronto

With offices in

Argentina Austria Brazil Chile Czech Republic France Greece
Guatemala Hungary Italy Japan Poland Portugal Singapore
South Korea Switzerland Thailand Turkey Ukraine Vietnam

Oxford is a registered trademark of Oxford University Press
in the UK and in certain other countries

Published in the United States
by Oxford University Press Inc., New York

British Library Cataloguing in Publication Data

Data available

Library of Congress Cataloging in Publication Data

Data available

Typeset by Laserwords Private Limited, Chennai, India
Printed in the UK
on acid-free paper by
the MPG Books Group

ISBN 978-0-19-929075-8 (Hbk.) 978-0-19-956167-4 (Pbk.)

10 9 8 7 6 5 4 3 2 1

For my brother Matthew Kulvicki,
a moving pictures man

Acknowledgements

Pictures piqued my interest many years ago in a seminar on I-forget-what. I do remember that in that seminar Thomas Levin introduced me not only to Siegfried Kracauer and Walter Benjamin but also to Nelson Goodman's *Languages of Art*. The latter piece has occupied my mind off and on since those college days. How could someone manage to be so right and so wrong at the same time? This book sketches an answer to that question, which will, I fear, please neither diehard fans of Goodman nor his determined detractors.

Chapters 2–4 formed about a third of my dissertation, which was split between artifact representations and some problems in the philosophy of perception. My committee was simply fantastic, not least for allowing me to split my time on these topics. Murat Aydede, Dave Hilbert, and Josef Stern each managed to be available, engaged, charitable, and critical. Josef Stern's familiarity with Goodman's work, in particular, was indispensable. I am a better philosopher for their efforts, and I can only hope this book fills out, to their satisfaction, a project that they let me leave incomplete.

Chicago was an excellent place to be working on pictures, and fellow students with interests in depiction—Anne Eaton, Jesse Prinz, Philip Robbins, and Gaby Sakamoto—were a welcome source of feedback and support.

Dom Lopes was incredibly encouraging early on and he ultimately wound up reading through the whole manuscript, parts of it more than once. I am deeply grateful for his efforts. Ken Walton also read through large portions of the manuscript and managed to make many insightful comments.

Parts of the book were presented at conferences over the years. I am grateful to Aaron Meskin for commenting on material from Chapter 3, and to Guy Rohrbaugh for comments on some of Chapter 2. Robert Stecker and Alan Goldman were the kind of conference attendees everyone hopes for: they were encouraging and even good enough to read through drafts of some of my work. More recently, Amy

Kind was nice enough to provide some helpful thoughts on Chapter 6 and Catherine Abell disagreed constructively with much of what I say in Chapter 11. I also received helpful comments on Chapter 11 from an audience at Carleton University and from my colleagues at Dartmouth.

Portions of Chapters 2–5 appeared as my 'Image Structure' in the *Journal of Aesthetics and Art Criticism* (61/4, 2003) and I am grateful for the journal's permission to reproduce some of that material. I also thank Rob Hopkins and Roy Sorensen for their comments on that article. A version of Chapter 11 appeared as my 'Pictorial Realism as Verity' in the *Journal of Aesthetics and Art Criticism* (64/3, 2006) and I thank the journal for permission to reproduce it here. Portions of Chapter 9 appeared online in a workshop on Art and Cognition at www.interdisciplines.org/artcognition on June 27, 2005. Thanks to John Dilworth and John Zeimbekis for their comments and to John Z. and Anouk Barberousse for inviting me to participate.

Most of the illustrations are drawn from the collection of Dartmouth's Hood Museum of Art. I am grateful to the Hood, the artists, and their estates for allowing me to reproduce these images. Kathy Hart and Kathleen O'Malley deserve much thanks for guiding me through the Hood's collection and the permission process. Van Gogh's *The Bedroom* appears thanks to the Art Institute of Chicago. Sonia Landy Sheridan was good enough to allow me to reproduce three of her works herein, and I am grateful to her for taking the time to talk to me about her art.

Many thanks also to Peter Momtchiloff and his team at Oxford University Press for bringing this project to light.

I am daily glad that Geraldine Caufield, Vijay Culas, Matthew Kulvicki, John Maloy, Dennis McCaughan, Timothy O'Reilly, and local partners-in-crime Timothy Rosenkoetter and Adina Roskies are on my side. Finally, Heidi Maibom deserves special thanks for her generosity and patience, for convincing me to pursue this book during a characteristically mild Ottawa winter, and for allowing me to mangle a perfectly nice photo for the sake of figures 3.4–3.8.

Contents

List of Illustrations

List of Figures

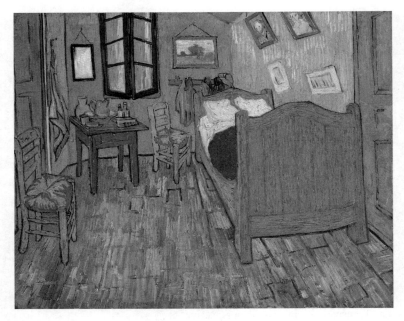

Vincent van Gogh, *The Bedroom*, 1889, oil on canvas, 73.6 × 92.3 cm,
Helen Birch Bartlett Memorial Collection, 1926.417. Photography © The
Art Institute of Chicago.

Introduction: Alberti's Window, Leonardo's Mirror, and van Gogh's Room

Whether it was the demands of life, leisure, or a combination of both that forced our hands, we have come up with a myriad of artifacts that stand for other things. Maps, notes, descriptions, diagrams, flow-charts, photographs, paintings and prints, all, in one way or another, manage to be about things or stand for them. The philosophical puzzles in the neighborhood of these practices concern what makes certain kinds of representations distinct from others and why these differences matter. The obvious answers to these questions all fail, at least absent some relatively obscure modifications, which leaves the philosopher with some interesting work to do.

We can just as well describe as record, photograph, or video tape tomorrow night's performance at the Velvet Lounge. In a sense all of these options represent the same jazz show, but they seem to do so differently, whatever that means. The goal of this book is to explain just what that means with a focus on what makes pictorial represen-tations special in that they seem to occupy a corner of a continuum of representational kinds. Descriptions and other linguistic kinds of representation seem to occupy the opposite corner with diagrams and graphs being the mongrels in the middle.

There are three ways to unpack the suggestion that these distinct artifacts represent, in a sense, the same glorious night at the Vel-vet, while doing so differently. They may differ in their *contents*, in

the way in which they *get* their contents, or in the *structure* of the representational systems to which they belong. (See Haugeland 1991.)

First, these representations differ in their contents with respect to both the sense-modality of the features they represent and the detail or fineness of grain of the features they represent. The recording represents audible properties of the performance, the video represents visible and audible properties, the photograph eschews the audible altogether, while the description is a combination of both and may even represent some features that are not perceptible at all. A good review of such a performance should describe the atmosphere, what it was like to be there, which is not something most other kinds of representation are suited to capturing. Moreover, though a written review can often be precise in describing the sounds, movements, and colors of the show, descriptions fall short of the global richness of detail characteristic of photos, videos, and recordings.

Though it is a plausible suggestion, few have tried to characterize the differences between these kinds of representations solely in terms of their contents. John Haugeland (1991), Flint Schier (1986), and Dominic Lopes (1996) have isolated features of the contents of these representations that distinguish them from one another. Haugeland alone has suggested that there is a theoretically interesting way to sort representational systems exclusively in terms of content. We will have occasion to discuss these views in Chapters 6 and 7.

Second, the photos, descriptions, and recordings may differ in what determines them to have the contents they do. The photograph is about a man with a tenor saxophone because, somehow, when we look at it, we *see* a man with a tenor saxophone. The description is about the same thing in virtue of the meanings of the words that constitute it. We must look at both artifacts to know their contents. But we look at inscriptions to discern the words that make up a description, which have their meanings because of some doubtlessly complex form of mutual agreement among speakers of the language. It could have been the case that 'saxophone' meant trumpet and 'trumpet' meant saxophone, had things worked out differently. The photograph has the content that it does because, somehow, it mobilizes the perceptual resources that we usually deploy in noticing things like saxophones and people in our environment. Something similar may

be true of the audio recording, too. When we hear it, we make use of the same resources that allow us to recognize audible aspects of the performance itself.

This approach is the most popular and ancient of the three. Variations on it are legion. Representation was a central concern of the visual arts from the beginning of the fifteenth century until, if we follow Arthur Danto (1997), Arles in 1888. There, during nine rocky weeks, van Gogh and Gauguin started to change things. Leon Battista Alberti, who in 1435 wrote the first sustained treatment of painting, and by extension pictorial representation, knew little about the physiological or anatomical details of sight. He was sure, however, that in making pictures and in understanding them we deploy the complicated perceptual resources that serve us in seeing objects generally. Our eyes let us see because they stand in a particular spatial relationship to the world at large, constituted by a visual pyramid of sorts. Alberti did not know that light travels in straight lines. He did not know whether some form of an intromission theory of perception would ultimately win out over the by then disfavored extromission theory, either (Alberti 1435/1991, 40). However the world contrives to let us see, the eyes are small holes and we do not, as Ernst Gombrich (1961, 250) pointed out in this context, see around corners. The *spatial* relationship that holds between the eyes and the environment could thus be characterized in conical or pyramidal fashion as a collection of rays originating at a point.

Making a picture of a piazza, for Alberti, amounted to making an object that would, when suitably placed with respect to a viewer, produce a cone of rays just like that produced by a piazza. This fact worked its way into his thinking about picture production as well as picture consumption. He said of artists that:

They should understand that, when they draw lines around a surface, and fill the parts they have drawn with colors, their sole object is the representation on this one surface of many different forms of surfaces, just as though this surface that they cover were so transparent and like glass, that the visual pyramid passed right through it from a certain distance and with a certain position of the centric ray and of the light, established at appropriate points nearby in space. Painters prove this when they move

away from what they are painting and stand further back, seeking to find by the light of nature the vertex of the pyramid from which they know everything can be more correctly viewed. (Alberti 1435/1991, 48)

The window captures exactly the aspirations of a skilled painter. First, the frame delimits what can be seen through it, much as the borders of the canvas mark the edge of the picture. The window is transparent, in that it does not interrupt the visual pyramid that connects one to the scene beyond, but it provides a surface that, without blocking one's view, nevertheless stands in one's way. Painting over the window opacifies it, of course, but the goal is that the opaque window resulting from the painter's efforts is a surrogate for the scene beyond it. Though the picture interrupts the visual pyramid, when it is well painted it presents the same bundle of rays that the scene did from a given point. This explains why we can interpret it as a picture of that scene. For Alberti at least, this is what the transparency of pictures consists in. We see, as it were, right through a picture to what it is a picture of because the picture serves as a visual surrogate for its object.

Leonardo, too, thought of pictures as mimicking what nature presents to the eyes, but he was a bit more circumspect about just what they mimic. The relevant comparison for Leonardo was not between the scene through a window and the painting, but between the picture and what one could see reflected in a mirror.

When you wish to see whether your whole picture accords with what you have portrayed from nature take a mirror and reflect the actual object in it. Compare what is reflected with your painting and carefully consider whether both likenesses of the subject correspond, particularly in regard to the mirror. You should take the mirror as your master, that is the flat mirror, because on its surface things in many ways bear a resemblance to a painting. That is to say, you see a picture which is painted on a flat surface showing things as if in relief: the mirror on a flat surface does the same. The picture has but one surface and the mirror the same. (Kemp 1989, 202)

A mirror is, in relevant respects, like what a picture should be. Both are single flat surfaces, and the mirror, though flat, 'shows things as if in relief.' In a sense, mirrors are natural pictures, and it is in comparison

with them that a painter can judge her own work or be judged by others.

Contemporary philosophers have taken the fact that pictures seem special perceptually as the starting point for their accounts of depiction and thus how pictures differ from diagrams and languages. All agree that pictures somehow evoke perceptual states akin to those evoked by the objects that are depicted. What it is to be a picture is to be the kind of thing that is apt for bringing such states about.

Ernst Gombrich (1961) thought that pictures fooled us into thinking that we were viewing the object depicted. Richard Wollheim (1980, 1987) thought that we are never fooled, but that pictures foster a special ability we have to see one thing *in* another. Pictures put us in a special, amalgamated perceptual state, at once aware of both the picture surface and what the picture depicts. Wollheim went so far as to say that *trompe l'œil* paintings are not pictures at all, since they admit of no twofold experiences. Others, such as Robert Hopkins (1998), have explicated the special perceptual state evoked by pictures in terms of experienced resemblance between an object and a picture of it. Still others like Flint Schier (1986) and Dominic Lopes (1996) have defended what seems the most plausible of perceptual accounts: pictures mobilize our recognitional resources. Whatever allows us to recognize things like tables and chairs, rainbows, and archbishops also allows us to recognize pictures of those things as such. When we see a picture of a bulldozer, we recognize it by using the same perceptual resources that allow us to recognize bulldozers. For Kendall Walton (1973, 1990), pictures are perceptually special because they serve as props in suitably vivid games of make-believe. We can imagine that our seeing of a picture is seeing the thing that the picture depicts. Even though we often imagine seeing things when we read descriptions, we do not imagine that our seeing the inscription is seeing what it describes.

The variety of perceptual accounts reflects their deep intuitive plausibility. Our perceptual facility with pictures seems rooted in our perceptual facility with things more generally. Looking at pictures is special. It is as if we look through Alberti's window or into Leonardo's mirror. Any full account of pictures must say something about why they seem so perceptually special, and the obvious route is to identify

pictures as a special perceptual kind. This book, however, does not discuss picture perception until Part II.

The central project of Part I is to account for what it is to be a picture, diagram, or what have you *independently* of how such representations are perceived. What makes a representation pictorial or diagrammatic is not how we perceive it, but how it relates to others, syntactically and semantically, within a system of representation. This puts my account in line with the structural option mentioned above. The great intuitive plausibility of perceptual accounts and the deep implausibility of the one well-developed structural account—Nelson Goodman's *Languages of Art* (1976)—have led to the neglect of picture structure in recent decades.

To get a feel for what such an account is like, consider a structural version of pictorial transparency that will be discussed in Chapter 3. Rooms were the topic of choice in much Renaissance painting because they provided the opportunity to show off techniques for producing pictures in linear perspective. Van Gogh's painting of his room in Arles is an interesting response to this tendency. It is not careful in its use of perspective, and that is something we notice, as if the goal is to draw attention to this technique. The facing wall presents two of the perceptual metaphors for depiction discussed in perspective's heyday: a mirror and a window. Alongside them is a painting. In contrast to many paintings up to this point—Degas comes to mind—one can see nothing at all through the window or in the mirror. In a sense, however, we readily see through the painting beside them to what the depicted painting is about: in this case, a tree in a field. Pictorial transparency, on my view, is not first and foremost a matter of our perceptual engagement with pictures, but a matter of how pictures represent one another. *The Bedroom* shows that when one depicts a depiction, the result is just like the original. Describing descriptions is not at all like this, and often it makes little sense to diagram diagrams.

This painting does more than make an interesting point about pictorial transparency. It is an example of transparency at work. There are actually three bedroom paintings, the latter two created in St. Remy, after van Gogh had left Arles. This one, which hangs in the Art Institute of Chicago, is the last. There is reason to believe that

the latter two were made using the first as a guide. They are all more similar than we would expect paintings of the same room to be. Not only is the furniture arranged in the same way each time, but the far table has the same collection of bottles, pitcher, and basin, and the towel hanging off to the left is folded in exactly the same way each time. In a way, van Gogh could just as well have been painting his painting as painting his bedroom. Arthur Danto locates the beginning of Modernist painting in Arles of the 1880s with the work of van Gogh and Gauguin. This is a period in which the central concern of painting is the art of painting itself and not the representation of other things, or so his story goes. As true as it may be, it is interesting that at the point when painting becomes concerned with itself it sheds some light on what makes representational pictures special in the first place. What it is to be pictorial is to be a representation that relates to other representations within a system in the right way. The modernist move sheds light on pre-modernist practice.

Structural transparency distinguishes pictures from other kinds of representations, but it also exposes some unexpected commonalities between representational kinds. The recording of the jazz show, like the photographs of it, is structurally transparent. Recordings of recordings are just like the originals, depending on the quality of one's audio equipment. Transparency is one of four syntactico-semantic conditions that Part I unpacks. On the whole, they carve the representational kinds at intuitively and theoretically interesting joints.

Chapter 1 discusses Goodman's theory, the virtues of his general approach, and the problems in his execution. This sets the stage for Chapters 2 and 3 to present four structural conditions, including transparency, that constitute an account of representational kinds. Chapter 2 in particular is a bit on the technical side, and unavoidably so it seems, but I promise that things lighten up considerably after that. Chapters 4 and 5 draw out the consequences of the account. Chapter 4 shows that transparency explains the sense in which pictures and related representations resemble what they are about. And Chapter 5 shows how the account accommodates the vast variety of representational kinds, including auditory and tactile representations.

Part II shows that a working account of the structure of representational systems can inform an account of why the perception of some is

special. In order to explain structural transparency, Part I appeals to a distinction between the bare bones content of a representation and its fleshed out content. The terminology comes from Haugeland (1991), but one finds something very close to this distinction in Gombrich's groundbreaking *Art and Illusion* (1961). Haugeland tries to distinguish 'iconic' representations from 'logical' ones solely in terms of differences in their bare bones contents. Chapter 6 shows that this proposal does not work, and that a condition like transparency is needed for bare bones content to explain what makes pictures special. Chapter 7 considers a proposal developed by Lopes (1996), following up on Block (1983) and Schier (1986) about what makes pictorial content special. This proposal has problems as well, but what makes it interesting is that it concerns fleshed out content, not bare bones content. This raises the question of how bare bones content and fleshed out content relate to one another.

Chapters 8 and 9 provide my account of picture perception. One thing that makes transparent representations interesting, I show, is that they are instances of their own bare bones contents. That is, pictures manifest the very properties that their bare bones contents attribute to their objects, and this is what makes the perception of pictures so special in comparison to the perception of diagrams and descriptions. We have a kind of immediate access to the bare bones contents of pictures that we lack with other kinds of representations. We come to know pictures' fleshed out contents on the basis of knowing their bare bones contents. Strangely enough, this makes the distinction between bare bones and fleshed out content very much like the distinction between sense data and what we come to know on the basis thereof. I am the last person to endorse a sense datum epistemology, or anything even remotely resembling it, as a theory of knowledge or of perceptual awareness. But it just turns out that a bad theory of perception turns out to be a very good theory of pictorial content. The reason pictures, movie theaters, and the like turn out to be such a good way of explaining sense data—George Berkeley (1713/1979) used pictures for this purpose in his dialogues—is that they capture more about how pictorial content works than they capture about perception.

In a slightly ecumenical move, Chapter 10 shows that thinking of pictorial content by a fairly strict analogy with sense data bridges some

of the gap between two rival theories of picture perception. Overall, Chapters 8 and 9 come down on the side of recognition theories of picture perception, like those proposed by Schier and Lopes. It turns out, though, that Robert Hopkins' version of an experienced resemblance account has an important grain of truth to it, which is found in the fact that pictures are instances of their own bare bones contents.

Part III wraps things up by considering what makes some pictures more realistic than others. No one doubts that realism is a multi-faceted phenomenon, and Chapters 11 and 12 champion two relatively implausible candidates. On the one hand, realism has been identified with truthfulness, in the sense that a picture is realistic to the extent that it accurately depicts its object. On the other, realism is related to informativeness, or the amount of information a picture conveys about its object. Neither of these is particularly plausible because neither says anything about the picture itself. They both focus on the content of the picture, while many think that realism amounts to some kind of comparison between the picture and what the picture depicts. Chapter 11 shows that within a system of representation, realism amounts to a kind of truthfulness—what I call 'verity' to distinguish it from other proposals—and that this accommodates the intuition that realism involves the picture surface itself. Between systems of representation—for example, comparing cartoons to color photographs—realism relates closely to informativeness, as is shown in Chapter 12. Inter-systemically, we judge how close to being an exemplar of a pictorial system a given system of representation is. Since exemplars of pictorial systems are quite informative—this falls out of the account of depiction from Part I—these judgments of realism track informativeness. It is misleading to call verity and informativeness two dimensions of realism, since strictly speaking they apply to different things: individual representations and systems thereof. Whether we compare individual representations as members of a system or as stand-ins for systems themselves varies quite a bit, however, and this is why verity and informativeness often seem to be merely dimensions along which individual representations are compared. That is a thumbnail sketch of the account, in any case.

PART I

Image Structure

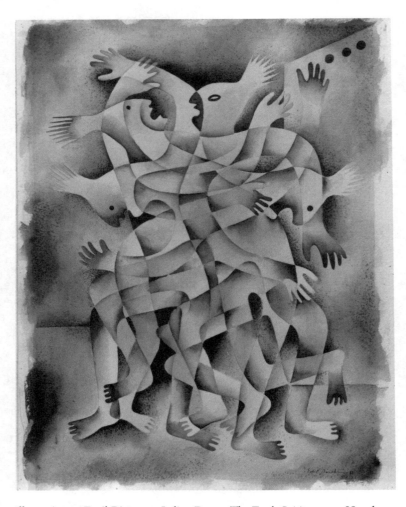

Illustration 1 Emil Bisttram, *Indian Dance: The Earth Spirits*, 1933. Hood Museum of Art, Dartmouth College, Hanover, New Hampshire; gift of Mrs. Howard Giles. Reproduced with the permission of St. John's College, Santa Fe, NM. Photography: Jeffrey Nintzel

1

Goodman's Progress

Goodman started it. His *Languages of Art* fashioned conceptual tools for understanding the structure of representational systems of all kinds. Pictures, diagrams, sketches, descriptions, and musical notations are systems of artifacts whose members can be about things. They are 'denotative systems' and 'The significant difference [between them] lies in the relation of a symbol to others in a denotative system' (Goodman 1976, 228). This systemic focus sets Goodman apart from everyone else who has written on depiction, and understanding it is the key to understanding the progress he made and the problems that any such account faces.

What Goodman said about pictures earned him mostly negative attention, in part, it seems, because pictures were not his main concern. The centerpiece of *Languages of Art* is Goodman's theory of notation, with pictures being bookends at best. Notation is essential for understanding scores for performances and the distinction between autographic and allographic art. 'A score . . . has as a primary function the authoritative identification of a work of art from performance to performance . . . From this derive all the requisite theoretical properties of scores and of the notational systems in which they are written' (Goodman 1976, 128). The three central chapters of *Languages of Art* are devoted to these topics, none of which is central to this book. By contrast, pictorial systems appear in a rather polemical discussion at the beginning and again at the end, where they are characterized as those that *lack* two features central to any notational system: syntactic and semantic finite differentiation. While he defines notational systems, Goodman never makes the effort to give sufficient conditions for a representational system to be pictorial. He was more interested in

choreographic notations than depictions of dances. It is enough for Goodman's purposes to show in what respects pictorial representation must be unlike notation. The theory of notation is one of Goodman's finest achievements, but in the context of *Languages of Art*, pictures are paradigms of what notation is not.

Part I of this book unpacks a set of necessary and sufficient conditions for a representational system to be pictorial. This proposal cuts against Goodman's at many points, not least because it is unburdened by a theory of notation. Nevertheless, all of Part I owes a deep theoretical debt to Goodman's work and this chapter focuses on making that clear. After reviewing what it means to think about representational *systems*, this chapter reviews the three conditions Goodman placed on a representational system being pictorial—syntactic density, semantic density, and relative repleteness—and shows how they relate to his theory of notation. This leads to some problems with Goodman's account, which motivate the alternative to Goodman presented in Chapters 2 and 3.

Thinking Systematically

To get a feel for Goodman's views about the importance of understanding systemic features of representations, consider a mark on paper, such as:

likeness

What representation is it? Intrinsically speaking there is no interesting answer to the question. In and of itself, this is just a mark on paper. This mark fits easily into a way we have of writing English, so we ordinarily take it to be a word. This judgment carries others with it, regarding what other marks on paper are of the same syntactic and semantic kind, such as, for example:

likeness

Despite being written in a different font, the latter inscription is of the same syntactic and semantic kind as the first. Both differ syntactically from, but are semantically similar to, for example:

similarity

Imagine, however, that it is not an inscription we are looking at but a photograph of an inscription. Now the mark must be interpreted differently. Not only is the photograph about something different than the inscription—the photo represents an inscription, while the inscription represents likeness—but our judgments as to what other marks are syntactically and semantically like it differ as well. Understood as photos of inscriptions, all three representations are syntactically and semantically distinct. Two depict inscriptions with serifs, one depicts a sans serif inscription. Judgments of similarity change as well. In terms of meaning, the word 'likeness' is rather like 'similarity' and in terms of spelling it is rather like 'lifelikeness'. The picture of 'likeness' is semantically more like a picture of

likene55

than it is to a picture of 'similarity' because the depicted inscriptions 'likeness' and 'likene55' are so similar in shape and organization. This is so even though as a word 'likene55' is gibberish. It is the system that matters, so understanding depiction unavoidably involves understanding how such representations relate semantically and syntactically to one another.

Representational systems consist of sets of possible physical objects that count as token representations. The inscriptions written above, bits of chalk on a blackboard, and colored planes, are all possible token representations. These objects are grouped under orthographic, syntactic, and semantic types. Orthography matters least for present purposes. In general, if two objects differ syntactically, then they differ orthographically. There are cases of ambiguity—e.g. the words 'bank', 'minute', and 'pen'—in which orthographic types are assigned more than one syntactic type while each syntactic type is assigned a different semantic type. The complications introduced by these kinds of ambiguity are simply not important given the goals of this chapter. Therefore, the following assumes that orthographic differences mark syntactic differences, and thus concerns itself with syntax and semantics alone.

The essence of syntactic types is that they are non-semantic, and that semantic distinctions supervene on syntactic distinctions. Different representational systems group objects into syntactic types differently.

For example, none of the objects that count as instances of the word 'likeness' count as words in German. The objects that count as instances of the English word 'rot' also fit into a type in German, though in English they are verbs and nouns while in German they are adjectives. In Greek and Hindi, both 'likeness' and 'rot' are gibberish. Pictures, too, can be non-semantically individuated. Differently colored planes count as different pictures, at least intuitively, and there will be a lot to say about non-semantically individuating pictures in what follows. Also, any token representation has features that matter for its syntactic identity and many that do not. The shapes of objects matter if we want to know what letters they are, but their masses do not. It doesn't matter, syntactically at least, whether the letters on this page are written in blood or synthetic ink, Monotype Bembo or Gill Sans. Pictures have masses too, and backs, and material constitutions, and many of these features are simply irrelevant to their being the pictures that they are, syntactically speaking. Pictures seem different from languages in that there seems to be little utility in non-semantically individuating pictures, but the following chapters will show that this really is an important part of understanding depiction.

Goodman said little about what features of representations matter for their syntactic identities because nominalists abhor reasons for kind membership. Saying that the shape of an object is relevant to its being the letter it is may be taken as an attempt to analyze being a certain syntactic type in terms of having *properties* like being a certain shape. A mereological nominalist like Goodman would be careful not to talk about properties or sets. Those without Goodman's metaphysical scruples need not worry about this. Goodman (1976, 230) called the relevant features of representations their 'character constitutive aspects' (CCAs). If, for example, color matters to a picture being the picture that it is, then color is a CCA of that system of depiction. For some systems, like black and white photography, color is not a CCA. Goodman refers to aspects of representations that are not CCAs as 'contingent', such as mass, chemical constitution, and the like. You cannot tell what picture a color photograph is without being sensitive to its color, just as you cannot tell what letter some mark is without being sensitive to its shape, but in either case mass matters not a bit. If we are to group tokens under syntactic types, we need to know what

Imagine, however, that it is not an inscription we are looking at but a photograph of an inscription. Now the mark must be interpreted differently. Not only is the photograph about something different than the inscription—the photo represents an inscription, while the inscription represents likeness—but our judgments as to what other marks are syntactically and semantically like it differ as well. Understood as photos of inscriptions, all three representations are syntactically and semantically distinct. Two depict inscriptions with serifs, one depicts a sans serif inscription. Judgments of similarity change as well. In terms of meaning, the word 'likeness' is rather like 'similarity' and in terms of spelling it is rather like 'lifelikeness'. The picture of 'likeness' is semantically more like a picture of

likene55

than it is to a picture of 'similarity' because the depicted inscriptions 'likeness' and 'likene55' are so similar in shape and organization. This is so even though as a word 'likene55' is gibberish. It is the system that matters, so understanding depiction unavoidably involves understanding how such representations relate semantically and syntactically to one another.

Representational systems consist of sets of possible physical objects that count as token representations. The inscriptions written above, bits of chalk on a blackboard, and colored planes, are all possible token representations. These objects are grouped under orthographic, syntactic, and semantic types. Orthography matters least for present purposes. In general, if two objects differ syntactically, then they differ orthographically. There are cases of ambiguity—e.g. the words 'bank', 'minute', and 'pen'—in which orthographic types are assigned more than one syntactic type while each syntactic type is assigned a different semantic type. The complications introduced by these kinds of ambiguity are simply not important given the goals of this chapter. Therefore, the following assumes that orthographic differences mark syntactic differences, and thus concerns itself with syntax and semantics alone.

The essence of syntactic types is that they are non-semantic, and that semantic distinctions supervene on syntactic distinctions. Different representational systems group objects into syntactic types differently.

For example, none of the objects that count as instances of the word 'likeness' count as words in German. The objects that count as instances of the English word 'rot' also fit into a type in German, though in English they are verbs and nouns while in German they are adjectives. In Greek and Hindi, both 'likeness' and 'rot' are gibberish. Pictures, too, can be non-semantically individuated. Differently colored planes count as different pictures, at least intuitively, and there will be a lot to say about non-semantically individuating pictures in what follows. Also, any token representation has features that matter for its syntactic identity and many that do not. The shapes of objects matter if we want to know what letters they are, but their masses do not. It doesn't matter, syntactically at least, whether the letters on this page are written in blood or synthetic ink, Monotype Bembo or Gill Sans. Pictures have masses too, and backs, and material constitutions, and many of these features are simply irrelevant to their being the pictures that they are, syntactically speaking. Pictures seem different from languages in that there seems to be little utility in non-semantically individuating pictures, but the following chapters will show that this really is an important part of understanding depiction.

Goodman said little about what features of representations matter for their syntactic identities because nominalists abhor reasons for kind membership. Saying that the shape of an object is relevant to its being the letter it is may be taken as an attempt to analyze being a certain syntactic type in terms of having *properties* like being a certain shape. A mereological nominalist like Goodman would be careful not to talk about properties or sets. Those without Goodman's metaphysical scruples need not worry about this. Goodman (1976, 230) called the relevant features of representations their 'character constitutive aspects' (CCAs). If, for example, color matters to a picture being the picture that it is, then color is a CCA of that system of depiction. For some systems, like black and white photography, color is not a CCA. Goodman refers to aspects of representations that are not CCAs as 'contingent', such as mass, chemical constitution, and the like. You cannot tell what picture a color photograph is without being sensitive to its color, just as you cannot tell what letter some mark is without being sensitive to its shape, but in either case mass matters not a bit. If we are to group tokens under syntactic types, we need to know what

features of those tokens matter for us doing so, and this is what the notion of character constitutive aspects is supposed to capture.

With a syntactic grouping of possible representations in place, a representational system assigns semantic types to the syntactic types. All syntactically identical representations are semantically identical, though semantically identical representations need not be of a kind syntactically: remember 'likeness' and 'similarity'. The semantics of a representational system is added onto its syntactic structure by pairing syntactic types with meanings and denotations. Given any syntactic structure—a fitting of possible physical objects under syntactic types—there are many different possible pairings of those syntactic types with semantic types. This schematic characterization of representational systems, CCAs, syntax, and semantics is incomplete but enough for present purposes. The idea is to present enough detail to make Goodman's proposals, and the subsequent criticisms of them, make sense. There will be occasions throughout Part I for reflecting on how best to understand the structure of a representational system. The next two sections lay out the three conditions that Goodman thought were necessary, though not jointly sufficient, for a representational system to be pictorial.

Differentiation and Density

The three structural features characteristic of pictures according to Goodman are syntactic density, semantic density, and relative repleteness. Syntactic density is a special case of a failure of 'syntactic finite differentiation' (Goodman 1976, 135–6), which is an essential feature of notational systems. In finitely differentiated systems it is always possible to tell of objects to which, if any, syntactic type they belong. For example, Goodman asks us to consider a system with two syntactic types. An object belongs to one if it is a line less than one inch long and the other if it is a line one inch long or longer. It is easy to discern the syntactic identity of most objects in this system, but there are some for which it is impossible to do so: those very, very close to one inch long. Take any measuring device or strategy that you like. It may be quite precise, but it will have some finite degree of precision. For the representational system in question, therefore, there will be

objects whose syntactic type the measuring method cannot discern. If you can measure lengths up to one ten-thousandth of an inch, there are indefinitely many objects within one ten-thousandth of an inch of one inch that are (a) members of one of the syntactic types or the other, but not both, and (b) such that our measuring method cannot discern to which type they belong. No matter what measuring method you choose there will be indefinitely many objects whose syntactic identities the method cannot determine. A system is finitely differentiated when it is possible in principle to tell of any object what syntactic type, if any, it belongs to. The system we have been discussing fails to be syntactically finitely differentiated, even though it only includes two syntactic types.

Syntactically dense schemes are a special subset of the non-finitely differentiated systems: the ones with a whole lot of characters or syntactic types. Goodman says '[a] scheme is syntactically dense if it provides for infinitely many characters so ordered that between each two there is a third' (1976, 136). The system we were just discussing is not syntactically dense, since there are only two syntactic types. Likewise, consider a language with all of the potential sentences written out according to some rule or other. The list is infinite, but it is not the case that between any two members of the list one can find a third, and hence this linguistic system is syntactically discrete despite having indefinitely many members. Imagine, however, a system in which lines that differ in length to any degree are *eo ipso* of different syntactic types (Goodman 1976, 135). There is a syntactic type corresponding to each real length. Not only does this system fail to be finitely differentiated—since it is impossible to tell just what syntactic type a line belongs to given any finitely precise measuring instrument—it is syntactically dense. Any total ordering of these syntactic types, unlike the ordering of the sentences above, is such that between any two members there is a third. There are such systems, at least if we idealize a bit. A thermometer is such that heights of mercury that differ to any degree count as distinct syntactic types, that is, the kinds of things that can differ semantically. This system is syntactically dense.

Pictures are like this, at least according to Goodman. They are sets of points in a plane, with each region of the plane assigned a hue, brightness, and saturation. Given any two pictures whose color

regions differ, no matter how small the difference, one can always find a third more similar to each of the two than the two are to each other. In Goodman's terms, 'any element lying between two others is less discriminable from each of them than they are from each other' (1976, 136). Arbitrarily small differences between pictures are sufficient for the two to be distinct syntactically, and in that sense the system is syntactically dense. To put this in terms of the last section, for many of the CCAs of pictures, including color, shape, and size, indefinitely small differences matter to what syntactic type the picture is. Pictures, in this sense, are an extreme example of a lack of finite differentiation. Notational systems must be syntactically finitely differentiated, so in this sense pictures are at one end of a continuum with notation at the other.

Because there is a parallel between figuring out what marks fit into a syntactic type and figuring out what objects fall into the extension of a syntactic type, representational systems can also be *semantically* finitely differentiated or not and semantically dense. Recall the system mentioned above in which there are two syntactic types, corresponding to lines that are one inch long or longer and those that are less than one inch long. We can assign denotations to these syntactic types as we please. So, for example, the short lines represent fire engines and the long lines represent gold. It is easy, at least in principle, to figure out whether an object is a fire engine, gold, or neither, so this system of representation is semantically finitely differentiated. On the other hand, we could assign to the short lines temperatures less than 32 degrees and to the long lines temperatures greater than or equal to 32 degrees. In this system, it is not possible, even in principle, to determine to which semantic type any denotation belongs. The reasons are the same in the semantic case, *mutatis mutandis*, as they are in the syntactic case. No matter how precise one's system for measuring temperatures is, there will be indefinitely many temperatures such that one cannot determine whether they belong in the extension of the long-line syntactic type or the short-line syntactic type.

Semantic density is a special case of a lack of semantic finite differentiation. A semantically dense system 'provides for an infinite number of characters with compliance classes such that between

each two there is a third' (Goodman 1976, 153). A compliance class is simply an extension (Goodman 1976, 144). Consider the thermometer again. Not only is it in principle impossible to discern the syntactic type of many heights of mercury, it is impossible to tell, of any given temperature, which syntactic type's extension it falls under. Even if we are given a syntactic type—a certain height specified with indefinitely fine precision—we cannot determine whether any given temperature falls under it because we cannot measure temperature to indefinitely precise standards. Moreover, in this case there are indefinitely many extensions and the only way to order them is such that between each two there is a third. The thermometer representational system is semantically dense (Goodman 1976, 152–3).

Goodman's idea was that pictures, too, are semantically dense systems of representation. For each of the indefinitely many syntactic types in a pictorial system, there is a distinct extension. Change the color of an arbitrarily small region of a picture surface and not only does its syntactic type change, its semantic type changes as well.[1] In order to figure out whether a given scene is within the extension of a picture, one needs an indefinitely precise characterization of that scene in terms of angles, sizes, distances, colors, and so on.

Syntactically dense systems can have a finite number of denotations that are easy to tell apart. To borrow an example from J. J. C. Smart (1975), imagine that each picture in linear perspective represents one of the following: a bulldozer, an archbishop, or a rainbow. In that case, though the syntactic types are plentiful, any particular representation is such that it represents one of only a few possible denotations and these denotations are easy to tell apart. This would be an odd system, to be sure, but it shows that semantic and syntactic density can come apart.

On the other side of the coin, there are syntactically discrete systems with semantics that are not finitely differentiated. Consider a digital thermometer that reads off temperatures in one-degree increments. Temperatures between 71 and 72 degrees are classified

[1] While it seems true in general for pictures in linear perspective, Goodman does not insist that the smaller the syntactic difference between two characters is, the smaller is the difference in their compliance classes. Kent Bach (1970) proposes such a requirement, continuous correlation, which I discuss in Chapter 5.

as '71', temperatures between 72 and 73 degrees as '72', and so on. This is a syntactically discrete system whose semantics is not finitely differentiated, since it is impossible to tell, for border cases, which temperatures fall into the extensions of which syntactic types. This semantics is not *dense*, since the compliance classes can be ordered in a non-dense fashion. Imagine, by contrast, that '71' is *ambiguous* between all of the determinate temperatures between 71 and 72 degrees. In this case, temperatures that differ to any degree are distinct extensions, so the semantics is dense, even though the syntax of the system requires that the syntactic types are radically ambiguous.

The marriage of syntactic and semantic density is analogicity. Pictures are, for Goodman, essentially analog representations, but they are far from being the only case. A graph that plots temperature versus time continuously is an analog representation since graphs that differ to any degree in the shapes of their curves are syntactically distinct and any distinct pattern of temperature over time constitutes a distinct extension of some graph. The thermometer, too, is an analog system of representation. None of those systems are pictorial, or so intuitions have it. The question is, then, what makes pictures special among the analog representations? Though being analog or not sorts representational systems into two classes, the difference between pictures and diagrams or graphs is, for Goodman, merely 'a matter of degree' (Goodman 1976, 230). Pictures are *relatively replete* analog representations.

Relative Repleteness

Pictures are more replete than diagrams and graphs because pictures tend to have more CCAs than these other kinds of representation. More features of pictures matter to their pictorial identity than features of diagrams matter to their diagrammatic identity. A diagram that plots on a Cartesian plane the position of a particle over time is a syntactically dense system in that its characters are continuously differentiated. The system is semantically dense since the position of the particle is continuously differentiated and all of those possible particle states can be contents of the representation. However, many features of these representations are not relevant to their syntactic

identity. The axes could be labeled or not, drawn with thick lines or thin, and be of any color or brightness without affecting the syntactic identity of the representation in question. Similarly, the thermometer records temperature in an analog fashion, but all that matters to the thermometer representing what it does is the height of the column, not its color, absolute size, width, or what have you. Within a system of color photographs, however, the number of properties that are relevant to the identity of each token is much greater. Pictures are more replete with syntactic significance than those in diagrammatic systems. Changing the color, brightness, or saturation of any patch of the picture—no matter how small the patch and no matter how small the change—results in a representation of a different syntactic type.

Goodman unpacks this vague idea by claiming that 'one dense scheme is more diagrammatic [less pictorial] than a second if the character constitutive aspects under the first are properly included among the character constitutive aspects under the second' (Goodman 1976, 230). The idea is supposed to be that we can compare pictures to diagrams with respect to how many CCAs they have. Doing so, of course, requires Goodman to answer the question of how we count them. If color is a CCA, does that determinable count as one CCA or as many, corresponding to the indefinitely many shades of color a picture surface can be? Similar worries hold for shapes and any other properties that are constitutive of characters, and Goodman does not address this issue.

Another worry here is that Goodman has not given us a condition that even tells us, for any pair of systems, which is more replete. For example, a diagram in which color matters—the red line plots the temperature of one object over time, and the blue line the temperature of another—seems less replete than a black and white photograph. This seems true because in the latter many shape and brightness properties matter to the syntactic identity of the representation while in the former they do not. Moreover, color in the diagrammatic system is rather uninteresting. What matters is that there are *two* colors, not what the two colors are, for example. According to Goodman's condition, however, neither system is more replete than the other because the CCAs of neither system are properly included within that of the other. More shape properties matter to the picture while more

color properties matter to the diagram. So, one may worry whether Goodman has given us the right way to distinguish pictures from other analog representations. The next chapter gives us a better way of understanding the intuitions behind relative repleteness.

With relative repleteness on the table alongside syntactic and semantic density, a couple of points bear mentioning. First, syntactic density together with relative repleteness presents quite a contrast to linguistic representational systems. For example, there are many configurations of many different substances that suffice for an object to be the letter 'a'. It is quite easy to produce 'a's at will and in and on many different media. There is no doubt that being an 'a' is a multiply realizable and multiply realized property. Because they are syntactically dense and replete, it is likely that no syntactic type in a pictorial system is ever instantiated more than once: even multiple prints of a photograph differ to some degree. In principle, the syntactic types in syntactically dense and relatively replete pictorial systems are multiply realizable—imagine a molecule for molecule duplicate of a given picture—though in practice they are not. That is to say, most likely there will never be more than one instantiation of any particular pictorial syntactic type according to Goodman's account. This fact is important for Goodman's (1976, 113) distinction between allographic and autographic art, which is beyond the scope of the present discussion. It is worth mentioning, however, that because pictures are parts of analog systems, they are autographic in that the artwork is identified with a unique, irreproducible particular. Allographic artworks, like poems, symphonies, and dances admit of multiple performances that are beholden to their scores, which are written out in notational systems. A performance is but one instance of an artwork that can be identified in terms of its eminently reproducible score. Scores are parts of notational systems, which are syntactically finitely differentiated and thus reproducible.

Second, notice that the analog nature of pictures makes it difficult to keep track of semantic versus syntactic descriptions of them. In pictorial systems semantic density is manifested in such a way that any two pictures that are syntactically distinct tend to be semantically distinct. Since just about all syntactic differences indicate semantic differences and conversely, the extensional distinction between these

two conditions collapses in the case of pictures, while it does not in the case of discrete (non-dense) and not-so-replete systems such as languages. This may be the source of intuitions that there is no interesting syntactic description of pictures. Pictures certainly do not exhibit an interesting *grammar*, or a compositional syntax, but it is important to keep in mind that for present purposes syntax is just a useful, non-semantic way of distinguishing representations from one another. The fact that any syntactic difference makes a semantic difference can obscure this way of non-semantically identifying pictures. Descriptions of pictures are also often ambiguous between describing their surfaces and what they are about. Shading, illumination, color, and shape are properties of pictures as well as properties of pictures' contents. It is important for the following chapters that syntactic descriptions of pictures are kept separate from semantic descriptions of them.

Worries about Goodman

Goodman (in Goodman and Elgin 1988) claims that analogicity and relative repleteness are necessary features of pictorial systems, but he is unwilling to claim that they are sufficient. That is a good thing, since among the systems that meet Goodman's conditions, many do not seem pictorial at all. A challenge for the next two chapters is to introduce conditions that are in fact sufficient for a representational system to be pictorial. Two examples have stood the test of time as challenges to explaining depiction and they apply particularly well to Goodman's view.

One is due to Richard Wollheim (1980). Consider a picture scheme like linear perspective, say, except for the fact that the pictures in linear perspective are broken up into many pieces and reshuffled according to some rule. This system is semantically and syntactically dense, and just as replete as more familiar picture systems, but it is a mess indeed. A second example, discussed by Wollheim (1980) as well as by Goodman (1976), is a picture scheme like linear perspective except for the fact that colors stand for their complements. In this system pictures of green grass are red, and pictures of the blue sky are yellow. Intuitions about this system are mixed. Some, like Goodman, are happy to classify it as pictorial while others, like Wollheim, loathe

doing so. The intuition that there is something strange about how this putatively pictorial system represents color is uncontroversial, however, and that at least calls into question whether and in what respects the system is pictorial at all.

Christopher Peacocke (1987) offers another convincingly non-pictorial, dense, and replete system. This system is so odd that it brings into relief just how many dimensions along which representational systems can vary while still meeting Goodman's conditions:

Suppose there is a metal bar.... There could be a graph on the y-axis of which we plot the width of the bar at a point on its length given by the value on the x-axis... the probability that at a given point along its length the width of the bar is n might be represented by the color—more specifically the hue—of the corresponding point on the graph. Similarly, the average temperature and density in a certain size of band around that length might be represented by the brightness and saturation of the color of the points along a line parallel with the y-axis. This would be a dense and relatively replete scheme: the hue, brightness, and saturation at every point in the diagram matter. But it is not a picture of the bar. (Peacocke 1987, 405)

Imagine measuring a bar with a very inaccurate instrument and from quite a distance, so that the instrument's results only allow assigning a probability that at some point along its length the bar has a particular width. This information, combined with a representation of temperature and density by the brightness and saturation of regions of the graph, results in a syntactically and semantically dense, relatively replete representation that is nonetheless not pictorial.

In Goodman's (1976, 230–1) words, 'this all adds up to open heresy... colors may stand for their complementaries or sizes, perspective may be reversed or otherwise transformed, and so on.' Our intuitions about which methods of pictorial representation are more realistic, or natural, or effortlessly apprehended arise merely, in some way, from our habits: 'among representational systems "naturalism" is a matter of habit' (Goodman 1976, 231). As noted above, any system in which the token representations and syntax are specified admits of many rules for pairing representations with denotations. This is no less true in the picture case than in the language case. We are left with,

it seems, nothing but habit to hold on to in explaining our strong intuitions about the realism of some pictorial schemes.

Almost any picture may represent almost anything; that is, given a picture and an object there is usually a system of representation, a plan of correlation, under which the picture represents the object. How correct the picture is under that system depends on how accurate is the information about the object that is obtained by reading the picture according to that system. But how literal or realistic the picture is depends on how standard the system is. If representation is a matter of choice and correctness a matter of information, realism is a matter of habit (Goodman 1976, 38).

If density and relative repleteness are sufficient for a system to be pictorial, then, as far as being pictorial is concerned, nothing recommends one system over another. Given that Goodman thinks density and repleteness are only individually *necessary* for being pictorial, some of his comments seem to be more dramatic than heretical. Is it at all plausible that mere lack of exposure to the neurotic shuffled up puzzles results in their being more difficult to understand than their linear perspective ken? If so, then fragment the picture into ten million pieces, or ten times again as many, and watch as the plausibility of Goodman's claim diminishes. There has been a certain antipathy toward structural accounts among theorists of depiction since Goodman, and because of his polemical remarks it is fair to say Goodman started that too.[2]

Goodman's characterization of pictures also falls short in a different direction: it fails to characterize some exceedingly ordinary and readily accessible pictorial systems as such. Digital pictures form a syntactically discrete system, which is also less replete than analog pictorial systems, so digital pictures are not pictorial according to Goodman. But analog and digital pictures seem to differ precisely insofar as some are analog and some are digital, and not insofar as some are pictures and others are not. So, while density and repleteness hold a certain intuitive appeal, they seem neither necessary nor sufficient for a representational system to be considered pictorial.

Finally, it is worth noticing that Goodman has said nothing about the perception of pictures and nothing even about whether pictures

[2] Lopes (1996) is an exception to this rule.

are essentially visual forms of representation. The three conditions he explicates characterize any of a number of representational systems that one can dream up. Some are visual, some auditory, and some are not perceptible at all. The following chapters show that in this regard Goodman was precisely on-target. Pictures are not essentially visual, prima facie intuitions to the contrary notwithstanding. Accepting that pictures must be visual risks missing the structural features that make visual pictures a lot like auditory ones. It turns out that audible pictures are used quite a bit, and one virtue of systemic approaches like Goodman's is that they allow us to notice this. By the end of Part I, with the structural account of pictures on the table and some of its consequences drawn out, it will be clear that the problem of picture perception looks more interesting if one first has some purchase on pictures' structure.

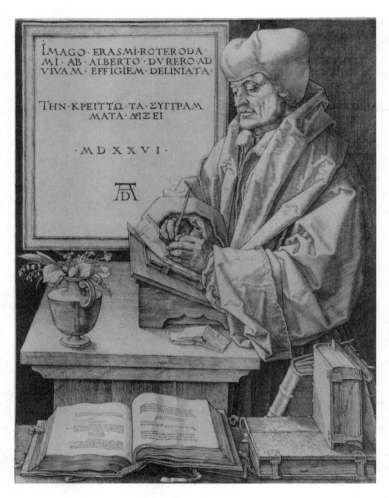

Illustration 2 Albrecht Dürer, *Erasmus of Rotterdam*, 1526. Hood Museum of Art, Dartmouth College, Hanover, New Hampshire; bequest of Hugh Mason Wade in memory of Alfred Byers Wade. Photography: Jeffrey Nintzel

2

Repleteness, Sensitivity, and Richness

Goodman's account may have some problems, and his polemics were pleasantly over the top, but none of this impugns his general approach. One complaint in the last chapter was that Goodman focused too little on character constitutive aspects. What are the properties responsible for a token representation being of a given syntactic kind? Can we understand different representational systems in terms of how tokens are classified under kinds in relation to their character constitutive aspects? All Goodman needed them for was counting, so that he could say which systems were more replete than others, and he did a bad job even on that score.

This chapter introduces a better way to understand how representations fit into syntactic types, in terms of syntactically relevant properties (SRPs). Goodman would hate talk of properties, of course, but this notion does a much better job than character constitutive aspects did for Goodman. With SRPs on the table, three conditions that are individually necessary for a representational system to be pictorial are introduced. The first is a modified version of relative repleteness that handles the problems raised for Goodman's notion in the previous chapter. Relative syntactic sensitivity is, like repleteness, defined in terms of the SRPs of representations. Sensitivity captures the idea that pictures are less tolerant of changes in their SRPs than, for example, inscriptions of words are. The third condition is semantic richness, which obtains whenever there are at least as many possible denotations in a representational system as there are syntactic types in that system. These

conditions do roughly the same work that Goodman's did, with the advantage that they do not exclude digital systems of representation from being pictorial. Furthermore, they do a better job than analogicity at accommodating our intuitions about what makes pictures different from other kinds of representation like diagrams and sentences. These three, like Goodman's, fail to be jointly sufficient for pictorial representation. The next chapter introduces transparency, which is the last piece of the structural puzzle of depiction.

Syntactically Relevant Properties

Let the *syntactically relevant properties* (SRPs) of tokens in a certain system of representation be those properties on which the syntactic identities of the tokens supervene. Changing the syntactic identity of a token requires changing its SRPs, though there can be changes in a token's SRPs that do not affect its syntactic identity. Shape, for example, is an SRP of most alphabets. One can change the shape of a letter without altering its syntactic identity, but if one wants to change a letter's syntactic identity, one must change its shape.[1] Two tokens of a certain letter written in different hands, for example, are quite different in terms of their instantiations of SRPs. Many of the properties of the token letter such as its mass and chemical composition, however, are not syntactically relevant since these properties as such have nothing to do with its syntactic identity. The SRPs are the realization bases of the multiply realizable, higher order properties, such as being of a certain syntactic type. For pictures, the shape and color of every patch of the picture surface are relevant. To change the identity of pictures, one must change the shapes and colors of their surfaces.[2]

[1] To be strict about it, the syntactic identities of letters supervene on their *oriented* shapes. On plausible accounts of shape (Van Cleve and Frederick 1991), the letters 'p', 'd', and 'b' have the same shape, though they differ in shape once one privileges a certain orientation. Thanks to Roy Sorensen for bringing this to my attention.

[2] There is nothing much like an interesting pictorial grammar, of course. The point of syntactic individuation is that it is non-semantic and relevant to their semantic individuation, as discussed earlier. Thanks to Jerry Sadock for making this clearer to me.

A *full characterization* of a system's SRPs is a set of just enough properties to constitute a supervenience base for the syntactic identities of all of the possible tokens of the system. The set of determinate, oriented planar shapes is a full characterization of the SRPs for most alphabets, since the identity of any token letter supervenes on its oriented shape. Incomplete characterizations of SRPs are those that do not suffice in the way just indicated. For example, being square, being circular, and having corners is not a full characterization for an alphabet's SRPs since token representations could be of a kind with respect to those properties though not of a kind syntactically. Full characterizations of the SRPs of a system are in general very large sets: there are uncountably many determinate planar shapes, for example.

A full characterization of SRPs contains 'just' enough properties to constitute a supervenience base because if a set of properties counts as a supervenience base, so does that set augmented by any properties one likes, but the sets in question are supposed to include only syntactically *relevant* properties. So, if the identities of letters supervene on oriented shapes, then they also supervene on oriented shapes plus the property of being a duck, but the latter set tells us nothing interesting about the representational system in question that the former does not. Now, the claim that full characterizations include just enough properties to count as a supervenience base does not mean that for any representational system there is a *unique* full characterization of its SRPs. SRPs are supervenience bases, and supervenience is a transitive relation, so there are typically many full characterizations of the SRPs of any given representational system. This point will become clearer once some more examples have been discussed, so for now the matter can be left abstract.

Two of the following conditions compare representational systems with respect to their SRPs, but because there are many full characterizations of the SRPs of any system, the comparisons are made with respect to characterizations that share members. If one cannot characterize the SRPs of two representational systems in such a way that they share members, then those systems are not directly comparable with respect to the conditions presented below.

Relative Repleteness Again

The introduction of SRPs as replacements for Goodman's CCAs makes it easy to see the problems with Goodman's version of repleteness and points the way toward a useful revision of it. The general idea behind repleteness is that more properties are relevant to the syntactic identities of token representations in some systems than in others. Goodman tried to make this idea explicit, recall, in the following way. In terms of SRPs, representational system A is more replete than representational system B just in case there are full characterizations of the SRPs of A and B, S_A and S_B respectively, such that S_B is properly included in S_A. More properties are relevant to the identity of a picture than are relevant to the identity of a diagram. In diagrams the shapes of lines in coordinate spaces are SRPs, but often the color of the background and thickness of the lines are not relevant while in pictorial systems all such properties are relevant. Pictures differ in a similar fashion from linguistic representations. Since there are characterizations of the SRPs of diagrammatic and linguistic systems that are properly included in characterizations of pictorial systems' SRPs, but not conversely, pictorial systems are the most replete among them.

Goodman's attempt to make the intuitive notion of repleteness explicit has some problems, however, especially when formulated in terms of SRPs. Consider the case in which the intersection of S_A and S_B is not identical to either S_A or S_B, but in which the intersection is a better part of one set than it is of the other. According to Goodman's version of the condition, neither system is more replete because neither set of SRPs is a proper subset of the other. This suggests that repleteness should not require something so strong as proper inclusion of one set of SRPs in another. On the other hand, Goodman was right to insist that the systems being compared have something in common, which means that some SRPs should belong to both S_A and S_B. In other words, $S_A \cap S_B$ should not be empty. Finally, as noted above, full characterizations of a system's SRPs are often very large sets. If repleteness is to capture the intuitive idea that

more properties are relevant to one system than to another, then it should be able to do so for systems with an infinite number of SRPs. Let's say, therefore, that representational system A is more replete than system B just in case:

(1) $S_A \cap S_B$ is not empty, and
(2) The cardinality of $S_A - (S_A \cap S_B)$ is greater than that of $S_B - (S_A \cap S_B)$.

Condition (1) simply requires that the systems being compared be characterizable and characterized in such a way that they share SRPs. It does not make sense to compare phonographs with diagrams, though it does make sense to compare photographs with diagrams since we can characterize the latter two in comparable terms. The second condition captures the intuitive idea that the more replete system is the one in which more properties of the tokens are relevant to their syntactic identities, and it is a bit complicated for two reasons. First, as noted above, proper inclusion of one set in another does not work. And second, since many representational systems have an infinite number of SRPs, a direct comparison of the sizes of S_A and S_B cannot work either. However, if $S_A \cap S_B$ is infinitely large, it may be that only a finite number of members remains when $S_A \cap S_B$ is removed from each of S_A and S_B. One of these remainders might have a greater cardinality than the other one even though this is not true for S_A and S_B themselves.

Repleteness is more of a mouthful in its present form than it was for Goodman, but the following example makes it clear how the definition's parts work and why the complications are worthwhile. Imagine two systems that include a countably infinite number of the determinate planar shapes among their SRPs. One of these systems also includes being red and being green as SRPs, while the other includes orange but neither red nor green. It is in the spirit of relative repleteness to classify the one that includes two colors as more replete than the one that includes just one, since they are otherwise alike. According to Goodman, neither system is more replete since neither set of SRPs is a subset of the other. Furthermore, each set of SRPs has the same cardinality, so it is of no avail comparing the sizes of S_A and S_B directly. However, the cardinalities of the remainders as in

(2) above are different, greater for the system with two syntactically relevant colors than for the system with just one. If S_A and S_B both have an infinite number of members that they do not share, then it makes perfect sense to say that neither one is more replete than the other. This explication of repleteness therefore respects the intuitive notion better than Goodman's does. When one system is more replete than another, in some sense *more* properties matter to the syntactic identities of tokens in one system than matter in the other.

Syntactic Sensitivity

With such an explication of SRPs and relative repleteness in hand, the following question is well posed, and not trivial. What changes in the SRPs of a token in a certain representational system are sufficient for a change in its syntactic identity?[3] SRPs are supervenience bases for the syntactic identities of token representations, so a token's SRPs can change though its syntactic identity does not. For example, removing serifs or making other small changes in the shape of a token letter does not alter its syntactic identity, though each change constitutes a change in the SRPs—in this case the oriented planar shape—that the letter instantiates. The syntactic identities of pictures, on the other hand, are much less tolerant of changes in their SRPs, so in that sense pictures are more sensitive to such changes. The easiest way to see this is to follow Goodman (1976) and imagine an inscription alongside a picture thereof. These representations may have the same properties—the same shape, color, and what have you—but removing the serifs from the inscription leaves its identity intact while removing them from the picture makes it a picture of a different inscription.

Dürer's *Erasmus* engraving, reproduced at the beginning of the chapter, is an excellent example of how sensitivity matters. He was fond of putting notes to viewers within his artwork, and here he points out that he created this portrait from life. The Greek inscription claims

[3] Certain manipulations of the shape of ink on a page can change an 'a' into a 'b'. Other manipulations change an 'a' into gibberish. Both of these types of changes constitute a change in the syntactic identity of the token representation.

that Erasmus' writings are an even better portrait (Schoch et al. 2001). Dürer depicts a frame around these words, so it not only seems that he has depicted an inscription on the facing wall, but that he has depicted a *depiction* of an inscription. We will have a *lot* more to say about depicting depictions in the next chapter. For now, notice that altering the portion of the picture that depicts the inscription makes it a depiction of a different inscription. But many of those alterations would not affect the syntactic identity of the inscription that is depicted. So, a modernization of the portrait, substituting Futura for the font Dürer used, would not change what the depicted inscription says, but it would change the depiction quite a bit.

Representational systems differ from one another with respect to the sensitivity of their tokens' syntactic identities to changes in their SRPs. One representational system is syntactically more sensitive than another if and only if the changes in SRPs sufficient for a change in syntactic identity in the latter are properly included among the changes in SRPs sufficient for a change in syntactic identity in the former. The more sensitive a system, the less tolerance the syntactic identities of its token representations have for changes in their SRPs.

How does one make a comparison between two systems with respect to sensitivity? First note that the comparison of two systems A and B with respect to syntactic sensitivity involves the SRPs that the two systems have in common, i.e. those included in the set $S_A \cap S_B$ for some characterization of the systems' SRPs.[4] Once the systems have been appropriately characterized, imagine grouping sets of possible representations in each system according to their syntactic type, and for each token generating the set of SRPs that it happens to possess. The less sensitive system is the one with the greater number of tokens that are syntactically alike but have different instantiations of SRPs that belong to $S_A \cap S_B$ for each syntactic type. That is, in the less sensitive system, each syntactic type tolerates more variation

[4] As noted above, there are many full characterizations of the SRPs of any given system. The judgment of relative syntactic sensitivity makes sense vis-à-vis characterizations of their SRPs that share members. Also remember that full characterizations of SRPs include just enough properties to constitute a supervenience base for the syntactic identities of the tokens in a given system. See the appendix for a discussion of one technical objection to this way of explicating how to compare systems with respect to sensitivity.

in instantiations of SRPs than in the more sensitive system. This strategy leaves it open that it might be quite difficult to tell, for some pairs of representational systems, which is syntactically more sensitive, but the foregoing explication of sensitivity suffices for the relatively coarse-grained distinctions between pictures, diagrams, and languages.

Notice that if a syntactic type in a representational system has certain features essentially, then there is a characterization of the SRPs of that system such that *any* change in them results in a change in the syntactic identity of that token. Furthermore, it is reasonable to think that for at least many representational systems there are essential characteristics of syntactic types, even if these characteristics are difficult to articulate, disjunctive, and/or vague. For example, one could presumably come close to articulating necessary and sufficient conditions for a letter to be an 'a' even though the characterization is likely to be complicated and disjunctive. Imagine doing the same for all the other letters, so the result is a set of complicated, disjunctive properties. This messy set of messy properties counts as a full characterization of the system's SRPs. What makes this full characterization special is that any change in these SRPs so characterized results in a change in a token's syntactic identity. But inscriptions were supposed to be a rather syntactically insensitive representational system. If their SRPs can be characterized such that any change in them results in a change in syntactic identity, doesn't it mean that every representational system is equally syntactically sensitive? No. The judgment of relative syntactic sensitivity is made with respect to characterizations of systems' SRPs that have members in common, and with respect to the SRPs they actually share: the members of the set $S_A \cap S_B$. The messy properties just mentioned are not parts of characterizations of SRPs that other representational systems will share. To compare inscriptions to diagrams, we need full characterizations of the systems that include properties such as planar shapes, colors, and the like which are characteristic of representations in both systems. What is important for syntactic sensitivity is that there is a characterization of the SRPs of each system such that they share members and one turns out, as articulated above, to be more sensitive than the other.

Sensitivity is a dimension along which pictures differ from languages, though not from diagrams. Diagrams are very much like pictures with respect to sensitivity, since changing the shape of a curve on a graph, even a little, results in a different diagram. Though fewer properties are relevant to the identity of a diagram than to the identity of a picture, the diagram's identity is just as sensitive to changes in the properties that do matter. Pictures and diagrams differ with respect to repleteness but not sensitivity, while pictures differ from languages with respect to both conditions.

Consider Dürer's engraving again. First, taken as a picture the representation is more replete than when it is considered as an inscription. As a picture, the brightness and saturation of every point in the picture area are syntactically relevant while as an inscription brightness and saturation don't matter much except insofar as they help set the letters apart from the background. Second, taken as a picture, the representation is syntactically more sensitive. While there are many alterations of the properties that are syntactically relevant to both the word and the picture that have no effect on the syntactic identity of the inscription, all of these changes have an effect on the syntactic identity of the picture. That is, all of the changes of SRPs that change the syntactic identity of the representation taken as a word also change the syntactic identity of the representation taken as a picture, but not conversely. While relative repleteness says something about the number of properties of token representations—viz. relatively speaking, how many of those properties are relevant to the syntactic identity of the object—sensitivity says something about how those properties relate to the syntactic types of which they are tokens. Goodman did not avail himself of the theoretical tools necessary for formulating syntactic sensitivity. He focused on syntactic and semantic density along with repleteness. Thinking of SRPs in terms of the supervenience bases for the syntactic types of token representations yields the tool needed to understand this condition. As we will see below, sensitivity, along with semantic richness, allows one to avoid appealing to syntactic or semantic density in an account of depiction and other kinds of representation. This is a plus because there are reasons for thinking that pictures need not be syntactically and semantically dense.

Semantic Richness

In addition to sensitivity and repleteness, a simple but import-
ant semantic condition that most representational systems satisfy is
semantic richness. To motivate this, notice that there could be a very
syntactically sensitive and replete representational system that distrib-
utes only a handful of denotations across its many possible syntactic
types. For example, one could take the system of all pictures in linear
perspective, but say that each of them represents one of only a handful
of possible scenes. Despite the rich set of syntactic types in this system,
each type gets only one of a few of the possible denotations assigned to
it. No matter how one might distribute these denotations, the system
is not intuitively pictorial because the richness of the syntax is not
matched by a rich semantics. Semantic richness captures this idea. A
representational system is semantically rich whenever there are at least
as many possible denotations in the system as there are syntactic types
in that system. Languages, diagrams, and pictures satisfy this general
and rough condition, so it does not distinguish between them. While
many denotations are picked out by syntactically different words in a
language, the number of possible denotations is at least as great as the
number of possible syntactic types. In general, a system with a very
rich syntax is not ideally suited to representing delimited classes of
objects. So, while representational systems are generally semantically
rich, this can sometimes fail to be the case.

An interesting case in which a lack of semantic richness plays an
important, if complicated, role is iconic art.[5] We can treat icons as
pictures, in that they depict people in certain poses, surroundings,
clothes, and so on, but when we take icons as icons, there is a large
gulf between the syntax of the pictorial system used and the number of
possible denotations assigned to them. For example, all of the pictures
of Saint Sebastian differ from one another syntactically, and they seem

[5] The following discussion of iconic art is incomplete and meant only to illustrate the
phenomenon of lacking semantic richness. Iconic art, vis-à-vis relative repleteness, semantic
richness, and syntactic sensitivity, is worthy of a study of its own, since these different features
of representational systems interact in interesting ways here, but the topic is nevertheless
beyond the scope of this book.

to depict rather different scenes, but they are all of an iconic kind in being icons of Saint Sebastian. These pictures are *pictures* in the sense that they are syntactically sensitive, relatively replete, and in some sense semantically rich. On the one hand, any of a number of scenes of people shot through with arrows could count as denotations of the pictures. On the other hand, these pictures are of a certain *iconic* kind insofar as they denote a very delimited number of scenes. Saint Sebastian icons all depict a man shot through with arrows. The number of arrows, the clothes he is wearing, the expression on his face, can all differ quite a bit, and despite these differences they are taken to be icons of Saint Sebastian, not anyone else who might have been similarly inconvenienced. A woman holding a sword is not the Virgin Mary in a combative mood, but likely Saint Barbara; a man in sackcloth with a staff is John the Baptist; the man with the keys is Saint Peter; and so on. The intuition that icons are a middle ground between depictions and language is rooted in the fact that we must treat icons like pictures while on top of their rich pictorial semantics we take them to have a semantics that is much more limited than that of pictures. Icons as such can only represent quite discrete states of affairs, but they are nonetheless, in some sense, pictorial.

Icons on a computer desktop are like this too. They vary in their particulars between operating systems and windows interfaces, of course, and this seems to be variation in pictorial content. Some systems have their folders seemingly rotated in three dimensions, while some have the folders seen head-on. Some like trash while others recycle. These differences are noticeable because the icons are, in a sense, pictorial. The differences in these particulars do not affect the identities of the icons from system to system, however. Computer icons make use of a very syntactically and semantically powerful system—something like pictorial representation—to represent a rather limited range of things like folders, files of different kinds, and so on. In cases like this, a failure of semantic richness is quite useful.

Analog and Digital

These last two conditions, relative syntactic sensitivity and semantic richness, differ quite a bit from Goodman's syntactic and semantic

density, but they are meant to serve the same purpose, and they seem to do a better job at it. To recapitulate, Goodman says: '[a] scheme is syntactically dense if it provides for infinitely many characters so ordered that between each two there is a third' (1976, 136). Semantic density 'provides for an infinite number of characters with compliance classes such that between each two there is a third' (Goodman 1976, 153). These conditions are meant to capture the idea that pictures are analog representations, so it is no surprise that density distinguishes pictures from languages. Any two pictures that differ in any way with respect to the colors and shapes of their surface regions are such that there is another picture more similar to each of them than they are to one another. In Goodman's terms, 'any element lying between two others is less discriminable from each of them than they are from each other' (1976, 136). Likewise, if we individuate pictures semantically, any pair of distinct extensions, no matter how similar to one another, is such that there is another extension more like each of the two than they are to each other.

One prima facie problem with this is that very many pictorial representations from newspapers, on television, and so on, seem to be digital. Digital systems flout the syntactic density condition, and it would be a stretch to claim that such digital representations are only pictorial insofar as we interpret them as if they were analog representations. (Cf. Goodman and Elgin 1988, 123–31.) Whether we can do without density depends, of course, on whether different distinctions can accomplish largely the same goals. Sensitivity and richness do just that. In contrast to Goodman's account, repleteness, sensitivity, and richness accommodate comfortably the claim that there are bona fide digital, pictorial representational systems in addition to suggesting the proper place for the analog/digital distinction in understanding the structure of representational systems.

All pictorial representational systems are relatively replete, syntactically sensitive, and semantically rich. It is difficult, however, to compare digital and analog systems with respect to repleteness and, especially, sensitivity. Analog systems are generally more sensitive than digital systems because digital systems are usually designed so that tokens of each syntactic type are easy both to produce and to recognize. (See e.g. Haugeland 1983.) In order for tokens of a certain syntactic type

to be easy to produce, they cannot be terribly sensitive to variations in SRPs. This does not, however, impugn the claim that digital pictures are more sensitive to changes in their SRPs than letters. Rather, it suggests that among the analog representational systems, the pictorial ones are exceedingly replete, sensitive, and rich while likewise among the digital systems the pictorial ones are exceedingly replete, sensitive, and rich. The analog/digital distinction sorts representational systems into classes within which they can be compared with respect to repleteness, sensitivity, and richness. This renders the analog/digital distinction irrelevant to whether a representational system is pictorial, but given the variety of analog systems and the ubiquity of digital pictures, that seems about right.

As mentioned toward the end of the last chapter, there are good reasons to doubt that Goodman's conditions are necessary *or* sufficient for a representational system to be pictorial. Relative repleteness, syntactic sensitivity, and semantic density are not jointly sufficient for a representational system to be pictorial either. After all, these conditions are more inclusive than Goodman's are, since they include many digital systems. Though they are not sufficient, they are plausibly necessary, so all pictorial systems are relatively replete, relatively sensitive, and semantically rich. Furthermore, they provide dimensions that explicate the distinctions between pictures, diagrams, and languages. These conditions therefore constitute an important part of an account of the structure of representational systems. The next chapter presents a further necessary condition—transparency—and claims that these four conditions *suffice* for a representational system to be pictorial.

Filling the Gap

Many strange systems satisfy repleteness, sensitivity, and richness. For example, Wollheim's (1980) shuffled up system is just as replete, sensitive, and rich as more ordinary examples of depiction. The color complement system is likewise quite replete, sensitive, and rich.

One task of the next chapter is to show why many syntactically sensitive, replete, and semantically rich systems of representation fail to be pictorial. There are also many intuitions concerning which representational systems are paradigmatic examples of pictorial ones

and which are not, which are quite realistic and which are not, and so on. The foregoing conditions do not address these topics at all, so the work done so far has left a gap in our understanding of pictorial representation, and no account of pictures should leave such an obvious gap.

That being said, one appealing direction in which to proceed is to claim that facts about us—about the ways our eyes and brains work, for example—contribute to determining which representational systems are pictorial. This approach is eminently plausible considering that what makes the problem cases like Wollheim's shuffled up pictures, the color complement pictures, and Peacocke's silver bar seem non-pictorial is that we cannot engage with them visually in the same ways that we can engage with everyday kinds of pictures. After all, a merely structural analysis of representational systems must fail to take into account how and by whom such representational systems are used, and Goodman's 'open heresy' of conventionalism might be rooted in such myopia. It is as if Goodman told us that stairs were, structurally speaking, repeated block-like patterns that ascend in regular intervals, and we then wondered why the stairs we use in everyday life always seemed so much more special than those whose steps are twenty feet tall.

The great plausibility of an appeal to facts about our visual systems in explaining depiction is not lost on thinkers like Wollheim (1980), Schier (1986), Peacocke (1987), Lopes (1996), Hopkins (1998), and Gombrich (1961), to name but a few.[6] Wollheim appeals to a special perceptual state, seeing-in, to explain why pictures have the contents that they do. Schier and Lopes claim that pictures mobilize our visual recognitional abilities. Gombrich appeals to the fact that pictures are visual illusions under the right circumstances. And Peacocke and Hopkins, albeit in rather different ways, appeal to some kind of

[6] Each of these authors, with differing degrees of explicitness, isolates facts about visual perception as establishing necessary (though not sufficient) conditions on an object being a pictorial representation. The force of this claim is not lost on Goodman either. In Goodman and Elgin (1988), he is more accommodating regarding the problems associated with claiming that the significance of one ostensibly pictorial system over another is just a matter of habit.

experienced resemblance between a picture and what it is about in explaining depiction.

For example, Hopkins (1995, 1998) claims that it is necessary for depiction that the viewer is able to see X in a depiction of X, and 'that to see something O in some part P of a surface S is to see P as resembling O in outline shape' (Hopkins 1995, 443). Hopkins then explains resemblance in outline shape by an appeal to projective constructions much like linear perspective. Project rays from a point to some object—Hopkins uses a pyramid as the object depicted—and, given an interposed plane, trace the outline of the object according to where the projected rays intersect the plane. Hopkins points out that we can, given such a construction, regard the object as subtending a certain solid angle from the projection point. The tracing that one makes subtends the same solid angle as the object does from the projection point. 'Let us call the solid angle an object subtends at a point its outline shape at that point' (Hopkins 1995, 441). Resemblance in outline shape, therefore, is resemblance from a certain point of view. Though he is not completely clear on this score, Hopkins believes that the linear perspective construction is the one that produces the appropriate resemblance in outline shape because our perceptual systems and the world around us work certain ways and not others. In restricting the claim quoted above he says 'we might claim that for a surface to depict there must actually be *someone so constituted* that, were she to see the surface in its intended viewing conditions, she would see in it what is intended to be seen there' (Hopkins 1995, 446, italics mine). In this way, Hopkins looks to perceptual facts to explain what makes certain representations pictures.

Goodman himself could, it seems, give in and claim that among the many candidate picture schemes, there are a few classes of them that hold pride of place in our psychological economies, and those are the truly pictorial representational systems. It is precisely such a plausible maneuver, however, that this book intends to resist. There is no doubt that facts about the visual system are intimately involved in explaining our perception of and understanding of pictures. Furthermore, there is no doubt that perceptual facts must figure in an explanation of pictorial realism, as it is almost through and through a psychological notion. However, it is still an open question whether there are other

structural features that further delimit the class of replete, sensitive, and rich systems so that the result includes only the intuitively pictorial ones. If there are such structural features, then the appeal to perceptual facts turns out to be premature, and risks being altogether misguided. That is to say, if there is such a structural feature that has been missed, then one's account, not only of what makes a representation a picture, but also of what makes the perception of pictures so interesting, and what makes pictorial realism so interesting, is likely to be inaccurate. Chapter 3 shows that transparency is a structural feature of representational systems that limits the class of replete, sensitive, and rich systems to one that contains (just about) only intuitively pictorial ones. This forces a reconsideration of what is so special about the perception of pictures in Part II, ending with a new account of pictorial realism in Part III.

Appendix on Syntactic Sensitivity

Recall that comparing systems with respect to sensitivity requires that we characterize each system's SRPs such that the systems share some SRPs. Since there are typically many characterizations of a system's SRPs, one would expect that there are many ways of characterizing each system such that the two share members. It would be a big problem for sensitivity if, given two systems, one is more sensitive than the other relative to one set of characterizations of their SRPs while the converse holds relative to another characterization of them. How can we be sure that it is not the case for any pair of systems that each one is more sensitive than the other one according to some characterizations of their SRPs? Another way of putting this worry is that it is supposed to be that one system is more sensitive than another, period. The claim is not supposed to be that one system is more sensitive than another with respect to some characterizations of its SRPs but not with respect to others. So, how can we be sure that sensitivity compares systems of representation and not just systems relative to one or another characterization of their SRPs?

Consider two systems, A and B, and two characterizations of the SRPs of each system: S_A or $S_A{}^*$, S_B or $S_B{}^*$. Let's stipulate that the judgment of syntactic sensitivity makes sense with respect to the pairs (S_A, S_B) and $(S_A{}^*, S_B{}^*)$ and that with respect to (S_A, S_B) A is the more sensitive system. Syntactic sensitivity is supposed to be a relation that holds between systems

of representation, and not merely between systems and characterizations of their SRPs, so it had better turn out that A is the more sensitive system with respect to $(S_A{}^*, S_B{}^*)$ as well. Since S_A and $S_A{}^*$ are both full characterizations of A's SRPs, one of them supervenes on the other in the sense that facts about the instantiations of members of one set supervene on facts about instantiations of members of the other set. Furthermore, since what makes A and B comparable with respect to the pairs (S_A, S_B) and $(S_A{}^*, S_B{}^*)$ is that the sets in each pair have members in common, so if S_A supervenes on $S_A{}^*$, then S_B supervenes on $S_B{}^*$, and conversely. Therefore, in order to show that sensitivity is well defined, one has to consider two cases, one in which $S_A{}^*$ supervenes on S_A and one in which S_A supervenes on $S_A{}^*$. In addition, since the judgments of relative syntactic sensitivity are made with respect to the SRPs that two systems have in common, we can limit our discussion to two cases: that in which $S_A{}^* \cap S_B{}^*$ supervenes on $S_A \cap S_B$ and that in which $S_A \cap S_B$ supervenes on $S_A{}^* \cap S_B{}^*$.

A is, by stipulation, more sensitive than B when the systems are compared with respect to (S_A, S_B). In this case, there are changes in properties belonging to the set $S_A \cap S_B$ that result in a change in syntactic identity for tokens in A that do not result in a change in syntactic identity for tokens in B. Since syntactic identity supervenes on $S_A{}^*$ as well as on S_A, one cannot change the syntactic identity of a token without changing some of its instantiations of members of $S_A{}^*$ and S_A. Now let's say that S_A supervenes on $S_A{}^*$, so there is no change in members of S_A without a change in members of $S_A{}^*$ and, as discussed above, $S_A \cap S_B$ supervenes on $S_A{}^* \cap S_B{}^*$. Given these supervenience relations, there can be changes in $S_A{}^*$ that do not entail a change in S_A and changes in $S_A{}^* \cap S_B{}^*$ that do not entail changes in $S_A \cap S_B$. If, by hypothesis, A is more sensitive than B with respect to (S_A, S_B), then there are changes in $S_A \cap S_B$ that result in a change in syntactic identity for tokens in A that do not result in such a change for tokens in B. Furthermore, all of those changes in $S_A \cap S_B$ entail changes in $S_A{}^* \cap S_B{}^*$ because of the supervenience relation that is being assumed for the moment.

Now, could it be that the foregoing holds, but that the judgment of relative syntactic sensitivity goes the other way with respect to $(S_A{}^*, S_B{}^*)$? No. If B were more sensitive than A with respect to $(S_A{}^*, S_B{}^*)$, then there would be changes in $S_A{}^* \cap S_B{}^*$ that result in changes in the syntactic identity of tokens in B but not of tokens in A. All of those changes entail changes in $S_A \cap S_B$ as well since in the cases we are considering syntactic identity supervenes, in the relevant respects, on $S_A \cap S_B$. But that means that there are changes in $S_A \cap S_B$—corresponding to all changes in $S_A{}^* \cap S_B{}^*$—that result in changes in token identities for B but not for A, which contradicts

the hypothesis that A is more sensitive to B with respect to (S_A, S_B). So if A is more sensitive than B given one set of full characterizations of their SRPs, then it is more sensitive for all other characterizations upon which the original characterization supervenes.

What should be said about the characterizations that supervene upon the original characterizations of SRPs? That is, if we take $S_A{}^*$ and $S_B{}^*$ to supervene on S_A and S_B respectively, is it the case that whatever system is more sensitive with respect to the latter is also more sensitive with respect to the former? Yes. Again, by hypothesis comparatively more changes in $S_A \cap S_B$ result in changes in syntactic identity for tokens of A than for tokens of B. Given the previous result, if $S_A{}^*$ and $S_B{}^*$ supervene on S_A and S_B and B is more sensitive to A with respect to $(S_A{}^*, S_B{}^*)$, then B is more sensitive to A with respect to (S_A, S_B) as well, contrary to hypothesis. Therefore, despite the fact that each judgment of relative syntactic sensitivity must be made with respect to a certain characterization of the SRPs of each system, the judgment is the same for any pair of characterizations. It makes sense, that is, to say of two systems without regard to specific characterizations of their SRPs that one is more sensitive than the other is.

Illustration 3 William Hogarth, *The Battle of the Pictures*. Hood Museum of Art, Dartmouth College, Hanover, New Hampshire; purchased through the Guernsey Center Moore 1904 Memorial Fund. Photography: Jeffrey Nintzel

3

Transparency

What could it mean to say that pictures are transparent? As a first pass it is tempting to say what we say of anything else that is transparent: we see right through pictures. We see through them to what? Well, to what pictures are about. Few claims about pictures have seemed both so obviously right and so obviously wrong. On the one hand, perceiving pictures bears a special relation to perceiving what they are about. Alberti and Leonardo compared pictures to windows and mirrors in no small part because of this special perceptual relationship we bear to them. But on the other hand, pictures are hardly invisible. They rarely fool us into thinking we are seeing what they are about. Moreover, we take it as a mark against the value of a picture when any interest we have in it is interest in what it is about. In many ways the debates over the nature of pictorial representation center on explaining this odd feature of pictures. Sure, they are transparent, but of course they are not.

The last chapter ended, however, with the claim that we should not focus on how pictures are perceived, so in what sense independent of how we perceive pictures could they be transparent? And in what sense does this non-perceptual notion of transparency relate to the more perceptually laden uses just adumbrated? A central claim of this book is that we can understand transparency not in terms of a special relation that we bear to certain representations, but in terms of a special relation that representations bear to one another. There is a sense in which transparent representations see right through one another, and it is here that the transparency and seeing metaphors find their proper place. In transparent representational systems, a representation of another representation is syntactically identical to its object. Because syntactic identity entails semantic identity, representations of representations in

transparent systems are about just what their objects are about. Not any old representational system is transparent, and it is rather difficult to make one that manifests this special structural feature. Moreover, once we add transparency to relative repleteness, relative syntactic sensitivity, and semantic richness, we get a class of representational systems that intuitively includes all and only the pictorial ones.

This notion of transparency deserves the name only if it elucidates the more common perceptual uses of the term in describing depiction. By the end of this chapter it will be clear that this structural kind of transparency tracks intuitions concerning perceptual transparency in pictures. So, those pictures that are intuitively the most perceptually transparent belong to systems of representation that are structurally transparent, while those that are not quite transparent perceptually belong to systems that are not quite transparent structurally. Chapter 5 claims that certain common forms of auditory representation are pictorial, and in that sense structurally transparent. What is interesting about this is that the structurally transparent systems of auditory representation track our intuitions about auditory transparency or clarity as well. Part II shows that structural transparency does not just track, but can help explain the perceptual notion of transparency.

Linear Perspective

The best way to get at transparency is by taking a look at a representational system that exhibits it, is rather familiar, and is taken to be a paradigmatic example of a pictorial representational system: linear perspective (LP). For the present purposes, LP is a system of representation in which pictures can bear the following *spatial* relationship to their contents. Consider a point that we can call the *projection point*, and a bounded section of a plane. Let's call the plane the *picture plane* and the bounded section of it the *picture*. The projection point can be anywhere but in the picture plane. Project rays from the point through the picture to the world beyond. Take the first object that a bundle of projected rays meets and make the corresponding region on the plane the same color as the corresponding region of the object from the point of view determined by the projection point.

Figure 3.1 Linear perspective

Doing this for all bundles of rays from the projection point through the bounded section of the plane yields a linear perspective picture (LPP). This characterization falls short of being complete. Pictures of objects behind glass when the glass is itself reflecting something, or pictures of objects under water, taken from above the surface, and pictures in which there are atmospheric effects are not included. Color is rather complicated, too, and merely mirroring the colors of objects as suggested will not yield what we normally take to be LPPs. One makes some improvement by considering all of the points from which light travels through the picture plane to the point, and some rule for generating a color from the light that is traveling to the point through the picture plane. This does not provide all of what one needs, of course, because there is no easy way to determine colors from collections of light rays. Luckily, the analysis offered here of linear perspective is completely independent of the explicit characterization of those situations, so they can be left aside. Representations in LP are paradigmatic examples of pictures, and more specifically, of exceedingly realistic pictures. (See Figure 3.1.)

Transparency

To get a feel for transparency, consider your favorite photograph, and imagine two representations of it. The first describes the photo, say

in terms of features of its content as well as features of the picture surface itself, such as the shading and relative brightness. Now consider describing this description of the photograph. The result is a rather different description than the one being described. The second order description describes the parts of language that make up the original description, and not the patterns of brightness that make up the photograph, so it is syntactically as well as semantically distinct from the original description.

The second is a photograph of your favorite photograph. Consider what happens when one photographs the photo. The result is just like the original in terms of the shapes and colors of its surface. Since the shapes and colors of a picture surface are what, in important part, determine the picture's pictorial identity, depiction of pictures results in pictures that are just like their objects. So there is an important sense in which a picture of a picture is just like its object and has the same content as its object. In this case the object is your favorite photo. In contrast to descriptions and other kinds of representations, pictures are transparent in the sense that they are blind to one another. Make a picture of a picture and you wind up with what you started with. (Cf. Newall (2003), who notices this fact about pictures but develops the idea differently.)

An immediate objection to this is that there is a sense in which a picture of a picture has a different content from its object. Aaron Meskin (2000) raised precisely this point as an objection to the way that I unpack the notion of transparency. For example, your favorite photo might depict a room in a house, while the photo of it merely depicts a photograph, and not a room. In fact, one of Sherrie Levine's important projects from 1979 involved photographing Walker Evans' 1936 photographs of the Burroughs family. The contents of Levine's and Evans' photos are different, so it would seem that the story about pictorial content is more elusive than transparency suggests.

It seems, however, that transparency captures *something* here. Levine's photos are interesting not just in having a different content than Evans' but precisely insofar as they do, in a sense, have the same content as his photos. In 2001, Michael Mandiberg scanned Levine's images and made them (or Evans'?) available on a website.

Mandiberg's pictures may in some sense have a different content from Levine's and Evans', but in a sense they do not.

Likewise, the painting depicted on the facing wall of van Gogh's room is the centerpiece of his painting because we can see right through the painting of it to the tree that the depicted painting depicts. Van Gogh's bedroom portrait is interesting because one can see nothing through or in the window and mirror that share the wall with the painting. As mentioned in the introduction, this distances van Gogh from Alberti's and Leonardo's metaphors concerning depiction—pictures are neither mirrors of nor windows onto the world—and brings him closer to the notion of transparency on offer here.

Understanding transparency requires some theoretical work on the contents of images, but at this point it is easy to state the condition.

A representational system S is *transparent* just in case for any token representation, R, in S, any representation of R in S is of the same syntactic type as R.

Roughly, given a representation, the result of representing it is another representation that is just like the original representation as far as its syntactic identity goes. Since syntactic identity entails semantic identity, in transparent schemes representations of representations are about what the original representations are about. Levine's pictures of Evans' photographs are clear, in focus, and such that her photographic plane was parallel to the plane of the Evans photo. When one does this, the result is just like the original picture with respect to the determinate shapes and colors of all regions on its surface. (See Figure 3.2.) Photography is a useful example not only because it is the most common way in which people make pictures, but also because photographs approximate LPPs.

Though the preceding example is intuitive enough, it does not suffice to show that LP or photographic approximations thereto are transparent. Transparency requires that any picture of another picture is of the same syntactic type as the original. It certainly need not be the case that two picture planes are parallel for one picture to count as a picture of another. (See Figure 3.3.) If Levine had photographed Evans' photos at angles oblique to their surfaces, the results would

Figure 3.2 Transparency, the special case

Figure 3.3 Transparency, the general case

not have been anywhere near indistinguishable from the originals. Resolving this problem is central to understanding transparency and depiction more generally, because it requires a close look at the structural features of pictures as well as a fine-grained account of their contents.

Transparency is a claim about syntactic identity, and since syntactic identity supervenes on representations' SRPs, a full characterization of the SRPs of linear perspective can help show in what respects it is a transparent system. Given a full characterization of a system's SRPs, if two token representations are alike with respect to them, then they are alike syntactically. So, if making a picture of another picture in LP is such that the result shares all SRPs with the original, then LP is transparent. One reasonable way to characterize the SRPs of LP is as the determinate planar shapes and the determinate colors. This counts as a full characterization of LP's SRPs because once one has determined the shapes and shades of all regions of a plane, one has done all that one needs to do to determine the syntactic identity of that plane. Other properties of the plane, such as its mass and temperature, are irrelevant to its identity as a picture. On this view of what the SRPs of LP are, Levine's pictures share them with the Walker Evans photographs. However, Levine could have photographed Evans' work from an oblique angle. The results would have depicted Evans' photographs but they would not have shared all determinate shapes and colors with them. So under certain circumstances—viz. those in which the picture planes are parallel—making a picture of a picture in LP results in a picture shaped and colored in the same way as and hence syntactically identical to its object. However, since nothing about LP itself requires the two planes to be parallel, there are cases in which one makes a picture of a picture with the result not shaped and colored exactly like the original.

The foregoing does not refute the claim that LP is transparent, but it is an important challenge to it. While the class of determinate shapes and shades is a full characterization of the SRPs of LP, it need not be the case that *any* change in the SRPs so characterized results in a syntactically distinct picture. Pictures that differ with respect to their determinate shapes and colors could nevertheless be syntactically identical. To establish transparency we need a characterization of the

SRPs of LP such that any change in them so characterized results in a syntactically distinct picture. Transparency, after all, is a condition that deals with syntactic identity, and though LP is a quite syntactically sensitive system, it is not necessarily sensitive to the highest degree with respect to all characterizations of its SRPs. Goodman actually exaggerated a bit when he claimed that *any* change in a picture's surface colors and shapes results in a syntactically distinct picture.

It turns out that there is a plausible characterization of LP's SRPs such that every picture of a picture in LP is syntactically identical to its object. To see this, first note that LP is a projective system and that there are well-known results from projective geometry concerning invariants under projective transformations. Points are mapped to points, lines to lines, conic sections to conic sections, and so on. (See, for example, Coxeter 1993.) One plausible characterization of the SRPs of LP, then, is the set of properties that are invariant under these projective transformations. Since the projective invariants strictly speaking involve exclusively geometric features of the scene, we need to include some color properties in the characterization as well. If this characterization of the SRPs of LP is reasonable, and if making a picture of a picture in LP is simply applying the perspective projection to a picture, then a picture of a picture is of the same syntactic type as the original picture. Planes related by a linear perspective mapping share by definition the invariants of such a mapping. In addition, facts about the projective invariants and colors supervene on facts about the determinate shapes and colors. Adopting this suggestion therefore does not require abandoning the claim that the determinate shapes and shades are also SRPs of LP. Nor does this proposal abandon the claim that LP is very syntactically sensitive. Though one can change the determinate shapes and colors of an LPP while leaving its projective invariants unchanged, one cannot haphazardly change the determinate shapes and shades of a picture plane and expect to preserve its projective invariants. This contrasts with letters and the like, which are much less sensitive even to haphazard changes in their determinate shapes.

Though it clearly shows that LP is transparent, is this choice of SRPs plausible on independent grounds? There is, after all, a whiff of circularity here, and if not that, then at least a worry that the choice

of SRPs is motivated only by the conclusion that is being sought. It is certainly intuitive to call pictures that share all determinate shapes and colors alike syntactically and, hence, semantically. But pictures that differ in the ways that they can under arbitrary perspective maps do not intuitively share content. (See Figure 3.4.) One motive for calling two possible tokens in a representational system syntactically distinct is that it is possible for them to be representations of different things: syntactically identical representations cannot be representations of different things. Whether the projective invariants are a reasonable choice of SRPs for LP, then, depends on whether there is a notion of the content of a picture according to which all pictures that share projective invariants share content. It turns out that there is such a notion of content, and it was implicit in our discussion of the Levine photographs.

The rules for producing LPPs are such that many different scenes can result in the same picture. The simplest example of this is the special case above—Figure 3.2—in which a picture of a picture is just like the original with respect to its determinate shapes and colors. In that case, the original picture could be a picture of anything one likes—say a dog—and both the picture of the dog and the dog itself result in syntactically identical LPPs. Remember that there is a sense in which the Levine photograph has a different content than Evans', but there is a sense in which they have the same content. The sense in which they have the same content is exactly the sense in which a picture has the same content as any other picture that shares perspective invariants with it. That is, if any scene from which one could produce a particular LPP counts as a part of the picture's content—e.g. the Burroughs' house or a photograph of it—then pictures that share all perspective invariants, however much they differ in other respects, have the same content. Two possible scenes that differ in some respect but not in terms of their perspective invariants from a certain projection point do not differ from one another with respect to perspective projections from that point.[1] It can be difficult

[1] Again, see Coxeter (1993). In projective geometry one usually considers only projective transformations from one plane to another. I have to refer to a point of view to accommodate the fact that in specifying a scene that an LPP is a picture of one has to specify a projection point in order to determine the specific character of the picture. Furthermore, since scenes

Figure 3.4 A picture (left) and a perspective transformation thereof (right). The transform on the right is the equivalent of rotating the picture 55 degrees from head-on. When appropriately oriented, either picture could be produced via a perspective transformation of the other, but the two do not intuitively share content. Moreover, the two are clearly not identical with respect to the determinate shapes of regions of their surfaces, though they are alike in terms of their perspective invariants

to *tell* whether two pictures are related by a perspective transformation and hence identical syntactically, but that is beside the point.

The notion of content here—viz. that whatever scenes could have resulted in a particular LPP via a perspective projection count as parts of the content of the picture—is quite abstract and has a lot in common with John Haugeland's (1991) 'bare bones content' of a representation. Gombrich (1961) also discusses something like this, though not in as well-articulated a form as Haugeland. Though abstract, bare bones content is a plausible way to articulate what pictures can be about and thereby establish conditions under which two pictures differ syntactically. The content that we usually ascribe to pictures—dogs, fire engines, and the like—is, in Haugeland's terminology, the 'fleshed out' content of pictures. Part II will focus on the relation between bare bones content and fleshed out content, and Chapter 6 in particular discusses Haugeland's attempt to account for the distinction between what he calls 'iconic' and other kinds of representation. For now the important point is that recognizing that pictures have bare bones contents allows one to see that pictures are transparent, which is something that Haugeland missed.

If the projective invariants are the SRPs of LP, then LP is a transparent representational system. There are many interesting consequences that follow from a system's being transparent, and the next chapters will investigate these in detail. One that bears mentioning now is that pictures satisfy *their own* bare bones contents. Part of the content of any LPP is a plane that is colored and shaped exactly like the LPP itself. Since such a plane counts as a picture in LP we can say that for any X included in the bare bones content of an LPP, a picture of X is also a part of that LPP's content. Also, many colored planes that an LPP can reasonably be considered a picture of—specifically, all of those that are related to it via a perspective transformation—when interpreted as LPPs, have the same bare bones content as the particular LPP in question.[2]

in three dimensions are such that different portions of them are obscured from different viewpoints, we need to specify the point of view before any claim about the perspective invariants for the particular LPP can be made.

[2] Here is an interesting suggestion due to Steven Glaister that offers another way of looking at the significance of the transparency condition. Taking up a point made by Elliot

Notice that if one were to insist that the contents of LPPs were of the more determinate variety that are commonsensically ascribed to them, then one would not be in a position to see the respects in which LP is transparent. Furthermore, notice that insofar as the perception of pictures motivates claims about their contents being quite determinate, it is only by eschewing the use of perceptual facts as explanans that one is in a position to see the respects in which LP is transparent. Thus one can see the danger in focusing on picture perception to the exclusion of picture structure. In fact, so far nothing has been said about the perception of pictures, whether pictures must be visual, or what role point of view plays in pictures, if any, but more on these topics later. For now, we have a notion of transparency and a claim about the SRPs of LP that shows the respects in which LP is transparent. It remains to be seen how transparency, when coupled with repleteness, sensitivity, and richness fills out an account of depiction.

Sober (1976), Glaister points out that the predicate 'part of' commutes with 'picture of'. So, if X is a part of a picture of Y, then X is a picture of a part of Y. It is also uncontroversial that 'part of' is transitive, so that if X is a part of a part of Y then X is a part of Y. What the transparency criterion does is claim that this transitivity is also, under specifiable circumstances, shared by the predicate 'picture of'. So, if X is a picture of a picture of Y, then X is a picture of Y. Any chain, no matter how complicated, involving each of these predicates will therefore be equivalent to the pair 'part of a picture of' or, equivalently, 'picture of a part of'.

The next natural question to ask after a discussion of pictures of parts is 'What about pictures of sums of parts?' It is not surprising that there is a strong relation between pictures of mereological sums of objects and mereological sums of pictures of objects. Under specifiable circumstances a picture of the mereological sum of X and Y is just the mereological sum of a picture of X and a picture of Y. If a part of a picture of X is a picture of a part of X, the (mereological) sum of parts of a picture is a picture of the mereological sum of the parts depicted. One can therefore distribute the predicate 'picture of' across mereological sums. One interesting case is that in which X is a picture of the mereological sum of Y and a picture of Y. In this case, X is equivalent to the mereological sum of a picture of Y and a picture of a picture of Y. Given transparency, the latter is equivalent to the mereological sum of two pictures of Y, which is a picture of the mereological sum of a Y and another Y. Glaister believes that the commutation of 'picture of' and 'part of', along with transparency, and the consequent relationship between pictures and mereological sums might be sufficient to characterize fully the distinction between pictorial and non-pictorial representational systems. The present author has some reservations about this though Roberto Casati and Achille Varzi (1999) favor a related approach. They point out that a mereological notion alone does not capture what it is to be maplike or pictorial and suggest making use of a topological notion like contiguity. On their view, maps (and presumably pictures) are such their contiguous parts represent contiguous parts of their objects.

Putting Transparency to Work

Transparency is a structural condition that should limit the class of syntactically sensitive, relatively replete, and semantically rich representational systems to those that are intuitively pictorial. The two important test cases mentioned in the last chapter submit to interesting analyses in light of transparency. Neither the color complement system nor the shuffled up picture system straightforwardly satisfies transparency.

In the color complement scheme, skies of blue and fields of green are represented by expanses of yellow and red respectively. This scheme fails to be transparent with respect to representing objects' determinate colors. As one makes pictures of pictures in this system, the colors of the resultant pictures keep jumping back and forth between complementary pairs. Create a picture of a picture of a green object and the result is a (green) picture of a red object, and so on. In this scheme, a picture of a green object cannot also be a picture of a red object. Therefore, the fact that a picture of a picture of a green object is itself a picture of a red object indicates that the picture of a picture is not syntactically identical to its object: transparency fails.

If, however, we ignore color entirely as an SRP of the system, and concentrate on shapes, then the system is transparent and pictorial, just not with regard to colors. Discounting color as an SRP also means that these pictures do not represent objects' colors. In a related vein, a grayscale picture system in which pictures have regions of varying brightness but not hue is also transparent. The worry about the color complement system was, recall, that it seems pictorial in a sense, but in another sense it does not. One way to unpack that intuition is that the complement system is pictorial insofar as one focuses on how it represents spatial properties to the exclusion of how it represents color.

There is another way in which we can reinterpret the token representations in the color complement system to make it pictorial *and* represent color properties. One can include color properties among the SRPs of the color complement system and have it come out transparent, but at the cost of the system only representing very odd color properties, not the standard ones we expect from a pictorial scheme. Specifically, if we take the disjunctive properties

red-or-green, blue-or-yellow, and so on, to be SRPs of the system then the result is a transparent pictorial scheme. A picture of a picture of a red-or-green object, in this scheme, is itself a (red-or-green) picture of a red-or-green object, and so on. This scheme does not, however, represent the determinate colors of objects. Rather, it represents disjunctions of complementary pairs of colors, which is non-standard to say the least. The lesson here is that there are many ways to make a pictorial system, but doing so requires modifying the things represented along with the SRPs of the system in question. Transparency shows in what respects the system is pictorial and in what sense it fails to be so, which accommodates the divided intuitions associated with such systems. One challenge in understanding pictures is to strike the right balance between conditions that describe pictures non-semantically and those that describe what pictures are about. Transparency seems to get this balance just right. It is a semantic condition in that it quantifies over all pictures that depict other pictures, and it is syntactic in claiming that pictures of pictures are syntactically identical to their objects.

The shuffled up picture system is also just as syntactically sensitive, replete, and semantically rich as linear perspective, but it conspicuously fails to be transparent. In this system, a picture of a picture of a horse does not include a horse as part of its content, but a jumbled up assortment of horse parts. Since the picture of the picture does not have the same bare bones content as the original picture, it is syntactically distinct from it and transparency fails. Imagine what goes on as one iterates the representational process in such a system. First, make an LPP of a horse and shuffle it up. Then make an LPP of the shuffled up picture and shuffle up the result. The result is basically a reshuffling of the original picture, which is a syntactically distinct representation. One could look for a reinterpretation of the shuffled up system's representations that renders it pictorial, by analogy with the reinterpretation of the color complement system. It may be difficult to come up with such an interpretation, but if one could, then one would have found a sense in which the shuffled up system is pictorial, but at the price of the system representing rather odd, disjunctive states of affairs.

Given that these two examples are standard test cases for a theory of depiction, we seem to be on the right track with transparency.

Not only does transparency give the correct answers as to whether these systems are pictorial, it provides some purchase on how one could change the interpretations of representations in the systems to get something pictorial. Transparency does all of this, moreover, without appealing to the perception of pictures. Transparency is a syntactico-semantic condition that restricts the class of syntactically sensitive, relatively replete, and semantically rich systems to a class that we intuitively take to be pictorial.

It is both necessary and sufficient for a representational system to be pictorial that it is relatively syntactically sensitive, relatively replete, semantically rich, and transparent. Naturally, it is difficult to demonstrate that the conditions provided here are necessary and jointly sufficient, and much easier to demonstrate that they are not. Toward the end of making the case for these conditions stronger, the following two chapters consider a number of examples that together make it plausible that the definition does the work that is expected of it.

Reworking Transparency

Transparency works well to round out the theory of depiction offered here, but in its current form it has some problems. One advantage of repleteness, sensitivity, and richness trumpeted in the previous chapter is that they do not, like Goodman's conditions, exclude digital representations from being pictorial. Insisting on pictures being analog seemed unreasonable and unmotivated, more in keeping with Goodman's desire to see pictures as extreme cases of failures of notation than an intuitively plausible aspect of a theory of depiction. The problem here, however, is that transparency is such a strong condition that many intuitively pictorial but digital systems fail to satisfy it. There are even many analog systems that are also intuitively pictorial but fail to be transparent as well. Since transparency is supposed to be a necessary condition on a representational system being pictorial, either these systems wind up being classified as non-pictorial or transparency has to be reworked. The intuition behind reworking transparency is that many digital and analog systems fail to be transparent strictly speaking, but are nevertheless transparent *enough*. The goal is to make sense of the notion that a representational

system can approach being transparent, or that one representational system is closer to being transparent than another is. Once this goal has been accomplished, the pictorial systems turn out to be those that are close enough to being transparent.

There are two deceptively simple examples that set the stage for this discussion: digital pictures and blurry pictures. The scheme according to which a blurry photograph is made is not transparent since a blurry photo of a blurry photo need not be identical syntactically to the original blurry photo. The more focused a photograph, however, the closer an equally out of focus photograph of it is to the original. When in perfect focus—when the photo is 'crystal clear'—it is a part of a transparent pictorial system, or so intuitions go. Digital pictorial systems seem to be a similar case: they include pictures all of which are composed of a finite number of units that are of specified sizes, colors, and shapes. One can argue that digital picture systems are not, strictly speaking, transparent. Since the digital units are of a fixed size, few pictures that are not the same size can be alike syntactically. Making a picture of a digital picture can often result in something that is smaller than the original, and thus of poorer quality: try this with your favorite digital camera. However, the bigger the picture gets relative to the size of its component units—i.e. the higher the resolution—the closer the system comes to being transparent. We pay money for megapixels because, in part, the more you have the closer the system is to being transparent. Blurry pictures and digital pictures are pictures, but they are not part of transparent schemes. On the other hand, it is intuitively plausible that these schemes approach being transparent, so we need to explicate in just what respect they do so.

There are a lot of moving parts to play with at this point in the book, and no fewer than three strategies for dealing with this problem present themselves. First, treat digital pictorial systems just as the color complement and shuffled up picture systems were treated. This approach has the advantage of claiming that digital and blurry systems are transparent *simpliciter*, so it does away with the need for claiming that some systems *approach* transparency. The problem with this approach is that it is incredibly implausible and close to unworkable. Second, and more promisingly, since transparency traffics in syntactic identity, claim that a system is transparent to the extent that

representations of representations in that system are syntactically *similar* to their objects, rather than identical to them. Syntactic similarity is not a well-defined notion, but there is a related notion, similarity with respect to SRPs, that does the trick. This approach presupposes that the digital and blurry cases are strictly analogous, which is fine but, it turns out, unnecessary. The third approach rethinks how the digital systems in question work, and shows that a combination of the first two strategies applies to the reconceived digital systems.

To begin, the first strategy is analogous to the one pursued with respect to the color complement and shuffled up picture systems. The price of making the color complement system pictorial was either ignoring color as an SRP or claiming that the pictures in that system say a bit less than ordinary pictures do about color. In the color complement system, the most a picture can say about the color of an object is that it is one of a complementary pair of colors. Perhaps we can understand the contrast between digital and analog representational systems in this way. Digital pictures say relatively less than analog pictures. They go into less detail about the colors and spatial relations between things that they depict. Likewise, a blurry picture says less about what it depicts than a focused picture of the same stuff. This is all uncontroversial. Perhaps, then, the digital pictures' contents are less determinate than those of analog pictures to the extent that a picture of a picture in such a system is syntactically identical to its object. Thus, there is no more to the content of a large high resolution digital picture and a smaller picture of it. On this view, the digital system is fully transparent, not almost or sort of transparent. It is just that pictures in such a system say less than related pictures in an analog system. This is plausible since we like more megapixels because we capture more detail about things we depict with such cameras. Cheap digital cameras make pictures, just not very good pictures. Similar considerations hold for blurry pictures. One can pay a lot of money for excellent lenses, even though without a large budget it is still possible to make pictures.

This approach to solving the problem runs into trouble, however, because it requires digital and blurry pictures to have the wrong contents. For example, consider a high-resolution digital LPP and another digital LPP of it. (See Figure 3.5a.) In order to make this

system straightforwardly transparent, we are committed to claiming that the low-resolution picture and its high-resolution object are syntactically and hence semantically identical. But the intuition at work here is that the high-resolution picture has a different content than the low-resolution picture of it. Similar considerations hold for the blurry picture systems. (Figure 3.5b.) As we make representation of representation we say less and less, rather than saying the same thing all over again. So even though this strategy is a way of showing how a digital or blurry system can be transparent, it does not do so while respecting our intuitions about the contents of such representations. If an alternative strategy is available, it is preferable to this one.

The second strategy starts by noting that for a system to be transparent, representations of representations within it must be syntactically identical to their objects. The obvious proposal, therefore, is that a system approaches being transparent to the extent that representations of representations in it approach being syntactically identical to their objects. A system is almost transparent when representations of representations in it are almost syntactically identical to their objects. This seems straightforward, but a moment's reflection shows that it is rather unclear what it would mean to say that one representation is syntactically similar to its object. Syntactic identity seems well defined but syntactic *similarity* does not. Recall, however, that the basis for claiming that two representations are syntactically identical is the fact that they are identical in terms of SRPs. We can appeal to similarity with respect to SRPs, which is well defined, rather than syntactic similarity in determining the extent to which a representational system approaches transparency.

Consider two systems of making digital LPPs, **A** and **B**, that differ only in resolution, so the former has higher resolution (smaller units) than the latter, but they are alike in the colors of the units that belong to each system. Now consider two digital LPPs, A and B, one in each of the systems just mentioned, that are scale duplicates of one another. Since the units in A are smaller than the units in B, A is smaller than B, but otherwise just like it in terms of SRPs. (See Figure 3.6.) Now depict A in **A** and B in **B** such that the resulting pictures, a and b, are of the *same* size. A is more similar, in terms of SRPs, to a than B is to b in virtue of the fact that the system **A** has greater resolution than the

Figure 3.5a In analog pictures like ordinary photos (above), pictures of pictures are just like their objects. This is not the case for digital photos (next page). Digital pictures are not transparent

Figure 3.5a continued

Figure 3.3b In a blurry system we start with a blurry picture (right) and make an equally blurry picture of it (left). The result is quite different from the original. The more subtle the blur, the closer the system comes to being transparent

system **B**. Hence system **A** is *closer* to being transparent than system **B** is. Blurry pictures admit of a similar treatment. The blurrier the system the less like a picture a picture of it will be in terms of SRPs.

The judgment of relative similarity with respect to SRPs works here because the digital and the blurry systems are each members of an ordered class of representational systems with a truly transparent one as a limiting case. For example, the digital LPPs can be ordered with respect to the sizes of their units. As the units get smaller and smaller, the system gets closer and closer to being true, analog LP. Likewise, the blurry systems can be ordered based on the degree of blur in the system. As they get less and less blurry they approach true LP as well. There are indefinitely many kinds of representational systems that can fit into such classes. Consider, for example, digital systems in which the units are hexagons or overlapping circles rather than squares. Alternatively, one can use astigmatically blurred representational systems and order them as they approach transparency. Many representational systems that may seem pictorial may not fit into such an obvious ordering, and many may fit into more than one. Representational systems are as multifarious in structure and content as the world they represent. For many representational systems it will be difficult to determine just how close to being transparent they are, or how to order them with respect to other representational systems. Moreover, it will be difficult in many cases to determine just how close to being transparent a system needs to be for it to be considered pictorial. These difficulties are nothing to worry about, however. In fact, they are just what one should expect. The goal of this strategy is to make sense of the claim that a system can approach transparency in one way or another, and this way of doing so for digital and analog systems seems to work just fine. If a system is blurry enough, it fails to be pictorial, or so intuitions go, and if it is coarse enough digitally, then it also fails to be pictorial. Just how much is enough? Who knows? What seems right is that some digital systems are pictorial and some fail to be, and that this is a result of their position along the dimension just discussed. This account therefore holds onto the advantage of accommodating digital systems within the pictorial systems.

Another advantage of this approach is that it shows at least one respect in which the structural notion of transparency captures our

Figure 3.6 Three pairs of pictures in three distinct representational systems, the small one a picture of the big one in a given system. Above is a transparent system, on the next page is a high-resolution digital system, and on the following page is a low resolution digital system. Notice that the units in each pair are of the same size. For this reason, a picture of a picture in the digital systems is not just like its object in terms of SRPs. However, the greater the resolution, the more like its object the little picture is

Figure 3.6 continued

Figure 3.6 continued

intuitions about the perceptual notion of transparency. As the system we work with becomes less and less blurry, or is given a finer and finer resolution, the representations within it become clearer and clearer in the intuitive, perceptual sense. True LP, as opposed to its digital and blurry counterparts, is intuitively perceptually transparent and, as shown above, structurally transparent. As we diminish its structural transparency along certain dimensions, we also diminish its intuitively perceptual transparency. So facts about structural transparency track intuitions about perceptual transparency. This does not count as an explanation of perceptual transparency, but the parallels between the structural and perceptual cases are encouraging. Part II offers an explanation of why these cases are parallel.

The second strategy seems to work well, but there is another approach worth mooting here, if only because it relies on a different conception of digital systems than we have been working with so far. Once we rethink how the digital system is supposed to work, we can combine the first two approaches to show in what respects it approaches transparency. The reason pictures of pictures are not syntactically identical to their objects in digital systems like those in Figure 3.6 is that the units that make up each picture are of a *given* size, but the relative size of a picture decreases as one depicts depictions. Since the picture of a picture has fewer units, it will not be syntactically identical to its object, and this makes digital systems analogous to blurry systems. Figure 3.7 illustrates another way to think of digital systems. In this case digital pictures are made by projecting units of solid angle from a point through a plane. Units are assigned to each region of the picture plane and then the whole is scaled up so that the units are of the proper size for the system in question. In this system, a picture of a picture produced as in Figure 3.7 is syntactically identical to its object.[3]

[3] Machines that make digital representations might not seem to implement such a digital system of representation. The pixels in one's camera, after all, do not change their sizes. But the practice of scaling such pictures up and down, along with the sizes of their pixels, does suggest that something like this system is at work. In general, it is difficult to read off from a device for producing representations just what the representations are that it produces, so the artifacts that help us produce representations cannot serve as a strict guide to our interpretation of those representations.

Figure 3.7 The digital system above is not transparent, as in the previous figure. The one below, however, is transparent because the picture of the system has the same resolution as the original. In the system above the sizes of the units stay constant, while in the lower system resolution is held constant. Some ways of implementing a digital system are transparent though many are not

This system is undeniably digital and it is in some sense closer to being transparent than the digital systems considered earlier. Indeed, the only reason this system might seem only to approach being transparent, rather than being transparent *simpliciter* is the fact that pictures of pictures from oblique angles in this system may not seem syntactically identical to their objects. If the angle is very oblique, for example, the picture of a picture may be nothing but a line of pixels—see Figure 3.8—which does not seem syntactically identical to the picture it depicts. This is the point at which appealing to the first two strategies becomes important. First, digital pictures have systematically less determinate contents than their analog counterparts. In this kind of digital system, it is more reasonable to think that a picture of a picture, even taken from a somewhat oblique angle, is syntactically identical to the original, just as it is reasonable to do so for true LP. Because of the digital nature of the system, however, extremely oblique angles seem to result in pictures that are not syntactically identical to their objects. For this reason we can fall back on the second strategy, characterizing the system as approaching but not realizing transparency. Like the digital systems appealed to earlier, these systems fit along a dimension with true LP as a limiting case at one end of the spectrum and such coarse representational systems at the other that they do not seem to be pictorial at all.

A system must possess a certain degree of transparency for it to be considered pictorial. Just as it may be difficult to draw a sharp line between the pictorial and the non-pictorial with respect to repleteness, sensitivity, and richness, it is difficult to draw a sharp line with respect to degree of transparency. Transparency is one of four structural characteristics such that possessing each of them to a relatively high degree is necessary and sufficient for being a pictorial representational system. This provides some purchase not only on what makes pictorial systems pictorial, but also on the dimensions along which pictorial systems relate to diagrammatic, linguistic, and other systems. By contrast to Goodman's (1976) conditions, these show that a structural account can cleave quite closely to the class of representations that we intuitively take to be pictorial.

The ultimate test of these proposals is whether they shed some light on representational systems and the traditional problems associated

Figure 3.8 As one makes oblique pictures of pictures within a digital system (below left), there is a profound change from the picture to the picture of it. This is more pronounced than the change from the original to a head-on picture of it (above left)

with understanding them. Some of the traditional problems have been discussed above, such as the possibility of digital pictures, the shuffled up representational system, the color complement system, and so on. The next chapter addresses the role that mimesis and resemblance play in depiction, and whether and in what sense linear perspective and other systems are mimetic. Chapter 5 addresses the question of pictorial variety. Pictures come in many kinds and the focus on linear perspective and closely related systems might suggest that this account cannot accommodate the variety of pictorial practice that we find today and throughout history. Another potential problem for this account is that it is too liberal in what it calls a picture. These four conditions on being pictorial do not require that pictures be visual representations, so auditory, tactile, and even imperceptible systems of representation can satisfy them. Chapter 5 ends by showing that this is not so much a problem as an advantage of the current approach.

Illustration 4 Leon Levinstein, *Untitled*, c. 1950s. Hood Museum of Art, Dartmouth College, Hanover, New Hampshire; gift of Bart Osman, Class of 1990. © Howard Greenberg Gallery, NYC. Photography: Jeffrey Nintzel

4

Mimesis

In the foreground of all the intuitions surrounding pictures and how they differ from other kinds of representations is the thought that in some sense pictures resemble what they depict. One simple way of fleshing out this intuition is to claim that the intrinsic characteristics of the possible objects of pictures are systematically like the intrinsic characteristics of the possible pictures of them. Furthermore, that pictures are similar to what they are about is in some way relevant to what pictures are about. Similarity drives semantics. Just as transparency admits of perceptual and structural articulations, resemblance can be thought of in terms of perceived likenesses, experienced resemblances, and so on, or in terms of genuine sharing of properties between picture and depicted. This chapter focuses on the latter—'mimesis' in what follows—and shows that any transparent system is mimetic. The question of how this sharing of properties relates to experienced resemblance between picture and what it depicts is addressed in Part II.

Even though every transparent system is mimetic, it turns out that many mimetic systems fail to be transparent. These systems are 'imagistic', but not 'pictorial'. On this view, pictures are but one kind of image. A system is imagistic if it is relatively replete, syntactically sensitive, semantically rich, and mimetic though not necessarily transparent. Pictures are the transparent images. This fits with common usage. It is easy to call the weatherman's tool a radar *image* even though it is a far cry from a picture of the weather. The chapter ends by considering how the mimetic representations relate to the more general class of isomorphic representations.

Resemblance

There are at least two senses in which one object might be judged to resemble another, and the differences between them need to be kept clear. Objects may be judged to look alike, in the sense of being apparently similar or experienced as similar to one another, or they may be judged to be genuinely similar in that they share specified properties. Apparent similarity is a psychological notion that can be and has been explicated in a number of ways by many proponents of perceptual theories of depiction.[1] Not every case of genuine similarity between objects counts as a case of apparent similarity. Furthermore, not every case of apparent similarity is underwritten by an easily ascertainable genuine similarity. One object might look like another while one is left in the epistemic dark concerning whatever genuine similarities underlie the apparent similarity.[2]

It is illicit, notice, to explain apparent similarity in terms of the supposed genuine similarity generated by ascribing inverse intentional properties to objects. One might be tempted, for example, to say that objects that look alike actually are alike in that they share the property of looking a certain way, W, to a subject S. That does not explain or underwrite but just restates the claim that the objects look alike. The problem of pictorial mimesis as framed here concerns genuine, systematic similarities between pictures and their objects.

Now, there are very strong restrictions on what a picture in a transparent scheme can be like if it is to count as a picture of another picture. As stated, transparency entails that a picture of a picture is similar to its object with respect to many of its SRPs. In LP, these SRPs are the projective invariants. More generally, though, does a picture of an X resemble that X, regardless of whether X is itself a colored plane, and if so in what respects?[3] As it turns out, all transparent representational systems are mimetic, so their representations exhibit systematic

[1] For example, Christopher Peacocke (1987), Karen Neander (1987), and Robert Hopkins (1995, 1998) are primarily concerned with experienced similarities, not genuine similarities.

[2] Gombrich (1972) on caricature is an interesting investigation of this issue.

[3] In what follows 'resemblance' is often better suited to many contexts than 'similarity', but unless otherwise noted I mean genuine and not just perceived similarities when I use 'resemblance'.

similarities to what they represent. Furthermore, though transparency entails mimesis, and mimesis entails a sharing of properties between picture and depicted, neither of the converses holds. Before this claim can be supported, however, mimesis needs to be defined.

Mimesis

In order to define mimesis in representation, a few remarks are in order about the properties a system can represent objects as having. First, the properties of objects come at many levels of abstraction. For example, all of the following characterizations of the table in front of me are accurate: a rectangle whose sides are in the ratio 2:1, a rectangle, a parallelogram, a quadrilateral, and a cornered figure. Each says less and less about the table, but is no less accurate for being less informative. Similar considerations apply for colors, relative orientations, relative locations, and so on. Second, a representational system can very well represent an object as being cornered while remaining silent regarding any more determinate details of the object like the number of sides it has. So, while being cornered is not a determinate shape—like, e.g., being a rectangle with sides in the ratio 2:1—one can represent determinately that an object has that indeterminate shape. Similar considerations hold for colors. One can be told that some book has a blue cover without being told that it does or does not have a sky blue cover. To bring in the discussion of similarity from above, two objects can be similar insofar as they share the property of being cornered, even though they share no more determinate properties than that.

 With that in mind, a representational system S is mimetic with respect to a set of properties *C* if and only if the following four conditions hold.

(1) All the members of *C* are SRPs of S.

Clearly, a system cannot be mimetic if the properties with respect to which the system is supposed to be mimetic are not SRPs of that system. Notice that this is why a representation is not mimetic simply in virtue of sharing properties with what it represents. Goodman (1972, 1976) rightly points out that everything resembles everything else in one way or another. Mimesis requires that the properties with

respect to which representations resemble what they are about are relevant to the representations being the representations that they are.

(2) All the members, P, of C are such that representations in S can determinately represent their objects as being P.

This semantic condition is also more or less obvious. S must be able to represent objects as being P if it is to have a chance of being mimetic with respect to P. The term 'determinately' distinguishes between representing an object as being P and remaining silent as regards the P-ness of an object. According to (2), not only is it consistent with all interpretations of representations in S that their objects are P, but for at least some representations in S it is inconsistent with their interpretations that their objects are not P. Now, given (1) and (2), what are the relations between the SRPs of S and the contents of representations in S?

(3) All representations in S that determinately represent their objects as being a member, P, of C are themselves P.

All representations in S that represent objects as being, e.g., quadrilateral are themselves quadrilateral and so on for every other member of the class of n-laterals. In this case, it need not be that rectangles are represented with rectangles or that 2:1 rectangles are represented with 2:1 rectangles, since all one needs for mimetic representation of n-laterals is systematic similarity with respect to laterality. Pictures in LP, for example, share perspective invariants with their objects, but these invariants are quite abstract properties. Not all LPPs of square objects are themselves square, but they are all quadrilateral. Sometimes one can only find mimesis in a representational system if one is willing to look at fairly abstract properties, like laterality. As we will see, pictures in LP turn out to be mimetic with respect to perspective invariants, while other representational systems like sculpture can be mimetic with respect to much more determinate properties. It is interesting that neither LP nor sculpture is mimetic with respect to size: both focus on shapes, albeit at different levels of abstraction. Finally, (3) leaves it open whether

there are representations in S that are *P* but nonetheless fail determinately to represent their objects as being *P*, so we need a final condition:

(4) All representations in S that are *P* determinately represent their objects as being *P*.

These four conditions are necessary and jointly sufficient for mimesis with respect to a set of properties in a representational system. This account does not entail that all representations in S of objects that are *P* are themselves *P*. Only representations that represent their objects as being *P* or are themselves *P* are considered in the definition. It is therefore unproblematic that there might be an object O that is *P*, such that O is represented in S, but the representation of O itself is not *P*, so long as the representation does not determinately represent O as being *P*.

The final condition, (4), is somewhat problematic, and the following considerations motivate some uneasiness about it. First, the Ames chair (Ittleson 1952) presents an interesting problem about how we individuate the objects of pictures. Specifically, one can construct a collection of lines, none of which are co-planar, such that they result in a picture which is itself quadrilateral in the region of it taken to represent the back of the chair, for example. There is no object of the picture, however, that is quadrilateral since none of the lines meet in a plane and form a quadrilateral figure. This is clearly a point at which a structural account of depiction meets higher-level constraints on understanding representation, since little has been said so far relating to the individuation of the objects of pictures. In the end, individuating the objects of pictures appropriately will require accounting for things like point of view. The Ames chair lines, for example, trace out a region into which a quadrilateral object could fit without remainder, and it therefore makes sense to say that the picture from that point of view determinately represents a quadrilateral region of space. What a counts as a quadrilateral region of space is likely explicable in terms of Hopkins' (1998) idea of outline shape as solid angle from a point, and this point is discussed in more detail toward the end of the chapter.

Another problem concerns the fact that (3) and (4) merely claim that in certain systems all of the representations with a certain content have certain properties and vice versa. But merely establishing co-extension might not be enough. First, nothing has been said to the effect that it is *in virtue of* being P that a representation represents its object as being P, and it seems as if that is of the essence of mimetic systems. There seems, however, to be a pernicious ambiguity in the phrase 'in virtue of'. On the one hand, one can claim that it is in virtue of resembling an object in certain respects that a given object is a *representation* of it. This ties facts about resemblance to the fact that some object is a representation and happens to represent the object in question. No claims have been made here about the facts in virtue of which a system of any kind is a representational system. Goodman (1972, 1976) did a nice job articulating the problems with linking facts about resemblance with facts about being representational.

On the other hand, the definition of mimesis offered above is sensibly interpreted as making a claim to the effect that it is in virtue of being P that a representation in S is interpreted as representing its object *as being* P rather than as being anything else. The present concern is with mimesis as a property of representational systems that is relevant to the semantic individuation of representations. It is given that we have a representation, and the question is what is that representation about? In systems mimetic with respect to P, there are no representations that are not themselves P that determinately represent their objects as being P. Furthermore, all representations that determinately represent their objects as being not-P are themselves not-P.[4] So, as far as semantic individuation goes, it is in virtue of being P that a representation represents its object as being P.

Mimesis is first and foremost a feature of the semantics of repre- sentational systems. If a representational system is mimetic with respect to the class of n-laterals, then whenever a quadrilateral surface is represented as such, that representation will also be a quadrilateral, and hence an instance of the same member of the class — quadrilaterals — as

[4] This point is a bit complicated because pictures tend not to represent things as being not-P except by representing them as having properties that are jointly incompatible with the represented object being P. See Schier (1986), Lopes (1996), and Chapter 7 for a discussion of this issue.

the object represented. Mimesis therefore entails similarity and the similarity entailed is semantically significant. There may be many ways in which a particular representation is similar to what it represents and there may even be many ways in which representations are systematically similar to what they represent, but not all of those similarities are instances of mimesis. Furthermore, similarity with respect to some property or other is necessary for mimesis, but this gives no reason for thinking that similarity is either necessary or sufficient for some object to be a representation. This analysis is therefore immune to Goodman's (1972, 1976) objections to the idea that similarity can help explain what makes certain objects representations.[5] It may be that systems whose members systematically resemble a class of objects are ideally suited to representing such a class of objects, but that is not to say that being a representation consists in being similar to some object. Finally, the foregoing makes no mention of apparent similarity, though it is reasonable to expect that mimesis with respect to perceptible properties results in representations being experienced as similar to their objects.

With a workable definition of mimesis in hand, the next section shows that transparent representations are all mimetic.

Mimesis and Transparency

Consider the following representational system that represents the density, conductivity, and temperature of points on planar surfaces. (Cf. Peacocke 1987.) It is a graph whose x-axis and y-axis correspond to the two dimensions of a planar surface. Every point on the planar surface has exactly one point on the graph corresponding to it, and each point on the graph corresponds to at most one point on the surface. Each region of the graph has a hue, brightness, and saturation. They represent, respectively, the density, conductivity, and temperature of their corresponding surface regions. So, the graph

[5] Neander (1987) advocates something like this view of the place for resemblance in depiction vis-à-vis Goodman's criticisms. On her account, the relevant metric of resemblance is system-relative, differing between cubist portraits, children's drawings, and photographs. Neander emphasizes experienced similarities, however, while I want to focus on genuine similarities.

indicates the density, conductivity, and temperature of every region of the surface in question. This scheme is not, intuitively speaking, pictorial, though it is intuitively image-like in some respect or other.

This system fails to be transparent but manages to be mimetic in certain respects, which explains the intuition that it is not pictorial but nevertheless image-like. A representation of the representation in question within the same scheme is another plane whose dimensions correspond to those of the original graph. The hue, brightness, and saturation of a region on the new graph correspond to the density, conductivity, and temperature of a region on the original. The new graph fails to be syntactically identical to the original, however, since the instantiations of its SRPs are such that they properly indicate the density, conductivity, and temperature of the original graph. There is no reason whatsoever to expect the density, conductivity, and temperature of the original *graph* to have any significant relation to the density, conductivity, and temperature of the surface originally represented. Only the colors of the original graph bear any significant relation to the density, conductivity, and temperature of the surface, and likewise for the relation between the new graph (of the original) and the original graph itself.

Naturally, one could change the representational system in question in order to make it transparent. If, instead of hue, brightness, and saturation, it were the density, conductivity, and temperature of the graph that stood for the density, conductivity, and temperature of a surface, the system would come closer to being transparent. Whether this modified system turns out to be transparent depends on how the density, conductivity, and temperature of the surface relate to that of the graph.[6] If density 2Y at a point on the graph stands for a density of

[6] This would not be the most useful representational system ever dreamed up, but it comes close to being pictorial, while the more useful system that uses colors fails to be pictorial. It seems wrong to build into the definition of what makes a representation pictorial that it is useful, or easily apprehended. Once we have a sense of the structure of pictorial systems, we can discuss which of them are particularly useful and which are not. Though a bit counter-intuitive on the surface, it is a great advantage of this approach that it does not make any assumptions about the particular medium and mode of pictorial representational systems, as the next chapter shows. Notice, by the way, that a written language just like English but written in invisible ink is plausibly both representational and linguistic, despite not being very useful or perceptually accessible.

Y on the metal bar, then the system fails to be transparent with respect to the determinate densities. A representation of the graph represents the point at which the graph has density 2Y by having a density of 4Y at that point, and so on. The conductivity and temperature of the representation could be similarly related to the conductivity and temperature of the object represented. In only one very special case is the representational system transparent with respect to determinate values of these quantities. If the system is transparent with respect to density, then a density of Y in a region of the graph stands for a density of Y at the corresponding region of the represented object. The more general case of transparency with respect to a property P should be clear.

Systems which, as above, represent regions of density Y with regions of density of 2Y, are interesting for a couple of reasons. First, though the system is not transparent with respect to determinate densities, it is transparent with respect to relative densities. If a region of one representation is three times as dense as another one of its regions, then the corresponding regions of a representation of that representation will stand in the same relations, and so on. Furthermore, the system is transparent with respect to the shapes of regions with uniform density. If there is a region of uniform density on a surface a representation of it as well as any representations of that representation will include a similarly shaped region of uniform density. In addition, this system is mimetic with respect to relative densities and with respect to shapes of regions of uniform density.

The unmodified version of this system, in which hue, brightness, and saturation are the SRPs, is also mimetic with respect to the shapes of regions of uniform density, but it fails to be transparent with respect to those properties. The system represents regions of uniform density with regions of uniform hue, and the shape of a region of uniform hue is identical to the shape of the region of uniform density that it represents. Since, however, there is no interesting relationship between the colors of a representation and the colors of a representation of that representation, transparency with respect to the shapes of regions of uniform density fails. Additionally, the original system is neither transparent nor mimetic with respect to relative density since the relevant SRP here is hue, not density itself. Though

there may be regions of a representation that have different densities, those densities play no syntactically significant role in the system, so it cannot be transparent with respect to relative density in the way that the modified system can be. The system that represents density with hue is a good example of mimetic representation (of shapes of regions of uniform density) that fails to be transparent.

Next consider a closely related but more familiar example: the radar images used during the nightly weather report. In these images the color of a region corresponds to the intensity of precipitation in that area. The weather radar is sensitive to different densities of the atmosphere at different distances from the antenna, which are directly correlated with the severity of precipitation in that area. This system of representation is an interesting mix of non-transparent, mimetic, and non-mimetic representation, much like the system just discussed.

First, regions of uniform color in the image represent regions of uniform intensity in the storm. Additionally, a region of uniform color has the same shape as the region of uniform intensity that it represents. Part of the point of this representational system is to pick out the locations and shapes of regions of stormy weather, and this system is mimetic with respect to the shapes and relative locations of these regions. The system is not transparent with respect to these properties, however. It is of course practically impossible to make a radar image of another radar image, but even if we bracket this practical difficulty, transparency fails. The radar represents relative densities of the atmosphere, and accordingly an image of another image would record the relative densities of the original image itself. Since it is the colors of the radar image that correspond to densities in its object, there is no reason to think that the densities of the parts of the image bear any interesting relation to the densities it represents its object as having. Hence, an image of another image differs from its object with respect to the colors and shapes of its surface, so it is syntactically distinct from its object.

In order to make this system transparent we could change its SRPs in much the same way that we changed the SRPs of the system that measures density, conductivity, and temperature. The problem for transparency in this system is that the densities of a radar image bear no interesting relation to the densities in the situation that it represents.

Colors carry information about density. If, however, we re-tool the system so that regions of uniform density in the representation correspond to regions of uniform density in the atmosphere, we would be one step closer to a transparent system. The extent to which this new system is transparent depends on the character of the relation between the density of the representation and the density of what it represents, as discussed above.

Finally, consider the color complement system discussed in Chapter 1 and again in the previous chapter. This system fails to be transparent with respect to determinate shades, and precisely where it fails to be transparent, it fails to be mimetic. As mentioned in Chapter 3, if one takes the SRPs that are definitive of syntactic types in this system to be disjunctions of complements of the determinate shades, then the system is transparent. For example, instead of being red, being red–or–green is definitive of syntactic type. Notice, however, that the system so construed is also mimetic in that it represents red–or–green objects only with representations that are red–or–green, and so on. The color complement system is therefore transparent and mimetic when it is taken to represent disjunctions of determinate shades, but it is neither if it is taken to represent the determinate shades themselves. Similar considerations apply to the shuffled up system.

Why does being transparent place such strong restrictions on the character of a representational system? Call a representation of X, in some system, $R(X)$. $R(X)$ represents X as having a certain determinate or indeterminate property, p, of a certain determinable P, and it does so partly in virtue of possessing certain properties relevant to its syntactic and semantic identity. Just which of $R(X)$'s properties are relevant to its being the representation it happens to be—its SRPs—and how they relate to the semantic individuation of representations in that system matter a lot to whether the system is transparent. A representation of $R(X)$, call it $R(R(X))$, must be such that its SRPs bear some significant, non–arbitrary relation to $R(X)$'s SRPs if $R(X)$ and $R(R(X))$ are to be syntactically identical. Let's say that the system in question represents objects as being p in virtue of possessing a certain property t of a determinable T. While the representation's being t is systematically correlated with the object represented being p, the determinates and

indeterminates of P possessed by the representation have nothing to do with the represented object being p or otherwise. If the object of the representation is another representation, like $R(R(X))$, whether $R(R(X))$ is p need not have anything at all to do with whether $R(X)$ is p, which conflicts with the transparency constraint.

So, at a minimum, if a system is transparent, then a representation's being some determinate or indeterminate of P, p, represents its object as being some determinate or indeterminate of P assuming that p is an SRP of the system. The example of a system in which objects are represented as having density Y in virtue of a representation having density 2Y shows that though transparency fails for determinate densities, it does not for relative density. If, on the other hand, the system makes use of colors to represent densities, among other things, then transparency with respect to density fails, though there may be mimesis with respect to properties such as shapes of regions of uniform density. In order to get transparency with respect to determinate densities, the determinate densities must be SRPs of the system and they must be such that a representation's being determinate density p is responsible for it representing its object as having determinate density p. That is, transparency with respect to a certain property or set thereof presupposes mimesis with respect to that property or set. A similar result applies for the indeterminates of density as well, since the foregoing discussion could have been worked out substituting density properties that are not determinate, such as having a density within a certain range. And, naturally, a similar result applies for relative densities, since the system that is transparent with respect to relative densities is also mimetic with respect to relative densities.

Because of the special relationship that transparency demands between representations and representations of representations in a system, making a system transparent with respect to certain properties entails making it mimetic with respect to those properties. Mimetic systems need not be transparent, however, as the examples above show. Though the radar images do not meet the conditions on being pictorial, they are called 'images' for a good reason. Specifically, in addition to the full-blown pictorial representational systems, there is the class of systems that are replete, sensitive, rich, and mimetic, though not necessarily transparent. This class corresponds to what

can be called the imagistic representational systems, and we use many of these in different contexts all the time. Pictorial representational systems are a subclass of the imagistic systems: the transparent ones. This proposal has the advantage of fitting well with our ordinary usage of the terms 'picture' and 'image' since everything that intuitively counts as a picture counts as an image, though not everything we are willing to call an image deserves to be called a picture.

Image and Isomorphism

One thing we often say about images and pictures in particular is that they are isomorphic to what they are about. Just as the class of images properly includes the class of pictures, the class of isomorphic representations properly includes the class of images. So, any system mimetic in certain respects will also be isomorphic in many respects, though it is easy to build isomorphic representational systems that are not mimetic. Representations are isomorphic when they systematically share a structure with what they represent and this sharing of structure is semantically significant. For example, the heights of a mercury column are isomorphic to the temperatures about which they carry information in the sense that for any height greater than another, the temperature corresponding to the former is greater than the temperature corresponding to the latter, and conversely. The thermometer is not a mimetic representational system, but the members of the system (heights of mercury) relate to one another in a way very much like the way in which the represented temperatures relate to one another.

In defining mimesis it was important to note the relevance of certain SRPs to the semantic individuation of tokens within a system. Though SRPs are first and foremost features of representations with respect to which one can individuate them non-semantically, SRPs also have semantic significance. For example, in a system mimetic with respect to being quadrilateral all quadrilateral representations represent their objects as being quadrilateral, and all representations of quadrilateral objects are themselves quadrilateral. One could also construct a system within which a representation's being quadrilateral was responsible for it representing its object as being circular, or red, and so on. For

convenience, let's call this relation between SRPs and the properties they are, in this sense, responsible for representing objects as having 'semantic relevance'.

Now consider a representational system, S, a class of its SRPs, **P**, and a class of properties that this system can represent objects as having, **H**. Take any set of SRPs you like, but include in **H** all and only those properties that are related to the members of **P** by semantic relevance. So if **P** includes heights of a mercury column, include in **H** all those temperatures that the heights in **H** represent and nothing else. If **P** includes a bunch of shape properties, as it could for pictures in linear perspective, include in **H** all those properties that the shape properties in **P** are responsible for representing, and nothing else. This process yields two sets of properties and a one–one mapping between them. Saying that the mapping is one–one is just a way of saying that, for any member of either set, there is exactly one member of the other set to which it corresponds. These sets are isomorphic whenever there is a relation between the members of **P**, R_1, and a relation between the members of **H**, R_2, such that members of **P** bear R_1 to one another if and only if the corresponding members of **H** bear R_2 to one another. These relations constitute the respects in which the sets are isomorphic and there may be, for any pair of sets, many respects in which they share structure. So far, we have just compared an arbitrary set of SRPs with the set of properties that they are responsible for representing. To say that a representational *system* is isomorphic in certain respects, we need to choose our sets of SRPs judiciously. We need to choose, for example, the set of all SRPs of the system that bear R_1 to one another, not just a subset of them.[7]

Thermometers are a straightforward example of isomorphic representational systems. One height of mercury is greater than a second if and only if the temperature corresponding to the former is greater than the temperature corresponding to the latter. In this case, $R_1 = R_2$; that is, the relation between the members of each set is the same—being greater than—even though the things being compared—heights and

[7] I discuss isomorphism as a feature of brain states that represent the world in Kulvicki (2004). This discussion is partly indebted to that one. Like the original, the unpacking of isomorphism is indebted to Rudolf Carnap (1958, 75–8).

temperatures—differ. It is possible to have isomorphic sets when those relations differ: for example, a thermometer that represents greater and greater temperatures with a dot that moves from left to right along an axis. In that system, one temperature is *greater* than another just in case the dot corresponding to the former is *to the right* of the one corresponding to the latter. Neither thermometer is mimetic with respect to temperature, since neither thermometer uses temperature to represent temperature. Thermometers are actually a good example of how representations can systematically share properties with what they represent even though they fail to represent those properties mimetically. Most thermometers work by reaching thermal equilibrium with the environment. So, it is in virtue of being the same temperature as the ambient air that the height of the mercury column corresponds to the temperature. Accurate thermometers will generally *be* the same temperature that they represent their environment as having. Despite this, thermometers represent the temperature via the heights of their columns of mercury, not via their temperatures. Temperature is not an SRP of the thermometer representational system.

There is a multitude of isomorphic systems of representation. They include many graphs, diagrams, images, and pictures, because in the latter cases any mimetic system of representation is isomorphic in many respects. This is easy to see, since in mimetic systems, sets of SRPs stand for instantiations of themselves. Any relation that holds among a set of those SRPs holds straightforwardly between the set of properties that correspond to the SRPs, since the sets have the same members.

Isomorphism is key to understanding *continuous correlation*, a condition on being pictorial proposed by Kent Bach (1970, 128–32). A system is continuously correlative whenever 'given the pictorial properties by which a symbol represents properties of its object, a slight change in the symbol in some respect means a slight change in some respect of what is represented' (Bach 1970, 128). The 'pictorial properties' are just SRPs in the current terminology. Continuous correlation is a well-motivated amendment to Goodman's (1976) view that pictures are both syntactically and semantically dense. Goodman characterizes syntax and semantics side by side, in part because they are strictly speaking independent of one another. Bach realized that what

makes many representational systems special are syntactico-semantic constraints. In this case, Bach relates changes in the SRPs of a representation to changes in its content. Isomorphism relates a set of SRPs to a set of content properties, so it also counts as a syntactico-semantic constraint of which continuous correlation is an instance. To determine whether a system is continuously correlative, we need to compare sets of SRPs along some dimension that admits of degrees so that it makes sense to distinguish a slight change from a large change. Then we need to ask whether the properties represented by representations that differ in those ways also differ along some other dimension that admits of degrees. If so, then the system is continuously correlative; if not, not.

Goodman's account needed an amendment, perhaps like Bach's, but the structural account on offer here has the consequence that pictorial systems are continuously correlative, at least in most cases. Pictures are transparent and hence mimetic, so pictures are instances of their own bare bones contents. Moreover, pictures are quite syntactically sensitive and replete, which means that a lot of their features matter to their syntactic identity, and they matter in a very sensitive way, such that small changes in the properties results in a different syntactic identity for the token in question. Because of transparency and semantic richness, these claims about the repleteness and sensitivity of the picture carry over to a complexity in the picture's content. Pictures are instances of their own complex bare bones contents and there are at least as many possible contents of pictures as there are syntactically distinct pictures. For this reason, we should expect pictorial systems to be continuously correlative, in that we should expect them to exhibit the kind of isomorphism characteristic of Bach's condition. However, as shown above, neither isomorphism nor continuous correlation is sufficient for a representational system to be imagistic, let alone pictorial.

Some Conclusions

The framework developed in Chapters 2 and 3 for describing representational systems has proven to be quite useful in formulating positions on a number of outstanding problems in the study of

pictorial representation. Being transparent with respect to a certain SRP, P, entails being mimetic with respect to P as well. Mimesis involves a systematic and semantically relevant similarity between pictures and the objects they depict. Pictorial systems are mimetic in the sense that they systematically represent objects as having certain properties by themselves manifesting those properties.

Also, a system can be mimetic without being transparent, as the radar image example shows. It fits fairly well with ordinary usage to classify the representational systems that are relatively replete, relatively syntactically sensitive, semantically rich, and mimetic, though perhaps not transparent, as being imagistic, though perhaps not pictorial. The class of pictorial systems is properly included in the class of imagistic systems. Another generalization of representational systems is achieved with the characterization of isomorphism. All mimetic systems are isomorphic, though the converse relationship does not hold. Furthermore, Kent Bach's continuous correlation is a form of isomorphism that we find in pictures, and this is predicted by the structural conditions presented in Chapters 2 and 3. It does not, however, fit with ordinary usage to classify all of the isomorphic systems as being imagistic as well.

An advantage of the structural account on offer here is that it is quite broadly applicable. The next chapter considers the variety of pictorial representation by considering a multitude of visual and non-visual systems of depiction. So far nothing has been said to suggest that pictorial systems must be visual, and it turns out that many systems of auditory and tactile representation are classified as pictorial by the current account. For example, audio recordings turn out to be pictures of audible properties in much the same way that photographs are pictures of visible properties. Such systems pictorially represent a different set of properties than the more traditional, visual pictures do, but they are no less pictorial for being non-visual.

Illustration 5 Jim Dine, *Dartmouth Still Life*, 1974. Hood Museum of Art, Dartmouth College, Hanover, New Hampshire; gift of the artist in honor of Professor Matthew Wysocki. © 2005 Jim Dine/Artists Rights Society (ARS), New York. Photography: Jeffrey Nintzel

5

Other Visibilia and Other Media

Up to now the standard example of depiction has been linear perspective. Depiction and related kinds of representation admit of multifarious instantiations and any theory of depiction worth its salt should account for pictorial variety. Previous chapters have made it clear that the account offered here does not require pictorial representations to be visual, or even perceptible. Understanding depiction is coming to grips with a certain structural kind of representation. That being said, it is still questionable whether the kind of variety that this account admits fits well with our intuitions concerning pictures. The point of comporting with intuitions is not just having an extension that tracks our pre-theoretic categorizations. Rather, it is providing some purchase on those categories that may render them sensible and theoretically useful.

This chapter takes up the task of showing that a lot of representational systems that have been taken to be pictorial are classified as such by the current view. First, many variations on the theme of linear perspective—some not so linear and some not so perspectival—are indeed pictorial. Each of these systems, such as orthogonal perspective and reverse perspective, has been used to make bona fide pictorial representations. In addition, many non-visual systems that one may not have thought of as pictorial turn out to be so. In particular, a rather common form of auditory representation is pictorial, though few have thought to regard it as such. This hardly strains the notion of depiction to the breaking point. Once one realizes what these representations are like, it is rather plausible that the theoretically interesting category

of pictorial representation should include them. Furthermore, recently there has been some discussion of tactile pictures, and the view on hand does a nice job of accounting for them and points to some questions one could ask about them which current biases about pictorial representation have obscured.

The chapter ends by considering a criticism that comes out of Robert Hopkins' (1998) work. According to Hopkins, any theory of depiction must explain certain features of such representations, and the current view does embarrassingly poorly at explaining them, at least on first inspection. Since the view seems not to explain the visual nature of pictures and the fact that they depict from points of view, this account must be barking up the wrong tree. It turns out that some of Hopkins' desiderata are under-motivated, and that the others can be plausibly reformulated in such a way as to better capture what a theory of depiction needs to explain. Not surprisingly, the current view turns out to fare rather well with respect to this modified set of conditions.

Varieties of Visual Depiction

Linear perspective is just one kind of projective system that can be employed to make pictures. Projective systems are ways of creating objects that bear systematic spatial relations to other objects. As remarked in Chapter 3, linear perspective should first and foremost be understood as picking out spatial relations that pictures bear to what they are pictures of. One can vary these spatial relations by varying whether rays are projected from a point, what orientation they bear to the picture plane, and whether the 'rays' in question are themselves just lines. Margaret Hagen's *Varieties of Realism* (1986) is an excellent introduction to and discussion of many kinds of projective systems. The best way to get a feel for how projective systems differ from one another is to look at some examples.

First consider parallel projective systems. These systems do not project from a point, but project rays parallel to one another through the picture plane and out to the object of the picture. This system has a different class of SRPs than linear perspective, simply because parallel projections have different invariants from those of linear perspective.

In particular, parallelism is preserved, as is collinearity, straightness, and topological features of the scene depicted. This system is transparent for reasons similar to those for which LP is transparent. There is a class of projective invariants that are SRPs of parallel projections, and any parallel projection of another parallel projection shares projective invariants, and hence syntactic identity, with it. (See Figure 5.1.) Parallel projection does not specify the orientation of the picture plane with respect to the rays projected through it, but one can imagine indefinitely many special cases of parallel projection in which the angle between the rays and the picture plane is specified and held fixed.

One particularly special case of parallel projection is orthogonal projection in which rays are projected perpendicular to the picture surface. These projections exhibit a more robust set of invariants, such as metric information, than other parallel projections. Strictly speaking, one cannot make an orthogonal projection of the Empire

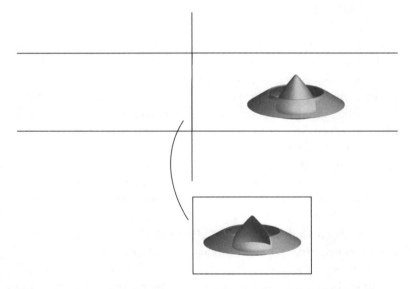

Figure 5.1 In parallel projection, rays are not projected from a point, but from a region, and parallel to one another. This results in different invariants than linear perspective, though pictures in such a system are readily comprehensible

State Building that is any smaller than the building itself. This is inconvenient at best. A scale-independent version of such a system is used in architectural and engineering drawings, however. Interesting discussions of these systems can be found in Hagen (1986) and Willats (1997). Just like the other parallel projective systems, orthogonal projections are transparent and deserve to be called pictorial. When they are used in architectural diagrams, however, they lack the repleteness characteristic of pictures, even if they remain transparent. A failure of repleteness is, after all, what one expects of diagrams, though many diagrams also fail to be transparent.

There are many other ways to project from a point through a plane and get something that seems like a picture. Though it has never been discussed, one could project semi-parabolas instead of lines from a point through a plane and make pictures as one does in LP, *mutatis mutandis*. This system is sensitive, replete, rich, and transparent. Another way to generalize the notion of projection is to project semi-hyperbolas from a point through a plane, and it seems likely that such a system would also satisfy the conditions on being pictorial. Part of the reason that such parabolic and hyperbolic systems have not been considered in the literature on depiction is undoubtedly that light travels in straight lines, not along parabolas or hyperbolas. So, as far as the workings of our visual systems are relevant to the perception of pictures, linear perspective is distinguished from its parabolic and hyperbolic cousins. Moreover, this fact about light makes it rather difficult to *create* an object that is spatially related to a scene in the way that a parabolic projection is. None of this addresses whether the parabolic and hyperbolic systems are pictorial, of course, since facts about perception and ease of production do not figure in the conditions that are necessary and sufficient for a representational system to be pictorial.

A variant on LP that has been used extensively in the history of art is reverse perspective. One can model reverse perspective projectively, and doing so makes it clear that representations in reverse perspective are indeed pictorial. In contrast to LP, in reverse perspective the object of the picture lies between the projection point and the picture plane and the viewpoint is taken to be the image of the projection point mirrored in the picture plane (Willats 1997, 65–9). In this case,

the closer an object is to the picture plane, the smaller the region of the picture it occupies. Since the viewpoint is reversed, however, the closer an object is to the picture plane, the farther it is from the projection point and the closer it is to the viewpoint. As an object recedes from the picture plane and hence from the viewpoint, it approaches the projection point and therefore occupies a larger angle of projection, taking up more space on the picture plane. Train tracks that recede from the picture plane are therefore depicted in such a way that when they are closest to the viewpoint they are closest together and as they recede they get farther apart on the picture plane.[1] (See Figure 5.2.) Reverse perspective constructions are quite syntactically sensitive, relatively replete, and semantically rich. In addition, they are transparent. The simplest way to see this is to note that what makes reverse perspective different from LP is not the projection but the way in which the projection relates to the viewpoint associated with each picture. The projection itself preserves the syntactic identity of representations just as it does in LP. (See Figure 5.3.)

What makes pictures in reverse perspective seem so odd is that they do not represent their objects from anything like a natural point of view. Hagen (1986, 147) claims that reverse perspective—she calls it 'divergent perspective'—was 'never adopted anywhere with enough consistency to be called a style of spatial depiction' (Hagen 1986, 149). In Hagen's view, this is precisely because of 'the complete absence of divergent perspective occasioned by observation of the ordinary environment. There is no place for an observer to stand and view a rectangular building... where the light reflected from the building would be structured in such a way' (Hagen 1986, 149). In contrast

[1] Though one can model reverse perspective projectively, its use in the history of art has been rather inconsistent. Hagen (1986) and Willats (1997, 2003)—'inverted perspective is not in itself a consistent system in the way that scientific perspective is a consistent system' (Willats 2003, 131)—agree on this much. This inconsistency, it seems, arises from the fact that, though the use of reverse perspective *could* be consistent, no one spent much time developing techniques for its employment. This contrasts sharply with linear perspective, for example, which since its development has seen a small industry of methods for making perspective constructions. These include the *construzione legittima* of Alberti and other techniques due to Piero, Barbaro, and Leonardo, not to mention the artists of the Northern Renaissance. See James Elkins' *The Poetics of Perspective* (1994, ch. 3) for an interesting overview of these techniques.

Figure 5.2 Reverse perspective can be modeled projectively. Rather than the picture plane interposed between the object and the projection point, the depicted object sits between the two. The viewpoint for this picture is the projection point mirrored in the picture plane. Parts of the object further from the projection point, and thus closer to the viewpoint, take up less space on the picture plane than similarly sized parts of the object farther from the viewpoint. Train tracks in reverse perspective splay out as they recede from the viewpoint instead of converging

Figure 5.3 Once reverse perspective is modeled projectively, it is easy to see why the system is transparent. The diagram above is just like the one illustrating transparency in LP. The only difference is that the plane on the left is the original picture and the plane on the right is the picture of it, which reverses LP's practice

to LP, the projection point and the viewpoint are not identical in reverse perspective. Point of view will not be discussed in detail until Chapter 9, but for now it is worth noting that reverse perspective has been used in many contexts in both western and non-western art. John Willats (2003, 131) uses this fact to question Hagen's claim that reverse perspective has not been a pictorial style. It is also not uncommon to find reverse perspective in children's drawings.[2] Moreover, it is not obvious what if any *point* of view parallel and orthogonal projections depict from anyway. Though there is something unrealistic and difficult about the interpretation of pictures in reverse perspective, they are, according to the conditions worked out in Chapters 2 and 3, pictures in the full sense of the word.[3] Whatever interesting facts there may be concerning our perception of such pictures, as opposed to pictures in LP, they have no bearing on whether reverse perspective is pictorial.

What about systems that are not quite parallel projective systems, or not quite reverse perspective systems, for one reason or another? Some of these are pictorial and some are not. It all depends on the extent to which each approaches being transparent, sensitive, and replete. Chapter 3 claimed that what makes digital, but not strictly transparent, systems pictorial is the fact that they are close enough to being transparent. The same thought applies here. Once we isolate different classes of transparent systems, those that come close enough to instantiating one of them also count as transparent enough to be pictorial. The fact that it is difficult if not impossible to draw a hard and fast line between the pictorial and the non-pictorial should not be troubling, since it is not clear that there should be such a line in the first place.

[2] Willats (1997, 66) points out that reverse perspective, or what he calls 'inverted perspective', appears in some cubist paintings, Chinese and Japanese art, Byzantine art, and Orthodox icons. He further cites work by Nicholls and Kennedy (1992) showing that children regularly make use of reverse perspective constructions in their drawings and work by Court (1990) showing similar results for rural Kenyan children.

[3] Hopkins (1995; 1998, 156–8; 2003, 162–3) gives yet another reason why reverse perspective is not a pictorial system. Specifically, we cannot perceive pictures in reverse perspective as resembling their objects in outline shape to the same degree of precision that we can when we view pictures in ordinary perspective. Outline shape and the perception of pictures are discussed in Part II.

One might think that it is fine to account for certain systems of depiction as being pictorial, but that pictorial variety far exceeds what can easily be systematized. Many individual paintings and drawings neither belong to one of these systems nor were they created so as to belong to a projective system at all. One may doubt whether de Kooning was making pictures, but it is difficult to claim that Cezanne wasn't doing so. How does one fit a Cezanne still life into a projective system? One of Cezanne's goals, after all, was somehow to exploit the rules of perspective by flouting them. How should we understand Jim Dine's *Dartmouth Still Life*, which starts off this chapter, as a picture? He is engaging with the practice of projection, as he does in much of his work, in particular orthogonal projection, which makes actual-size outlines of objects. But the still life is not just a collection of object outlines, as the hand and scribblings show. This brings up a bunch of subtle issues, concerning not just under what conditions a picture was made, but how it is properly interpreted. Pictorial interpretation is the focus of Part II, and it will not be until the end of the book in Part III that we are in a position to account for the kind of pictorial diversity that such apparently systemless examples realize.

Audio Pictures

Repleteness, sensitivity, richness, mimesis, and transparency are quite general conditions that make no reference to specifically visual modes of representation. It is an open question, then, whether some common non-visual representational systems fit the bill for being pictorial. The existence of such systems would show why, in part, it is valuable to work out a structural account of pictures and images and why perceptual accounts that take the visual nature of pictures for granted are fated to mischaracterize what it is to be a picture. According to the account offered here, playbacks of audio recordings are pictures of things and their audible properties just as visual pictures depict things and their visible properties.

It is not clear just what counts as an audio representation. Is it the pattern of marks on a CD and the grooves in a record, or is it the *playback* of sound that these artifacts help produce? For present purposes, the playbacks turn out to be the theoretically interesting

entities, because they are what most straightforwardly turn out to be pictorial on the account offered here. Since it is not clear why the playbacks should not be treated as representations, and since this does not bar one from also treating the soundless marks on a CD as representations, it seems legitimate to focus on the playbacks without further argument. The way in which the fields on the tape or the marks on the CD encode the sound is not pictorial, but the playbacks are.

First consider the difference between an audio tape that records 'ticks', say of a Geiger counter, and one which is meant to record all of the sounds in a room from a particular point in space. In the former case, all that matters to the representation is that a tick happens at such and such a time. One could change the audible quality of the tick in any way one likes without affecting the representational content of the tape, and one could even insert background noises as long as those noises do not obscure the ticks. Such a recording is akin to a diagram on which a dot is placed along an axis that represents time each time an event occurs. Both such systems are syntactically sensitive since arbitrarily small differences in the timing of the tick in the playback or its position on the diagram correspond to different representations in each system. The tape's playback, like the corresponding diagram, is not very replete, since many additions and changes in the character of the playback that represents the ticks are not relevant to the representation of the events in question: they are not relevant to the timing or presence of the 'ticks'.

When recording all of the sounds in a room, however, things are quite different. The system is indeed syntactically sensitive, since arbitrarily small changes in the magnetic field on the tape, and hence in the playback characteristics of the tape, are sufficient for syntactically distinct representations. All of the representations that are syntactically distinct (have different playback patterns) are semantically distinct since if the playback is different then the sounds it represents are different. Therefore, this system is semantically rich. Also, the recording of all the sounds in the room differs from the diagrammatic recording with regard to relative repleteness. The aspects of the playback that are relevant to the syntactic identity of the tick recording are a proper subset of the aspects of the playback that are relevant to the syntactic

identity of the ambient sound recording. Both recordings are quite sensitive, but more aspects of the playback matter to the recording of ambient sound than matter to the recording of ticks at particular times. In the ambient case, all of the nuances of all of the sounds matter. In addition, playbacks of digital recordings can be treated strictly analogously to digital pictures.

There is also a straightforward audio analogy to the differences between a token representation taken as an inscription on the one hand and a picture of an inscription on the other. We can treat a recording of a spoken word as a representation of the word and nothing more, or as a representation of a particular enunciation thereof. That is, we can consider the recording as a word or as an audio picture of a particular vocalization of a word. Taken as a word only, the representation is less syntactically sensitive than when taken as an audio picture of an utterance of a word. Many changes in aspects of the playback that are relevant to the spoken word being the word it happens to be—that is, many changes in the SRPs of the recording—preserve the syntactic identity of the word that is spoken. We can, for instance, add reverb or distortion, change the pitch, flange it, muffle it, filter it, and what have you. In the end the representation is still the same word. Some changes in the playback, of course, result in a nonsense recording or a recording of some other word. When we take the recording to be of a particular instantiation of a spoken word, however, then there are far fewer changes in the SRPs of the recording that preserve syntactic identity and hence representational content. Add reverb and the spoken word sounds quite different, as if uttered in a room with bare walls and floors. While the word enunciated might endure throughout some of these transformations, the enunciation of the word and hence the sounds represented surely change.

It is easy to see how relative repleteness judgments are made with this example as well. When the recording is just taken to be of a certain word and no more, sounds in the background, as well as sounds before and after the enunciation of the word, are irrelevant to the syntactic identity of the recording. In the case where we are recording the particular enunciation in all of its idiosyncratic detail, all of the details of the sounds occurring before, during and after

the word's enunciation count, and hence all the characteristics of the playback count as SRPs.[4]

Transparency, just like sensitivity, repleteness, and semantic richness, is a very pronounced and often exploited characteristic of these systems of audio representation. Under certain specifiable circumstances, a recording of a recording of X is syntactically identical to a recording of X. It is a familiar fact that making a recording of a playback of a recording, under ideal circumstances, results in a duplicate of the original recording, i.e. a recording that shares all SRPs with the original. In general, because of imperfections in audio equipment, a recording of another recording is not identical to the original, just as a photo of another photo is not identical to it.[5] If a recording is noise-laden because of bad equipment, poor reception, or what have you, then making recordings of recordings on the same equipment results in worse and worse recordings. However, the better and better the equipment becomes—the less and less noise that intrudes—the clearer the recording gets. That is to say, the better the equipment, the less noise-laden are the recordings and the more transparent is the system of representation that the equipment implements.

To sum up this section, first, systems of audio representation of the kind here articulated bear many striking analogies to systems of visual representation. Second, those audio representational systems that stand in the strictest analogy to pictures are themselves syntactically sensitive, relatively replete, semantically rich, and transparent. They are therefore appropriately taken to be pictorial representational systems. Naturally, audio recordings are pictorial representations of the audible

[4] It would be beyond the scope of this section to spend a lot of time articulating the SRPs of audio playbacks. Frequency over time and amplitude over time certainly seem relevant. One interesting quality that does not seem relevant is volume, or overall amplitude rather than relative amplitude. This is analogous to the fact that in linear perspective, all of the SRPs are scale independent, and hence scale duplicates represent the same stuff.

[5] A striking and even beautiful exploitation of the lack of true transparency in a system of audio recording is Alvin Lucier's composition 'I am sitting in a room'. Sitting in a room, Lucier records his reading of a script he has written. He then records a playback of the recording, taking care to play the original recording back in the same room in which he first read the script. After many iterations of this process, nothing of the original script is recognizable. Rather, there is a flowing cadence of tones dominated by the resonant frequencies of the room he was sitting in.

properties of things, not of their visible properties. It is a virtue of structural accounts of pictorial representation that they are not bound to a particular medium. The system mentioned earlier in which densities are the SRPs shows that not every pictorial system has to be visual in nature, and the fact that the most common system of audio representation turns out to be transparent, sensitive, replete, and rich is a welcome result.

One thing that makes audio pictures distinct from their visual counterparts is that it is less obvious in the auditory case how to distinguish bare bones content from fleshed out content. In a sense, it is easy: the playback of a recording can represent a bird or the playback of a recording of a bird, or a good imitator of bird calls, etc. With audio recordings, however, there seems to be less distance between the representation—the playback of the recording—and what it represents—the bird—than in the visual case. Visually, one can focus on features of the picture surface itself, while in the audio case this is less straightforward. This is not the place to work out the distinctions between auditory and visual media in all of their detail, but a few points bear mention. First, audition differs from vision in the extent to which we distinguish perception of the sounds of objects from auditory perception of the objects. C. D. Broad (1953) pointed out that we are just as happy to say we hear an oboe as to say that we hear the sound of an oboe, while we see the oboe, not the sight of or light from an oboe. Second, this means that the degrees open to one for appreciating auditory pictures are more limited than in the case of visual pictures. Audiophiles often appreciate the quality of a recording, but this usually tracks its transparency and not lack thereof. By contrast, the aesthetic appreciation of pictures often involves interesting departures from transparency which allow us to focus on the picture surface itself. Photo-realist pictures are but one form of aesthetically interesting depiction. Part III looks at this in some detail. There are some analogs of failed transparency in the audio case, such as recording the popping of an LP or scratching a record, so it may be that this appreciation of transparency and its lack in the audio case is just relatively untapped, and not non-existent.

Tactile Pictures

Audio pictures have been sitting right under our noses for quite some time, and we have not noticed them. The structural account of depiction is what allows one to see the respects in which these representations are pictorial. Recently, the hegemony of the visual medium for depiction has been challenged in a different way, and from a different perspective on what a picture is. Dominic Lopes (1997) argues that John M. Kennedy (1993) and his collaborators' work on how the blind use pictures undermines the prejudice that pictures are essentially visual. Lopes (1997, 432) asks: 'What is it about our conception of pictures as visual that has bewitched us as thoroughly to obscure the possibility of tactile pictures?' Well, it is the same thing that obscured the pictorial nature of auditory pictures: our failure to attend to the sense-modality independent structural features of representations. Lopes' answer is rather different, of course, since he supports a perceptual account of depiction. Be that as it may, tactile pictures are much more like visual pictures than auditory pictures are, because they are taken to represent haptic spatial analogs of the visual spaces that pictures represent.

Even those blind from birth manage to interpret and create raised-line drawings of familiar objects. These pictures are touched by running one's fingers over the raised lines in order to get a sense of the whole's layout. The blind can recognize the outlines of objects as silhouettes, and they even produce and understand drawings in linear perspective. For example, a trapezoidal contour is taken to stand for a rectangular surface at an oblique angle, which is just what the sighted do when they see a trapezoidal picture part. One of Kennedy's volunteers drew a table from underneath with its legs splayed out in the way they would be were one to see a table from the bottom looking up (Kennedy 1993, 109). Moreover, 'blind volunteers in our studies often mentioned a vantage point' (Kennedy 1993, 180) when describing the content of a picture.

For Lopes (1997, 430), 'Tactile drawings are recognized because outlines in pictures represent touchable as well as visible boundaries.' We have a haptic sense of space around us and of the spatial relations

that parts of an object bear to one another. The raised lines of the drawing are taken to correspond to the boundaries of objects. One's haptic sense of where the parts of objects are relative to one another allows one to recognize certain outlines as standing for those objects, say a person's silhouette, just as one's visual sense may allow one to recognize people in pictures.[6]

It is important to point out that while many can be taught to 'get' such pictures in perspective, rather few are good at identifying even the outline drawings. With untrained subjects and novel outline drawings the identification rate is somewhere around 10 percent for the blind and a bit higher for sighted subjects who touch the picture without viewing it.[7] That being said, the point is not that raised line drawings are a particularly salient form of representation for the blind or anyone else. Rather, despite difficulties with interpretation, people have no trouble conceiving of these collections of raised lines as representations of other things. Furthermore, one can, with context and practice, use these representations effectively and consistently.

The syntactically relevant properties of these representations seem to be the configurations of raised contours on their surfaces. Given the spatial nature of the pictures' contents and the spatial nature of the pictures' syntactically relevant properties, this is at least a candidate for a mimetic system of representation. Moreover, because the haptic spatial features are analogous to visual outline and perspective projections, there is reason for thinking that the representational system in question is transparent. These drawings, consisting merely of outlines, are certainly not as replete as most pictures, but they are rather sensitive, in that changing the configuration of contours in indefinitely many ways can result in a distinct tactile picture. One could make this system more replete, too, if one were to include textures within

[6] The debate between Hopkins (2000) and Lopes (2002) over whether tactile pictures are really pictorial is motivated in part by Hopkins' (1998) account of pictorial representation. Whether we need an aesthetics for tactile pictures is an interesting question also, and one that animates the debate between them, but it is of tangential concern here.

[7] Kennedy (1993, 70–1) reports this rate as being consistent between multiple studies in which the pictures are presented without context and without a list of possible contents, including Lederman et al. (1990), Kennedy and Fox (1977), and Heller (1989). Providing a list of possible contents, as Heller (1989) did, improved the identification rate substantially, though Lederman et al. (1990) did not find this result.

the surfaces. The extent to which this would aid or interfere with the interpretation of the pictures is an empirical question, though. Thompson et al. (2003) found that textured tactile pictures were more easily recognized by sighted but blindfolded subjects than simple raised line drawings.

One obvious question to pursue, given the present account, is what would count as a drawing of another drawing to the blind people who use them. This would help settle the question of whether the representational system being employed is transparent. If a projective outline of a person is understood as such then it is reasonable to think that a projective outline of that projective outline could be understood as such as well. Similar considerations apply to the perspective pictures. It would be quite surprising to learn either that the question made no sense to subjects or that a picture of a tactile picture was considered to be quite different, configurationally, from the picture it depicts. This research has not been undertaken, however.

It is quite interesting that often when subjects fail 'correctly' to identify a picture's content, they offer an interpretation that 'make[s] sense of the pictures visually' (Kennedy 1993, 69, reporting on Kennedy and Fox 1977). Pring (1992) notes a similar result. These answers are considered *errors* because of an antecedent commitment to the content of the drawings. The experimenter looks at some drawings and it is clear that they depict a phone, a rubber stamp, a flower, and a watch. When a blind subject touches those pictures and concludes that they represent a mushroom, a table, a toothbrush, and a tray, respectively, it is easy to say that he or she has made mistakes.

There are two reasons to be a bit circumspect at this point, however. First, if these tactile representations are pictorial, we should expect a distinction between their bare bones content and their fleshed out content. As in visual pictures, bare bones content systematically underdetermines fleshed out content. Visually speaking, there may be an obvious way to flesh out the line drawings' contents, but that fleshing out may just be less obvious tactilely because other options present themselves as relatively more salient. This worry will be brought into clearer relief in Chapters 8 and 9, which explicate the relation between bare bones content and fleshed out content. For now, there are reasons to take interpretations that square well

with the tactile picture's configuration as successful interpretations of the representation. In what sense, after all, does the interpretation 'make sense of the pictures visually'? Watches and trays, tables and rubber stamps do have similar shapes, and we should not assume that every aspect of our interpretation of a picture visually carries over to its tactile interpretations. Moreover, since visual pictures, as any transparent representation, are instances of their bare bones contents, we should expect tactile pictures to be the same. In that sense, Hopkins' claim about visual pictures might just carry over to tactile pictures: 'the picture offers us the satisfactions that seeing the object would, because looking at the picture makes present to us, visually, some of the very properties which looking at the object would' (Hopkins 2000, 165).

Second, the varying interpretations offered of these pictures provide a way to probe how bare bones content relates to fleshed out content. The reason Kennedy says that the false interpretations make visual sense of the pictures is that they are, in a sense, consistent with the configuration of lines on its surface. After Heller (1989) presented his subjects with a list of possible picture contents, their performance improved substantially. This is somewhat unsurprising, since the set of available options for the pictures' contents was reduced quite substantially. In effect, Heller made the system the subjects were trying to interpret fail to be semantically rich. What would be perhaps more interesting, given the account of pictorial content that is on the table, is to see how subjects respond when they are presented with a list of possible contents, *many* of which square well with the configurational aspect or bare bones content of the picture. In that case we could discover that certain pictures bearing an obvious visual interpretation bear rather obvious but distinct tactile interpretations. This approach is more in keeping with the goal to avoid privileging visual pictures over tactile pictures as a standard kind of depiction. That one and the same token has different interpretations in distinct schemes does not impugn the claim that in both cases the schemes are pictorial.

Explaining Depiction?

As mentioned in the introduction to this chapter, any account of depiction must accommodate a rather wide variety of pictorial practices.

The above gives some sense of the kind of variety that this theory countenances. Some work by Hopkins (1998), however, suggests that the present view is wrongheaded. Hopkins thinks any reasonable theory must explain the following six features of depiction:

(x1) There is a significant minimum pictorial content.

(x2) Everything depicted is depicted from some point of view.

(x3) Whatever can be depicted can be seen.

(x4) Pictorial misrepresentation is possible, but it has its limits.

(x5) General competence with depiction and knowledge of the appearance of O . . . suffice for the ability to interpret depiction of O.

(x6) General competence with depiction and knowledge of the appearance of O . . . are necessary for the ability to interpret depiction of O. (Hopkins 1998, 36)

Some of these no doubt require unpacking, but consider the fact that on the current view pictures are not essentially visual forms of representation. This renders (x2) and (x3) false immediately and renders (x5) and (x6) at least problematic, since Hopkins must want 'appearance' to be read in strictly visual terms. Nor will it help to exchange variants of 'perceptible' for the variants of 'visible' that occur above—e.g., 'whatever can be depicted can be perceived', etc. There can be depictions that, given our perceptual constitution, are just imperceptible, such as the depictions of relative densities mentioned in Chapter 3. Furthermore, since nothing much has been said about the pictorial representation of particulars, (x4) has been ignored. It seems as though (x1) alone yields to the analysis in this book, and that only partially because a full explanation of (x1) requires one to say something or other about the depiction of particulars. So if (x1) to (x6) are the gold standard for an account of depiction, it seems we're stuck with tin.

Hopkins introduced his explananda out of frustration with the fact that accounts of pictures focus on getting the extension of the term 'picture' right without an eye to what a theory of depiction is supposed to explain. A useful, helpful, and correct theory of pictorial representation, on Hopkins' view, will explain what makes pictures different from other kinds of representations. Without some sense of what we are trying to explain, we may lose the thread of what we are talking

about altogether, providing an account, not of depiction, but of something else. It is dangerous, however, to start an inquiry into depiction or any other topic with fuzzy boundaries insisting that certain features be explained, because this too may unduly constrain the account. Even though, on a first pass, the account on offer does a poor job with Hopkins' explananda, it suggests some rather natural modifications of some and the rejection of others. These modified explananda are, it seems, just as plausible as those in Hopkins' original set.

Consider first (x1). Pictures are relatively replete in that, relatively speaking, many properties of the picture matter to its syntactic identity. Moreover, pictures are mimetic in that if a property is part of the picture's bare bones content, then the picture instantiates that property and that property is an SRP of the system in question. In the last chapter we saw that if we characterize the SRPs of a picture in such a way that changing them amounts to changing the syntactic identity of the picture, then the properties in that set are also the properties included in the picture's bare bones content. For these reasons, there is a significant minimum pictorial content. One can have many transparent, and hence mimetic, systems of representation which nevertheless fail to be pictorial because of a lack of repleteness. Once one builds the repleteness requirement into depiction, however, that combines with the requirement that pictures are mimetic to ensure that they say, relatively speaking, quite a bit about what they depict.

Nothing about the view offered here suggests that pictures must depict from a point of view, since, among other things, pictures are not necessarily even perceptible. One question to ask, however, is whether this viewpoint requirement is really worthwhile. Hopkins himself admits that some pictures can depict from multiple viewpoints. Moreover, how are we to find a point of view for parallel projections, orthogonal or otherwise? There is no projection point, which is often used to find the point of view from which pictures depict. There are, for each of these pictures, it seems, indefinitely many points of view, or, what seems more plausible, no points of view at all. That doesn't mean that there is no way to view the picture, of course. But it doesn't seem right to say of a picture of a house in parallel projection that it depicts every part of the house from indefinitely many viewpoints, and it seems equally odd to say that each portion of

the house is depicted from its own viewpoint. Hopkins could stick to his guns and claim that there are indefinitely many viewpoints for a picture in parallel projection. The motivation for doing so, however, seems to be more preserving the integrity of his explanandum than comportment with our intuitions concerning pictures. We will see in Part II, especially in Chapter 9, that there is a sense in which point of view fits into our interpretation of pictures. For now, the point is just that the status of (x2) is sufficiently uncertain for it to be wrong to fault an account that does not explain it.

What about (x3)? Is it true that anything that can be depicted can be seen? More generally, can anything that can be depicted be perceived, even if it cannot be seen? If the account so far is on the right track then, no, there is no such requirement on the objects of depiction. On the other hand, the fact that any pictorial system must be mimetic suggests a revised version of (x3). Let's call a 'visible picture' a representation that is pictorial and such that all of its SRPs are visible properties. Representations in LP or any of the other projective systems mentioned above are visible pictures while playbacks of audio recordings are audible pictures, for example. Pictures are instances of their own bare bones contents, remember, so there is always some characterization of a picture's SRPs that is also an accurate characterization of its bare bones content. This is, in part, what it amounts to for a picture to be a mimetic representation. Because of this, it is fair to say that all visible pictures depict what can be seen, audible pictures depict what can be heard, and 'pictures made up of touchable lines should depict touchable edges' (Lopes 1997, 429). What makes it seem as though (x3) is true is, first, the assumption that pictures themselves are all visible, and second, the fact that pictures are essentially mimetic, so if we restrict attention to visible pictures, they all turn out to depict visibilia. Broadening the set of pictures to include invisible representations does not force the abandonment of the claim that there is a close connection between the way in which we perceive a picture and whether we can perceive what it represents.

In order to talk meaningfully about pictorial misrepresentation, as in (x4), one needs to have a sense of what particulars pictures depict. If I know that a picture depicts my brother, then I can compare the

properties I know my brother to have with the properties the picture ascribes to him. To understand misrepresentation, we must be able to compare what a picture says about something to what the thing is like. Since I have said nothing about the pictorial representation of particulars, I really do not have a lot to say about pictorial misrepresentation, and now is not the time to focus on it. There is a standard suite of philosophical problems, moves, and countermoves associated with understanding the representation of particulars, and most of them are orthogonal to the claims made in this book, so I propose to leave the topic to one side.

Working out a structural account of pictorial representation has required avoiding reference to the perception of pictures. It is therefore not surprising that little has been said about (x5) and (x6). This is a significant lacuna. The structural account offered in this part of the book frames the problem of picture perception quite nicely, however. Part II focuses on the contents of images and how we come to know them, which will provide the tools for saying something interesting about (x5) and (x6).

PART II
Image Content

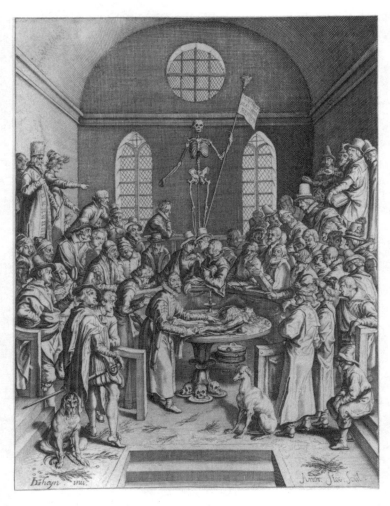

Illustration 6 Andries Jacobsz, *Peter Pauw's Anatomy in Leyden*, 1615. Hood Museum of Art, Dartmouth College, Hanover, New Hampshire; purchased through the Guernsey Center Moore 1904 Memorial Fund. Photography: Jeffrey Nintzel

6

Bare Bones Content

Part I accounts for what makes a representation pictorial in terms of structural features of the systems to which representations belong. The main opponents there are perceptual theories that distinguish pictures from other representations by appeal to how they come to have the contents they have. For the perceptual theorist, what makes a representation a picture of a horse is that there is some special relation between the perception of horses and the perception of the representation. There is a third way to go, however. John Haugeland's (1991) account is unique in that it distinguishes pictures and images from other kinds of representation exclusively in terms of their contents without making reference to their structure or how we perceive them. For Haugeland, the bare bones contents of images have features that distinguish them from the bare bones contents of descriptions, and these distinguishing marks suffice for understanding what makes different kinds, or 'genera', of representation distinct from one another.

Haugeland's account raises a worry for the structural account offered in Part I. If he is right, and we can effectively distinguish images or pictures from other kinds of representations solely in terms of their contents, then structural or perceptual considerations may be interesting but beside the main point. Since bare bones content is an essential feature of the account on offer here, what real work is there left for the structural aspects of these representational systems to do? The structural account may just be a footnote to Haugeland's more fundamental considerations.

This chapter shows that Haugeland fails to identify features unique to the contents of images, and thus fails to account for what makes a

representation pictorial, imagistic, or what have you. Since bare bones content does not form the core of a successful account of pictorial or imagistic representation in Haugeland's hands, more needs to be said. The shortcomings of Haugeland's account can be traced to a failure to appeal to the structure of such representations as worked out in Part I. Furthermore, the specific way in which Haugeland's account fails points directly to transparency, and indirectly to sensitivity and repleteness, as features distinctive of pictures. The upshot is that Haugeland has introduced an important and unfortunately neglected tool for understanding the distinctions between images and other kinds of representations, but the true value of his contribution can only be realized by an appeal to the structure of images as well as their content.

It is also worth keeping in mind that Haugeland's aim is a somewhat coarser sorting of representational systems than that achieved in Part I. He is looking for the 'representational genera', not the species. The 'iconic' genus includes the images plus some graphs and diagrams, while the 'logical' genus includes descriptions, and other logico-linguistic kinds of representations.

Bare Bones Content

Chapter 3 appeals to the bare bones content of pictures in order to explicate transparency, but it does not mention the bare bones contents of descriptions, diagrams, and graphs. For Haugeland to claim that features of bare bones content distinguish pictures from linguistic and other kinds of representations, he needs to give some account of their bare bones contents.

For example, the claim 'Johnny went to bed with a frown and without his supper' has a rather rich fleshed out content. Arguably one does not fully get that content without being able to draw some connection between the frown and the lack of a meal, without being able to guess that Johnny is likely a child or being portrayed as one, and so on. The sentence relies on the reader to draw out what is implied, implicated, and otherwise suggested by and alluded to in the remark without being built into the sentence itself. What one has to build upon, however, is the bare bones content of the sentence,

which amounts to nothing more than that someone, Johnny, went to bed, that he was frowning at the time, and that he did not have any supper.

One could ultimately challenge whether there really is anything like the bare bones content of logical representations as Haugeland construes it. If this is a problem, however, it is a problem for many more philosophers than Haugeland. The bare bones/fleshed out distinction builds on, for example, the distinction between what is implicit and what is explicit in a logical representation. (Haugeland 1991, 186).[1] While bare bones content closely tracks what is explicit in a representation, fleshed out content seems to include not just what is, strictly speaking, implicit, or implied by what is explicit. It also includes what is implicated, and 'Only if "implication" is stretched to the full gamut of what can be expected from conversational skills, topical associations, critical judgments, affective responses, and so on can it hope to encompass [fleshed out content]' (Haugeland 1991, 187).

By way of contrast, the bare bones/fleshed out distinction is distinct from the literal/figurative distinction. There is nothing figurative about what is implied by a representation, but fleshed out content includes what is implied. Haugeland (1991, 186) also notes that if something is figurative, then it is not literal, and conversely, while fleshed out contents include bare bones contents. Bare bones content is certainly literal, but so is fleshed out content. Whether there are bare bones to a representation's figurative content is interesting, but will not be pursued here and Haugeland does not pursue it either.

The bare bones contents of pictures are by now more familiar than those of descriptions. Pictures are often taken to be ambiguous or at a minimum rather indeterminate in content. Those pictures in one's family album certainly represent family members on different occasions and at different locations, but there is a sense in which they are indeterminate as to whether they represent one's family or cleverly designed mannequins on cleverly designed sets. Thought of in this way, pictures are quite indeterminate in what they represent, and if one takes this to its extreme, 'all the photos "strictly" represent is certain

[1] In what follows all page references are to the version of Haugeland's (1991) that is reprinted in his (1998).

variations of incident light with respect to direction' (Haugeland 1991, 189). In terms of linear perspective, for example, these pictures pick out some information about color and illumination and spatial features that are invariant under projective transformations. This is no more and no less than what all of the different interpretations of a given picture in LP have in common, so it is a good candidate for a picture's bare bones content: that upon which any precisification of the content must build. This is a far cry from the content that we usually ascribe to pictures—dogs, trees, people, places, etc.—but ascribing these fleshed out contents to pictures is consistent with them having a rather abstract bare bones content. For Haugeland, 'The point is not to deny the obvious, but rather to distinguish, within the undeniable contents of everyday representations, a substructure that is skeletal—in the special sense that it does not draw upon the user's antecedent familiarity with the situation and the world' (Haugeland 1991, 189).

Distinguishing Genera

Now that we have a more expansive sense of what bare bones content is, and how it might apply to descriptions as well as pictures, what are the relevant differences between the bare bones contents of images and those of logical representations? Haugeland's answer is deceptively simple: '[T]he primitive elements of logical contents... are always identifiable separately and individually. That is, they can enter into... contents one by one, without depending on their concrete relations to one another, if any' (Haugeland 1991, 191). Earlier we characterized Johnny as frowning, which was quite independent of any other characterization of him, including those concerning whether he had had his dinner. What is important here is that it is possible to identify the elements of the bare bones content of a logical representation wholly on their own terms, independently of how these elements may relate to the other elements of that content. The claim is not that there are no relations between these elements, or that there can be no relations between these elements. The point is just that what it is to be an element of the content of a logical representation does not essentially include any relations to the other elements of such content.

With images, the situation is quite different. '[I]conic contents might be conceived as variations of values along certain dimensions with respect to locations in certain other dimensions.' (Haugeland 1991, 192). The bare bones content of a color photograph involves the differing values of hue, saturation, and brightness along two spatial dimensions. Unlike logical representations, the elements of an image's bare bones content are not specifiable without reference to the other elements of that content. Each location is relative to the other locations depicted, and does not count as an element of the picture's content without being placed relative to those other locations. When we say of a picture's bare bones content that it includes something like 'red outline there', the immediate question to ask is 'where is there?'. Understanding where the red outline is depicted as being requires understanding where everything else depicted is depicted as being. Not only are all depicted locations relative to the other depicted locations, but each location is depicted in terms of color. What unites all of the regions in the picture is that each is specified in terms of a hue, saturation, and brightness. The 'elements [of an image's content] are always organized relative to one another in some regular structure that every representational token of the pertinent scheme essentially presupposes' (Haugeland 1991, 192). So, given that one element of the picture's content is some color at some relative location, we know that some other element of the picture's content is a color at a relative location.

It is quite difficult but absolutely essential to understand the foregoing as claims about the *contents* of representations, and not as claims about the representations themselves. Note, for example, that every sentence in English is such that its elements are 'organized relative to one another in some regular structure that every representational token of [English] essentially presupposes', since all languages have a grammar and syntax. This is beside the point. The elements of the contents of sentences of English are not like this, since one can specify the frown of Johnny quite independently of any other elements of the content of a sentence containing it. The rest of the sentence can discuss any kinds of features of just about any object one likes. There is no spatial, topical, or other kind of unity that the contents of descriptions all have in common, and this is what distinguishes descriptions

from images. One cannot specify an element of the content of a picture independently of its concrete relations to other elements of that content because every representation in the system presupposes a structure whereby all elements are related to one another. Every depicted location is assigned some hue, saturation, and brightness, and it is part of the nature of certain pictures that they do so. That is not to say that the color at a certain location places constraints on what colors appear at other locations, but just that if color-at-a-location is an element of a picture's content, then other elements of that content are also colors at locations relative to that one. Likewise, if temperature-at-a-time is an element of a graph's content then other elements of that content are also temperatures at times.[2]

Problems with the Account

This is an interesting and subtle observation about the nature of the contents of images, graphs, and related representations, but does it really distinguish this class from others like descriptions? At first glance, and no less in light of Part I, it seems as if part of what makes a representation pictorial is the structure of the representations themselves and not just what they are about. These intuitions may be false, of course, but if so, one is obliged to explain them away. It is not as though the account in Part I fails to grate against intuitions. In line with Part I, Haugeland thinks that there is nothing essentially perceptual or even visual about pictorial representations. For all that Haugeland says, images could be auditory, tactile, or what have you. What makes Haugeland's claim quite radical is that, in addition, he thinks it is only in terms of content that we need to distinguish the iconic genus from other kinds of representations, while Part I appeals to structure and content. There are problems with the account as Haugeland works it out, however, which suggest that Part I is on the right track.

[2] It is worth pointing out, even if it is a bit of an aside, that Haugeland's (1991) account makes room for digital pictures, graphs, and diagrams much as the account of Part I does. There is nothing about this feature of pictures' contents that requires them to be in an analog medium, since dimensions of variation can be discrete as well as continuous.

According to Haugeland's account, one could create an imagistic representational system by assigning undeniably iconic contents to the syntactic types of any system at all. Chapter 1 distinguishes semantic features of representational systems from their syntactic features and points out that once a set of syntactic types is in place, one is quite free to assign any of a number of contents to them. This immediately renders Haugeland's way of identifying images a bit dubious. For example, the representational system in which the *contents* of color photographs are paired with the sentences of English is an imagistic system on Haugeland's account. The contents of color photographs are paradigmatically iconic, but we can assign what contents we like to a representation, including the sentences of English. So this kind of reinterpretation of English results in a pictorial, or at least iconic, representational system on Haugeland's account, which is an unfortunate result.[3]

What seems to make pictures pictorial is not just that they represent 'variations of values along certain dimensions with respect to locations in certain other dimensions', but that they do so in virtue of having non-semantic elements that are related to one another as variations of values along different dimensions. The picture does not just represent variations of hue, saturation, and brightness along two spatial dimensions, it also does so by *being* an instance of a two-dimensional surface at each point of which there is a certain value of hue, saturation, and brightness. Another example that Haugeland uses is a graph of temperature versus time. The graph has a bare bones content characteristic of an image. Each element picks out a time and assigns a temperature to it. But we loathe calling anything a graph of temperature versus time independently of how the properties of the representation manage to tie it to the content that it has. Such graphs usually use spatial dimensions to indicate the time and temperature, so the elements of the representation itself—its syntactically relevant properties—are related to one another in ways, perhaps isomorphic (see Chapter 4),

[3] Note that there are ways of reinterpreting English so as to make its representations pictorial. Just take each representation to be a depiction of an inscription of an indeterminate kind. So the sentence 'the cat is on the mat' picks out an inscription of the English sentence, which may be written in any of a number of styles, fonts, hands, and so on. This reinterpretation seems plausible, whereas Haugeland's does not. Both are odd.

to how the elements of the content are interrelated. But the foregoing are all structural facts concerning how parts of representations relate to one another and how syntactic types within a system are paired with semantic types. This is not to say that structural features of representations, completely independently of their semantic features, are sufficient to identify the pictorial. Part I ties pictures' structure to their bare bones contents. The point here is just that it cannot be exclusively in terms of content that images are distinguished from other representations.

A closely related problem for Haugeland's account is that it seems to allow rather ordinary logical representations, without recherché reinterpretations, to have the same contents as images. For example, a list of quintuples of numerals corresponding to two spatial coordinates and numerical values for hue, saturation, and brightness is not a pictorial representation, though in a sense it carries the same information as a pictorial representation. Likewise, we can construct a list of pairs of numerals—one for a moment of time, another for temperature—which would contain all of the information carried by the aforementioned graph. The list, however, is no image, graph or otherwise. This is a problem. Lists cannot have the same contents as images, at least according to Haugeland's account, since it is precisely in terms of content that such representations are supposed to be distinguishable from one another.

Recording and Representing

Haugeland is not unaware of the second objection just raised, which he responds to by drawing a distinction between recording and representing. For Haugeland, the lists just mentioned are not representations with the same content as their corresponding icons, but instead are logical *recordings* of those icons (Haugeland 1991, 179). One can recover the image or graph from the list, because the list is an accurate representation of the token representation in question, not because the list has the same content as the original. Notice that this is plausible given what Haugeland has said so far. It is not the case, it seems, that the elements of the content of the list are essentially related to one another in some scheme that every list presupposes. But this does

seem true for the photograph and the graph of temperature. The distinction between recording and representing is supposed to capture the mistake behind thinking that a description or list can have the same kind of bare bones content as an image or graph.

Haugeland's defense of this claim is initially quite convincing. First, consider things the other way around. Instead of a list with the same content as an image, let's try to make an image with the same content as a description. One might think that a simple way of doing this is to make an image *of* that description. Photograph an inscription of 'The cat is on the mat' and you get an image with the content that a cat is on the mat. This is clearly though cleverly wrong: photographing an inscription that happens to be about a cat on a mat results in an image with an inscription as its content, and the image does not *eo ipso* inherit the content of the inscription. Such an image is what Haugeland calls a recording of a logical representation in an iconic medium. The recording does not share content with the representation recorded.

Likewise, Haugeland argues, given an image one could always generate a list of points and their corresponding values of hue, saturation, and brightness, but this would constitute a logical recording of an imagistic representation and the former would not share content with the latter. After all, 'explaining perceptual recognition—how, for instance, a system can look at a scene (or picture) and produce an articulate verbal description of what it sees—is a profound outstanding problem in psychology and artificial intelligence' (Haugeland 1991, 177). Simply listing the pixels in a picture could not have the rich content that we usually associate with images, so it would also be wrong in this case to suppose that logical and imagistic representations share content. One is simply a recording of the other. We even use such recordings to generate images all the time on our computer. We tend to think that the image is not stored in the computer's memory in imagistic form, but recorded there in logical form, ready to be unpacked on the screen in all of its pictorial glory.

There are three big and related difficulties with this analysis of the problem. First, recording is representing a representation, not representing just what the representation represents. Haugeland thinks the intuition that pictures and descriptions can have the same contents is rooted in mistaking a logical recording of an image for a

representation of what the image represents. This is unconvincing at best. The lists proposed above were not meant to contain descriptions of parts of images but rather descriptions of parts of the *contents* of images. The list for the graph of temperature versus time includes representations of time and temperature, not representations of regions of a graph, just as the list of regions of differing hue, saturation, and brightness is not about the image, so much as what the image is about. It may be that the photograph of the inscription 'the cat on the mat' does not have the same content as the description so inscribed, and it may even be that no picture has just the content that the cat is on the mat.[4] That is a far cry, however, from the claim that no description can have the same content as a picture or vice versa. It seems that Haugeland just acknowledges a difference between representing a representation and representing what the representation represents. He needs to do more to show that the best we can do to get a description to have the same content as an image is to record that image in a logical medium.

Haugeland has a reply to at least some of this. He is happy to admit that we can describe the content of an image—e.g. color and location of the depicted scene—rather than the image itself—color and location within the picture. In such a case 'we must say that the resulting sentences describe the scene, since there is no image in play for them to describe, or to record logically.' (Haugeland 1991, 179). Nevertheless, 'even when the sentences are generated directly from the scene, what they are doing is logically recording an image-like representation—a virtual image, we could call it—... and it is this which the sentences describe, pixel by pixel.' (Haugeland 1991, 179). So even if the descriptions pick out features of the scene depicted, they do so from a point of view, much like a picture would, and they thus record a virtual image of the scene. The description is nevertheless just a recording of that virtual image in a logical medium. The description of the scene captures only the varying intensity of color from a certain point of view within a certain solid angle. But, Haugeland points

[4] No doubt, this is because pictures tend to represent more detailed states of affairs than descriptions represent, as discussed at the end of Chapter 5. But this difference between pictures and descriptions cannot be analyzed in terms of the recording/representing distinction.

out, describing the variations of color within a solid angle is a far cry from describing the content of an image. To repeat a remark mentioned before, the descriptions in question 'don't describe the scene in anything like the way an articulate observer would describe it' (Haugeland 1991, 179), and it is quite counterintuitive that such descriptions of (virtual) pixels have the same content as an image. Pictorial content is rather rich and complicated, and it most certainly is not captured by a mere list of locations and colors.

The foregoing leads to the second and third problems mentioned above. Second, even if we grant Haugeland this proposed solution, it does not apply to the list generated from the graph of temperature versus time. The descriptions in that list have temperatures and times as their contents. Neither the graph nor even a virtual graph of temperature versus time is plausibly taken to be a part of the content of those descriptions. Haugeland still has a problem, then, because it seems as if the list of descriptions and the graph itself can have the same content. This problem applies to a huge class of what Haugeland takes to be iconic representations. He could always exclude graphs on these grounds from the iconic genus, but this would cut strongly against the grain of his argument. In any case, he would have to revise his view substantially, because it seems as though the elements of the content of a graph are organized with respect to one another in precisely the way he takes to be characteristic of the bare bones contents of icons.

The third and most important problem is that his reply to the first problem misses the mark, even if it is true. He claims that the lists of locations and colors do not track what 'an articulate observer' of a scene or image would describe as an image's content. This should make us doubt that the description and the image have the same content. But the insightful core of Haugeland's account is that we are *not* supposed to be focusing on what articulate observers regularly take to be the contents of images. Imagistic representation, on Haugeland's view, must be understood in terms of bare bones content and not fleshed out content. While the fleshed out content of an image may be a cat on a mat, its bare bones content is nothing more than 'variations of values along certain dimensions with respect to locations in certain other dimensions' (Haugeland 1991, 192). For Haugeland, it is only insofar as we consider images in terms of their bare bones content that

we can distinguish them from descriptions. But if we take images in this way, then the lists we have been considering seem as though they can have exactly the same contents as images. It is precisely variation of temperature with respect to time or color with respect to position that these lists describe: no more, but certainly no less. Haugeland is therefore wrong to treat, on the one hand, making a picture of an inscription and, on the other, describing a picture as analogous cases. A picture of an inscription does not inherit the content of the inscription, just as certain descriptions of pictures do not inherit their content. But a description of the bare bones content of a picture inherits that picture's bare bones content just as a picture of what an inscription describes can have the same content as the description.

Might Haugeland reply that the elements of the description's content nevertheless 'can enter into... contents one by one, without depending on their concrete relations to one another, if any' (Haugeland 1991, 191) while this is still not true of the elements of the picture's content? Perhaps, if Haugeland takes the lists in question to be mere parts of English, since in English it is not the case that the 'elements [of content] are always organized relative to one another in some regular structure that every representational token of the pertinent scheme essentially presupposes' (Haugeland 1991, 192). This reply does not rescue his position, however. On the one hand, the descriptions pick out relative locations, so in that sense the elements of their content can only be understood in relation to one another. On the other hand, one could easily construct a representational system whose purpose it is to do nothing but describe variations of color with respect to position. Every possible token in this system is a list that indicates position, hue, saturation, and brightness. The contents of representations in such a system would all essentially involve the 'variations of values along certain dimensions with respect to locations in certain other dimensions' (Haugeland 1991, 192). This system would not be iconic, despite the contents of its representations being what Haugeland takes to be characteristic of images. The representations in this system are sets of lists of numerals: paradigm examples of logical representations.

Perhaps Haugeland can claim that even in the specialized representational system just adumbrated, constituents of the content can be

understood independently of the other constituents. Just looking at the list, for example, tells one about color in a certain location without reference to other locations or the fact that the rest of the content is colors at locations. The rest of the list might say nothing about colors or locations. This too is implausible because, first, if the list is accurate it locates colors at relative locations, not locations in any interesting absolute sense. Second, one can come to know about elements of the picture's content by focusing on a portion of the picture, without taking in the whole. If this does not challenge the claim that a picture has a certain bare bones content, then the corresponding situation, in which one focuses on a portion of the list, doesn't challenge the claim for the list, either.

One more possibility is that Haugeland could claim that the lists in this special representational system are indeed images or iconic representations. It is counterintuitive, certainly, but philosophical accounts sometimes need to bite the bullet and be counterintuitive. The problem with this response is not that it is counterintuitive, however. The problem is that it undercuts the motivation for the view in the first place. The representing/recording distinction was introduced precisely to show why a list like the one we have been discussing does not have the same kind of bare bones content as an image. To the extent that this approach is successful, it allows Haugeland's account of representational genus in terms of bare bones content to track our intuitive sorting of representational systems into classes. It is fine to give up on the intuitive way in which we sort representational systems as long as one has an explanation of why our intuitions have led us astray, and why the counterintuitive sorting does some good theoretical work. Haugeland does not do this, however, and it is not clear how he would. This response seems more motivated by a desire to keep a flawed theory than a desire to account for what makes a representation iconic as opposed to logical.

At this point, we could be pulled in either of two directions: toward perceptual accounts or toward structural accounts. Haugeland has failed to explain imagistic representation solely in terms of content. If we were to add some convincing perceptual conditions, however, they may, along with Haugeland's discussion of bare bones content, yield a workable view of what makes a representation an image. For

example, Haugeland could claim that it is not just features of the bare bones content of an image that make a representation an image, but bare bones content plus the way in which a picture makes its content available for fleshing out. The reason the description of variations of color at relative locations is not an image is that we cannot flesh that content out to a dog in a field just by looking, while we can do just that with an image. Chapters 8 and 9 consider the role that bare bones content plays in fleshing out pictures' contents. But in order to understand that role, we need to understand the structure of such representations. Haugeland's claim goes wrong precisely where his account points to the structural conditions worked out in Part I, transparency in particular. That is, once you see that pictures are transparent, it is easy to see why Haugeland's deployment of the recording/representing distinction in defense of his claim that the bare bones contents of images are distinctive is bound to fail.

The Link to Transparency

Why did Haugeland think that the recording/representing distinction could save his account of representational genera? This is an important question because, on the face of it, a recording represents a representation in another medium, not what that representation is about. If the problem is to figure out whether imagistic and descriptive representations can have the same content, the question we should be asking is whether a description of a depicted scene can have the same content as the picture. The question is not whether a description of a depiction can have the same content as the depiction. Furthermore, this approach immediately gets Haugeland into the uncomfortable position of calling descriptions of depicted scenes, as opposed to descriptions of pictures, descriptions of virtual pictures. It turns out that this approach seems plausible mainly because pictures are transparent. Ironically, precisely what makes Haugeland's proposal prima facie plausible is what renders it unworkable upon closer inspection.

Recall that in transparent systems representations of representations are of the same syntactic, and hence semantic, types as their objects. That is, a representation of another representation in a transparent system has the same bare bones content as the original. One

consequence of this is that pictures satisfy their own bare bones contents. Descriptions, graphs, and even many imagistic representations fall well short of meeting this condition. Transparent systems are also mimetic: pictures, among other representations, are similar to their objects in semantically significant ways. So whenever a picture's bare bones content includes a certain shape, the picture itself is that shape.

Notice, though, that if a picture is an instance of its own bare bones content, then there are many descriptions of the picture itself that wind up being accurate descriptions of its bare bones content. Describe the projective invariants and colors of a picture's surface and you not only describe its syntactically relevant properties, you describe features of its bare bones content. So this structural fact about pictorial systems makes it plausible that one could confuse a recording of a picture in a logical medium with something that represents just what the picture represents.

Only *some* descriptions of a picture's SRPs are descriptions of its bare bones content, though. Recall from Chapter 3 that the syntactic identity of a picture in, say, linear perspective depends on its projective invariants and not the determinate shapes of the regions of its surface. If one describes a picture's shapes and colors in all of their determinate glory, one is describing more than the bare bones content of the picture. The picture surface is square, but its bare bones content includes only a four-sided region of space. Since bare bones content is rather abstract, no object just satisfies bare bones content. So, pictures are instances of their bare bones contents, but they are *fleshed out* instances of it. There is more to the picture surface than the picture itself determinately represents. So describe the picture's SRPs in all of their determinate glory and you describe a fleshing out of that bare bones content.

Transparent systems are special for many reasons, and the present discussion brings out another one. We already know that within such a scheme if you represent another representation the result shares bare bones content with the original. The foregoing points out that if you *describe* a representation in such a scheme, the result can share either bare bones or even fleshed out content with the original. Contrast this with describing descriptions, in which case there is no reason to think that the result shares any content with its object.

In this sense pictures translate well into a descriptive medium even when it is the picture itself one describes. This is ultimately why the recording/representing distinction is of no avail in saving Haugeland's view from the objections made earlier.

Moreover, descriptions and other non-transparent representations do *not* translate well into pictorial media. Haugeland found it appealing to illustrate his point about recording versus representing by considering a photograph of an inscription. Even if the photograph captures all of the SRPs of the description so inscribed, the picture will not share content with the description. This asymmetry between depicting descriptions and describing depictions can be traced back to the transparency of pictures, and the fact that transparency entails mimesis. Pictures are instances of what they represent, so any accurate representation of their SRPs, in whatever medium you choose, will share fleshed out or bare bones content with the picture itself. Descriptions do not hold onto their content in such a way as to make them easily translatable into other media.

Transparency, and not just mimesis, is at the heart of this feature of pictures. Non-pictorial images—representations that are mimetic while failing to be transparent—fail to translate well into other media. Describing the weather radar does not yield a characterization of its bare bones content. The radar image is reddish over Chicago, but only yellowish over Flint. One could certainly describe the content of the image, in terms of intensity of precipitation, but access to that content does not come for free once one has access to the representation itself. This isn't really because one has to 'learn' the rules that assign colors to intensities in order to 'read' the representation correctly. We needn't assume that the describer of a picture has any sense of what it depicts or, more generally, any sense of how to read pictures in order for the description to capture the picture's content. It is because the picture is an instance of its bare bones content, not because it is easy to learn the scheme that pairs sets of SRPs of a picture with its content, that pictures translate well into other media.

Recall that the recording/representing distinction, though initially plausible as a defense of Haugeland's view of pictorial content, did not even get off of the ground when it came to graphs and diagrams. There is no reason to think that a description of the

graph of temperature versus time captures anything like a virtual graph of temperature versus time. Graphs encode information about temperature and time in a spatial medium. They may encode this information isomorphically, but they do so neither mimetically nor transparently, so one cannot describe a graph and *eo ipso* describe its content. Any accurate description of a graph—a recording of it—must describe the spatial dimensions of variation in the graph, not the temperature and time. And any description that picks out only spatial features of something, and not temperature and time, fails to share content with the graph. But this does not mean, as mentioned above, that there is no description that shares content with the graph. After all, one can always describe changes of temperature over time.

This discussion of graphs and non-pictorial images highlights the fact that the intuitive appeal of Haugeland's claims relies on the systems he is discussing being transparent. Only in transparent systems does it seem plausible in the first case that we are recording a representation rather than representing what the representation does. The irony here is that in these cases even if we are describing the representation, we are doing so in a way that does in fact capture its content. The resulting description therefore can have the same bare bones content as the representation it describes. Though Haugeland has given us an important way of describing pictures' contents, he has not given us a way of singling out pictures, or even what he calls 'icons', from other kinds of representational systems. Precisely where his account has problems, though, transparency steps in to fill the gap. In the end, Haugeland was not wrong to look to the contents of images and descriptions for an answer to how they differ from one another, but he was wrong to eschew reference to the structure of those systems as well. Transparency, as we have seen, is a feature of the structure of representations in a system vis-à-vis what they represent. Only proper attention to structure and content can account for what it is to be a picture.

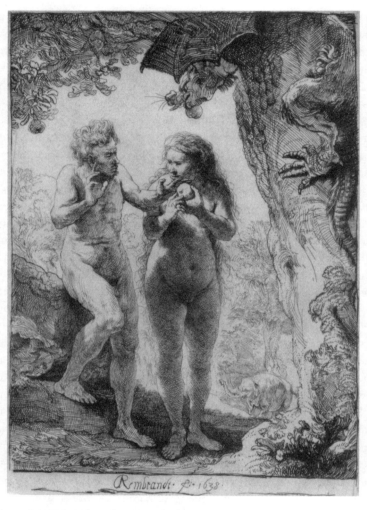

Illustration 7 Rembrandt Harmensz van Rijn, *Adam and Eve*, 1638. Hood Museum of Art, Dartmouth College, Hanover, New Hampshire; gift of Jean K. Weil in memory of Adolph Weil, Jr., Class of 1935. Photography: Jeffrey Nintzel

7

Understanding Commitments

Dominic Lopes (1996), like John Haugeland (1991), thinks that pictures do not have contents that are quite as specific as many have taken them to be, though he does not go so far as to say they have bare bones content. Lopes takes up and improves upon an idea suggested by Ned Block (1983) and developed by Flint Schier (1986) to the effect that the key to understanding pictorial content is recognizing that pictures are selective in a very special way. Pictures are only able to say what they do about their objects at the cost of not saying other things. Van Gogh could have described his bedroom from the point of view from which he painted it. Let's say that the description even included all of the detail present in the painting. Haugeland (1991) might call this a recording of a virtual image of van Gogh's room. One thing that makes the painting's content different from the description's is that insofar as the former depicts the chairs and bed where they are, it cannot say anything about what the wall and floor obscured by the furniture is like. The description, by contrast, is in no way limited from describing features of the room that are obscured from the picture's point of view. So, in order to say certain things, pictures are committed to not saying other things, while descriptions are not hampered by such a constraint.

Lopes locates an interesting feature of image content, holding out some hope that Haugeland was right after all. Perhaps we can distinguish pictorial representation solely in terms of its content once we have added Lopes' commitments to Haugeland's skeletons. This chapter argues that this kind of selectivity is neither necessary nor sufficient for a representation to be pictorial. That being said, Lopes has located an important feature of the contents of images that needs to be explained: this feature of pictorial content does not turn up in

the contents of descriptions. Indeed, this feature of pictorial content is even absent from bare bones content, resulting only from fleshing out pictures' bare bones contents. Seeing how fleshing out can result in this kind of selectivity paves the way for the account of the fleshed out content which comes in the next two chapters.

Commitments

Borrowing his terminology from Block (1983), Lopes (1996, 118) claims that pictures make 'explicit non-commitments', while descriptions do not. What is a commitment? Representations ascribe properties to objects, regions of space, or what have you. So the description 'the green apple' ascribes the property of being green to the apple, much as a picture of the apple would. We can say of both the picture and the description that they are committed with respect to greenness. That is, a representation is committed with respect to a property, P, when it represents its object as being P or as being not-P. So the description 'the apple that is not green' is committed with respect to greenness as well: it is committed to greenness not being a feature of the apple. A representation is non-committal with respect to P when it fails to represent its object as being P or as being not-P, such as the Rembrandt at the beginning of this chapter.

Representations can make conflicting commitments. For example, 'the apple that is green all over and red all over' commits to properties that no object can have. Moreover, there are at least two ways in which representations' commitments can conflict. On the one hand, the conflict can be manifest in the description as in 'the apple that is green all over and not green all over'. Let's call this an explicit conflict of commitments. The earlier example, 'the apple that is green all over and red all over', makes conflicting commitments, but they conflict inexplicitly. The point is not that representations can make explicit and inexplicit commitments, since there seem to be problems with such a claim that are not worth getting into.[1] Lopes does not

[1] Commitments are what a representation represents as being the case, not what follows from what a representation represents as being the case. It is therefore problematic in the extreme to claim that 'the apple that is green all over' commits albeit inexplicitly to the

discuss distinctions between kinds of conflicts between commitments, but this distinction will prove worthwhile presently.

Unlike commitments, non-commitments come in explicit and inexplicit varieties, but it is difficult to make non-commitments conflict with one another. A representation is non-committed to P just in case it says nothing about whether its object is P or not-P. The description 'The green apple' says nothing about the type of apple being described, and in that sense it is not committed with respect to type of apple. There is nothing, however, about describing the fruit as green that prohibits one from also describing it as being a Granny Smith. 'The green, Granny Smith apple' is committed with respect to both greenness and being a Granny Smith. Because of this, the description 'the green apple' is only *inexplicitly* non-committal with respect to being a Granny Smith. There is nothing about its being committed to greenness that prohibits it from being committed with respect to being a Granny Smith. By contrast, imagine a picture of an apple tree, its fruit obscured by leaves. The picture is committal with respect to greenness in that it represents the apples as being green. The obscuring leaves that are depicted prevent the picture from being committed with respect to Granny Smith-ness, however. It's just too hard to tell what kind of apples they are because of all the leaves. The picture's failure to commit to being Granny Smiths results directly from some of the other commitments that it makes. In this case, it is in part because the picture is committal about features of the tree and its spatial relation to the depicted apples that it cannot be committal with respect to being Granny Smiths. For that reason, Lopes says that the picture is *explicitly* non-committal with respect to being a Granny Smith.

Non-commitments have trouble conflicting because they pick out what a representation does not say about its object. That a representation is silent as to whether its object is red or not red does not conflict with its being silent regarding whether its object is P or not-P for any P you can dream up. Moreover, non-commitments do

apple not being red all over. On the other hand, whether commitments conflict is more a matter of how the world is (or can be) and not about how it is represented. For that reason, there is no corresponding worry about distinguishing explicit and inexplicit conflicts between commitments.

not conflict with commitments. Committing with respect to *P* entails that the representation does not non-commit with respect to *P*.

Lopes' claim is that only pictures and perhaps their close ken are explicitly non-committal. We could certainly describe the apple as 'the green apple obscured by foliage' but this in and of itself does not preclude describing it as a Granny Smith as well. Descriptions may seem to make explicit non-commitments, but this is just a surface appearance: 'Saying "I have no comment about the allegations of the mayor's corruption" does not preclude me from adding, "except to say that she's an extortionist"' (Lopes 1996, 119). With descriptions, committing to some set of properties never carries the price of not committing to other properties. To the extent that a picture commits with respect to certain properties, however, it must explicitly non-commit to others. Velasquez' *Las Meninas* is explicitly non-committal regarding the features of the canvas the painter is working on because the canvas is depicted facing away from the viewer. You cannot depict a canvas from behind, and thus commit to features of its back, while also committing to features of its front. It is not clear how tidy things were under van Gogh's bed, not because he could not have depicted such things but because his commitment to properties of the top of the bed from a certain point of view precluded committing to features in and around its underside.

One immediate objection to Lopes' view needs to be dispelled at this point. One might think that it is easy to commit to the front and back sides of a canvas in one picture. *Las Meninas* is famous in part because it includes a mirror on the facing wall that includes the reflections of the king and queen, who are ostensibly the subjects of the painting whose back side we see. Velasquez could have included a mirror in the background that revealed features of the canvas that we cannot see. Had *Las Meninas* been a little different, it could have committed to features of the painted portion of the canvas. The objection that follows from this is that committing to any given feature of an object does not entail non-commitment with respect to any feature in particular, so it would seem that the price of commitment is not, after all, explicit non-commitment. Though mirrors and the like are quite interesting things to depict—they are often taken to be metaphors for what pictures do, as we saw in the introduction—it

is misleading to use them in this way to object to Lopes' view. Lopes claims that the totality of a picture's commitments entails a set of explicit non-commitments. Velasquez could have inserted a mirror into *Las Meninas*, but that would have entailed explicit non-commitments to other things, like features of the facing walls, and so on. Once we have the total set of a picture's commitments on the table, Lopes claims, we find certain features of objects to which such a picture cannot commit, given that it is already so committed.

One final point about explicit non-commitment bears mentioning. There is an interesting distinction between the kinds of properties to which a picture explicitly non-commits and the properties as a result of committing to which a picture must non-commit. Pictures are explicitly non-committal with regard to any kind of property that they can represent objects as having—colors, textures, shapes, and so on—but only commitments to spatial properties *result* in explicit non-commitments. It is not in virtue of depicting the leaves as green that the picture explicitly non-commits to the kind of apple that is depicted. It is because the leaves are depicted as obscuring or being spatially in front of the apples and opaque that we get a non-commitment with respect to apple kind. Explicit non-commitments result from commitments to the three dimensional layout of scenes and thus are tied to what Gombrich (1961, ch. 8) called the 'ambiguities of the third dimension'.

Aspects

There is more to what makes the contents of pictures special than that they make explicit non-commitments. For Lopes (1996, 126), pictures present spatially unified aspects of their subjects. An aspect is just '[t]he totality of a picture's commitments and non-commitments' (Lopes 1996, 119), and since pictures tend to represent the visible properties of objects, pictorial aspects tend to be 'patterns of visual salience' (Lopes 1996, 119). Pictorial aspects therefore include commitments and explicit non-commitments to shapes, distances, colors, textures, relative orientations, and the like.

What makes an aspect spatially unified? Lopes (1996, 126) says: 'every part of a scene that a picture shows must be represented as

standing in certain spatial relations to every other part'. This is a claim about pictures' contents, not about the surfaces of pictures. If something is depicted, then it is depicted as standing in certain spatial relations to all of the other depicted things. The discussion of mimesis and isomorphism in Chapter 4 shows that if certain spatial relations obtain between parts of a picture, then those spatial relations obtain between parts of its content, but this claim is no part of Lopes' view. The following example helpfully illustrates the intuitive appeal of spatial unification. A picture postcard that depicts four of the sights in London—one in each quadrant of the postcard—is not a single picture on Lopes' view, but four. All of the sights bear some spatial relations to one another, but it is not the case that each part of the depicted scenes is represented *as* standing in certain spatial relations to all of the other parts of the depicted scenes (Lopes 1996, 126–7). For all that the postcard tells us, the sights could be spatially related to one another in any number of ways.

Notice that spatial unification has natural affinities with Haugeland's view that 'iconic' representations essentially represent 'variations of values along certain dimensions with respect to locations in certain other dimensions' (Haugeland 1991, 192). For Haugeland, the elements of an image's content are only specifiable in relation to the other elements of that content. Lopes is being more restrictive than Haugeland in claiming that the relations must be spatial, but this restriction is plausible enough given that pictures are usually taken to represent spatial relations, among other things.[2] Where something is depicted as being depends on where everything else depicted is depicted as being. Haugeland too could resist calling the postcard pictorial because it is not the case that the 'elements [of an image's content] are ... organized relative to one another in some regular structure that every representational token of the pertinent scheme essentially presupposes' (Haugeland 1991, 192). The scene depicted in the top right quadrant could be anywhere with respect to the one depicted in the lower left.

[2] Let's bracket for now my claim that any medium can have pictorial representations in it, so that pictures are not essentially visual. I think that is correct, but keeping to Lopes' (1996) take on things will yield fruit for my view as well, in good time.

That is all well and good, since intuitions have it that the postcard is a collection of four pictures, at least on the standard way of interpreting the content of those pictures. But the intuitive appeal of spatial unification fades in the light of other examples. For one, let's say that the postcard is part of the following representational scheme. The top left quadrant is a picture (say in linear perspective) or a scene precisely one mile to the west of the scene depicted in the top right quadrant, which is precisely one mile north of the scene depicted in the lower right quadrant, which is precisely one mile to the east of the scene depicted in the lower left. Each of the quadrants is a picture, since by assumption they are photographs, which approximate linear perspective. What about the whole? It seems to satisfy Lopes' condition on being spatially unified, since each part of the depicted scene is represented as standing in certain spatial relations to each other part. Also, the postcard makes explicit non-commitments, since each quadrant is a photograph. Intuitions have it, however, that this kind of representation is not pictorial. Lopes could bite the bullet and claim that it is pictorial, but he has another way out of the problem.

Lopes (1996, 119) says that an aspect is 'a pattern of visual salience', so it is open to him to deny that the modified postcard scheme is pictorial because the spatial unification present is not visually salient. The parts of the contents of these representations are all represented as standing in spatial relations to one another, but they are not represented as standing in relations to one another that are visually salient. Lopes claims that 'Precisely what kinds of unified spatial aspects pictures can present, given the limitations of the two-dimensional medium for representing three-dimensional space, is a matter for empirical study' (Lopes 1996, 127). This suggests he is committed to the characteristic pictorial aspects being closely tied to the ways in which we can perceive things, which is a matter of empirical inquiry.

Psychologically plausible, spatially unified aspects are an important part of Lopes' view, but at its core is the notion of explicit non-commitment. Lopes admits that descriptions can present spatially unified aspects of things—'The knee bone's connected to the leg bone' (Lopes 1996, 127)—so what makes pictorial content special is explicit non-commitment. Because, as we will see below, explicit non-commitment turns out not to be unique to pictorial

representations, Lopes' account has some problems. Like Haugeland's account, however, Lopes' has a lot to offer. The remainder of this chapter shows why explicit non-commitment does not distinguish pictures from many other kinds of non-pictorial representations. Despite this, Lopes' discussion of explicit non-commitment is valuable because it sheds important light on the distinctions between pictorial content and the contents of other kinds of representations. Also, Lopes offers an explanation of why pictures make explicit non-commitments that will be particularly valuable in the next chapter, which articulates the relationship between bare bones content and the more everyday, fleshed out contents of pictures.

Problems with the View

The first problem with explicit non-commitment is that one can design a representational system that is not pictorial but that makes explicit non-commitments. Let's say theorists of depiction have decided that it is just too easy to slip between talking about the design features of pictures—features of pictures surfaces—and features of the contents of those pictures. In fact, it is rather difficult to keep the two separate at times. In order to make progress in understanding pictures, and avoid unnecessary confusions, the theorists adopt the following representational system. It is just like English except for the fact that one cannot describe content features and design features in the same description. So, 'the painter before the canvas' explicitly non-commits to the color and shapes of the regions of *Las Meninas*' surface, since it is a precondition for describing its *content* that one does not describe those design features. Likewise, discussing the use of color on the canvas explicitly non-commits to features of the picture's content.

This representational system is quite helpful if one's goal is to keep talk of content and design features separate, which can never hurt in discussing depiction. On the other hand, this system is not terribly good if one's goal is to discuss how design features relate to content features since any description like 'the golden brown that picks out the . . .' is poorly formed in this system. The idea is that if one wants to discuss how design and content features relate, then one should just revert to English. Since it is easy to translate from this specialized

system into English, we can use it for what it is good for and abandon it when our goals change. Representational systems are tools, after all, and this tool seems as good as any. Haugeland's (1991) slip, discussed in the last chapter, resulted from a slide between talk of design features and talk of content features, after all. Once that was cleared up the problem with his view became apparent and bare bones content could take up its proper place in a theory of depiction.

Now, every representation in this system makes some explicit non-commitments, as any description of design features explicitly non-commits to content features and conversely. The problem, of course, is that this system for describing the contents of pictures is not pictorial in any interesting sense, despite making explicit non-commitments. Explicit non-commitment is therefore not unique to depictions, though they may be a particularly interesting case of it.

An immediate response to this counterexample is that it describes an instance of implicit non-commitment, not explicit non-commitment. Black and white pictures are only implicitly non-committal with respect to hue, since they are unable to say anything at all about the hues of objects. Likewise, each of these descriptions is implicitly non-committal with respect either to design features or with respect to content features because it can say nothing about one or the other. Since Lopes has already admitted that any representation can be implicitly non-committal, this example makes no problems for his view.

This response is misguided. The system described above can represent content and design features of pictures, but it cannot do so in one and the same description. The black and white picture system simply has nothing to say about hue under any circumstances. What makes the proposed system valuable is that it can do both while keeping each kind of content distinct. Let's say scientists were interested in depicting certain phenomena, some of which were such that the color of the object was important while in some only the relative brightnesses of the objects matter. They adopt a system of depiction like LP except for the fact that when they depict the former they use full color pictures while in the latter case they use grayscale or black and white pictures. In this system a black and white picture is explicitly non-committal with respect to color because it is a precondition on

representing situations of the latter kind that the picture be black and white. Like the scientists' system, the proposed system for describing pictures makes it a precondition on representing content features that one does not represent design features.

Now, this supposed counterexample seems to cut against the spirit of Lopes' proposal. It feels *ad hoc*, even though the system described serves a specific and valuable purpose. The point is not supposed to be that we just get to invent representational systems that make explicit non-commitments. Making explicit non-commitments is integral to how pictures represent in the first place, while the system just described only makes explicit non-commitments because we want it to. It is not clear, for example, how we could make a variant of LP that differs only in that it makes no explicit non-commitments (well, see below). This all suggests that Lopes is on the right track in some sense, but a proposal's spirit cuts little ice. We need an account that in spirit and in letter captures what is special about the contents of pictures, and in this regard Lopes has problems.

A virtue of Lopes' general account is that it tries to locate features of the perception, structure, and content of pictures that make them a special kind of representation. Haugeland's proposal does not work because he limits its scope to content. It seems that when we focus on explicit non-commitment, we run into a similar problem. To the extent that we focus on content, we can devise non-pictorial representational systems that make explicit non-commitments. If we were to consider the structure of these systems, as well as the way in which we perceive them, however, we would see why explicit non-commitment is such an important part of depiction. Lopes attempts just this. He has an explanation of why pictures make the explicit non-commitments that they do in terms of how we perceive pictures, not in terms of how pictorial systems are structured. If this section is on the right track, Lopes is forced to retreat a bit. He needs to claim merely that what is special about pictures is that they make explicit non-commitments because of how we get at their contents, i.e. how we perceive them. He cannot help himself to the claim that the contents of pictures are *unique* to them and that this is explained by something special about what pictures are like for us perceptually. This is not too much of a retreat, and Lopes' work on what makes pictures

special perceptually will play an important role in understanding the way in which we flesh out the bare bones contents of pictures.

Conflicting Commitments

It seems as if Lopes could have said more about what makes pictures distinct from descriptions ordinarily construed. To see why, consider the following putative counterexample to Lopes' claim that descriptions make no explicit non-commitments. It is not clear that for every stone on earth, there is a fact of the matter as to whether it is a part of Mt. Everest. Many stones definitely are, while many—e.g. those in my backyard—are not, and some are neither.[3] The description 'the stones in the vague boundary of Everest' would seem to non-commit, explicitly, to the property being a part of Mt. Everest. That is, a description cannot represent something as being part of the vague boundary of Everest without non-committing to whether it is a part of Everest.

One might think that this is a straightforward counterexample to the claim that descriptions never explicitly non-commit. An immediate reply to this, however, is that the description itself could be emended to read 'the stones that are in the vague boundary of Everest and are definitely a part of Everest'. Though this description would fail to refer to anything, it seems (1) to be a bona fide description and (2) to represent and thus commit to being a part of the vague boundary of Everest. So it seems one needn't explicitly non-commit to being a part of Everest in order to describe something as being part of the vague boundary of Everest.

One interesting thing about descriptions, it would seem, is that they are quite good at making conflicting commitments. It really seems as though committing to being part of the vague boundary of Everest makes an explicit non-commitment, but a simple trick afforded by descriptions shows that this is false. Pictures have a lot more trouble

[3] It is not important for the example that we have an account of vagueness ready to hand. The idea is to illustrate how a putative counterexample to Lopes' claim fails. If the vagueness cards fall so that it does not make sense to say that some stones are neither part of Everest nor not part of Everest, then that is just one more reason why the counterexample does not work.

making conflicting commitments. We cannot depict the apple as being red all over and green all over, though it is easy to describe it as such. Likewise we cannot depict it as being a Granny Smith and as not being a Granny Smith. This suggests that pictures are interesting in that they cannot make the same kinds of conflicting commitments that descriptions can.

To flesh out this point, recall that conflicts between commitments come in explicit and inexplicit varieties, and that descriptions can manifest both. It is rather easy to see that pictures cannot make explicitly conflicting commitments since pictures never seem to say that something is *not* the case. This is not just a point about conflicting commitments, of course, but about pictorial commitment more generally. While descriptions can commit by claiming that an object does not have a given property, pictures cannot commit in this way. As a result, pictures cannot make explicitly conflicting commitments, either.[4]

What about implicitly conflicting commitments? It seems on the surface that pictures can do this, though there are even grounds for rejecting this kind of conflict in pictures. For starters, ambiguous and so-called 'impossible' pictures are the place to look for implicitly conflicting commitments. Escher's ever-ascending staircase, Hogarth's playful *False Perspective*, and other impossible figures are good examples, it seems, of implicitly conflicting pictorial commitments. Take the well-known three-pronged impossible figure, for example (Figure 7.1). One portion of the picture commits to three juxtaposed cylinders and the empty spaces between them. On the ordinary way of interpreting pictures and how their parts relate to one another, these commitments conflict with those made by the other half of the figure. The space between lines that represents the space between the cylinders now represents a portion of a rectangular box. What is a portion of the background on the most straightforward reading of the left half of the picture is a portion of the figure on the right.

This seems clear enough on the surface, but making the conflict apparent is a bit difficult. There is nothing problematic with depicting a box in one part of a picture and a row of cylinders in another, even

⁴ Schier (1986) and, in a different context, Elliot Sober (1976) point this out.

Figure 7.1 Impossible figure?

if they are depicted right next to one another. The conflict seems to come from the fact that at some point, the picture commits either to one of its regions being part of the background or to its being part of the figure. Any decision one makes as to the commitment at this point renders the interpretation of one of the sides of the figure untenable. Since the commitments on both sides are obvious, the conflict comes from being forced to give one of those up in order to interpret the whole consistently.

Now it is an interesting fact about pictures that it always seems possible to reinterpret them so as to resolve the conflict. Roy Sorensen puts the matter thus:

A consistent interpretation is always logically available. Any 'impossible figure' can be interpreted as a consistent drawing by treating the drawing

as a two-dimensional assembly of lines or as a conglomerate of distinct pictures. With opposite deviousness one can interpret any possible figure as an impossible figure. It is just a matter of connecting consistent dots in an inconsistent way. (Sorensen 2002, 356)

If we give up on the picture committing to three cylinders, we can consistently interpret the whole. What's more, we can give up on the picture committing to three cylinders. This does not require taking the drawing just as a collection of lines, as Sorensen suggests. Significantly, we can take the drawing to be a *picture of* a collection of lines. This conflict resolution happens within the contents of pictures and not by retreating from characterizing a picture as having content in the first place. Because of what Gombrich (1961) called the 'ambiguities of the third dimension' we are used to the fact that pictures could have resulted from a myriad of distinct three-dimensional scenes. The essence of bare bones content is that it captures what any of the sources of a picture must have in common. It may well be that Escher intended his prints to be interpreted as pictures of impossible scenes, but one can always consistently interpret them as pictures of perfectly possible states of affairs. In the 1980s Shigeo Fukuda built models which, when photographed, result in pictures with precisely the spatial features of Escher's *Belvedere* and *Waterfall*.[5] Reinterpreting the latter amounts to taking them to have the content of one of Fukuda's models, rather than a content that cannot be realized and thus which seems to make conflicting commitments.

The availability of reinterpretation in the face of conflicting commitments distinguishes pictures from descriptions as well. The description 'the red apple that is green all over' makes implicitly conflicting commitments. Reinterpreting the terms therein to dissolve the conflict, however, does unacceptable violence to the meanings of those terms. Not only do descriptions make implicitly conflicting commitments, therefore, they make irresolvable implicitly conflicting commitments. Pictures, by contrast, can always be interpreted consistently, even if that interpretation is not the most salient or obvious choice.

[5] I owe this reference to Sorensen (2002). In case you haven't heard, by the way, he offers $100 to the first person who shows him a picture of a logical impossibility.

So far we have made five conclusions about pictorial and descriptive content vis-à-vis commitments. First, pictures make explicit non-commitments, even though this is not unique to pictures. Second, descriptions ordinarily construed do not make explicit non-commitments. At the very least, therefore, explicit non-commitment is a way of distinguishing pictures from descriptions, even if it does not distinguish pictures from all other kinds of representational systems. Third, pictures do not explicitly commit to properties by claiming that their objects do not have them. Fourth, pictures cannot make explicitly conflicting commitments while descriptions can. Pictures can make inexplicitly conflicting commitments, of course, but the fifth point is that these commitments can always be overridden, resulting in a consistent, non-conflicting set of commitments. We cannot dissolve descriptions' conflicts in this way.

Conflicts and Non-commitments in Bare Bones Content

Important for the first part of the book was adopting Haugeland's (1991) suggestion that pictures have bare bones content. It was only once we could understand pictorial content in those terms that we were able to see what makes pictures transparent. Bare bones content, interestingly enough, makes no explicit non-commitments and makes no conflicting commitments. The conflicts and non-commitments that seem to characterize pictures are all features of their fleshed out contents. Thus, explaining how we get from bare bones content to fleshed out content should also explain how and why pictures make explicit non-commitments and implicitly conflicting but resolvable commitments.

One easy way to see that bare bones contents do not include explicit non-commitments is to recall that pictures themselves are instances of their bare bones content. Commitments to spatial features of a scene result in explicit non-commitments, as when one object is depicted as partially obscuring another. All that the bare bones content of a picture picks out, however, is what all of the fleshed out contents of pictures have in common, which in LP are the perspective

invariants and some color properties. Now one might think that all fleshed out contents of a given picture have in common the fact that one depicted object obscures another, so they all explicitly non-commit to properties of the obscured object. Not so. One fleshed out content of any picture is a plane colored and shaped exactly like the picture plane itself. Nothing that is depicted is depicted as being obscured in this fleshing out of the picture's content, so as far as the spatial commitments of such a fleshed out content go, there is no reason to think that it should involve explicit non-commitments. Given this fact about at least one of the fleshed out contents of a picture, it follows that the bare bones content needn't specify any explicit non-commitments.[6] Furthermore, we make these kinds of pictures of pictures all the time—see any of the pictures in this book, for example.[7] For many good reasons it is implausible to deny at this point that a plane just like the original picture is one way of fleshing out a picture's bare bones content. Explicit non-commitments are features only of some of the fleshed out contents of pictures, which means that they are *not* parts of pictures' bare bones contents.

Not only do bare bones contents fail to make explicit non-commitments, but they also fail to make any kind of conflicting commitments. Bare bones content picks out a set of rather abstract shape and color properties. As noted above, pictures' fleshed out contents are unable to make explicitly conflicting commitments. Bare bones contents no more make explicitly conflicting commitments than fleshed out contents do. Unlike fleshed out contents of pictures, however, bare bones content cannot make inexplicitly

[6] This point can be strengthened. There are many planes, all of which share projective invariants with the picture plane, that count as fleshings-out of the bare bones content of the picture. None of these involve any explicit non-commitment. So it is not just that there is one instance of a picture's fleshed out content, but indefinitely many, which involve no explicit non-commitment.

[7] Aren't the pictures in this book just reproductions of pictures, and not really pictures of pictures? Haugeland (1991), as we saw in the previous chapter, is fond of this distinction. We also saw, however, that even if that is a good distinction, it does not impugn the claim that we can make pictures of pictures. This raises the question of how we can deny that a picture just like the original counts as a fleshing out of the picture's bare bones content. This topic is discussed in more detail in Chapter 9.

conflicting commitments either. One way to see this is to note that a proper fleshing out of any picture is a plane colored and shaped just like the picture plane. This fleshing out of the bare bones content has all of the features specified in the bare bones content, and some more. If the bare bones content made conflicting commitments, then it would not be possible for an object like the picture plane just mentioned to satisfy all of them. Bare bones content therefore makes no inexplicitly conflicting commitments, either.

Another way of looking at this issue is in terms of the fact that pictures are mimetic. Chapter 4 argued that for a system to be transparent with respect to a property, P, representations in that system must be mimetic with respect to P. But being mimetic with respect to P means that, among other things, any time a representation represents P it is itself P. An implicitly conflicting set of commitments arises when an object is represented as being P and Q while no object can be both. For the bare bones content of a picture to specify an implicit conflict, the picture would have to manifest an implicit conflict—by being both P and Q, for example—which is impossible by hypothesis. Furthermore, any representational system whose represented properties include only those with respect to which it is mimetic will therefore fail to make implicitly conflicting commitments. This includes many representations that count as images but not pictures, as articulated in Chapter 4, as well as pictures themselves.

Given all of this, imagine a variant on LP that differs from the real thing only insofar as representations are not interpreted as having fleshed out contents: all they have are bare bones contents. Such a system satisfies all four conditions set out in Part I, so the scheme is pictorial, and it makes *no* explicit non-commitments. This suggests that making explicit non-commitments is not *necessary* for a system to be pictorial. The previous section suggests that explicit non-commitment is not sufficient, either. Many pictorial systems make explicit non-commitments, and this needs to be explained, but it is unlikely that explicit non-commitment can play such a central role in explaining pictorial representation as Lopes wants it to play.

Fleshing Out

For Lopes, it is in part what pictures explicitly refuse to say about their objects that make them special. His rejection of the 'myth of determinacy' is rooted here. That is to say, he thinks it is only once we have realized that pictures are not the kinds of things that specify maximally determinate details of their objects that we can see what is special about pictures: explicit non-commitment. It is somewhat ironic, then, that really dispelling the myth of determinacy by focusing on bare bones contents makes explicit non-commitment as well as conflicting commitments disappear. Lopes is right to claim that even the fleshed out contents of pictures are not as determinate as many have taken them to be and that pictures, ordinarily construed, make explicit non-commitments. But we have come to a point where we can see more clearly the source of explicit non-commitment and implicitly conflicting commitment in pictures. Fleshing out pictures' bare bones results in these interesting facts about commitments.

For one reason or another—which will be discussed in the next two chapters—we take pictures to have contents that are much more specific than their bare bones content. The way in which we go from bare bones content to these fleshed out contents results in pictures' fleshed out contents making explicit non-commitments as well as implicitly conflicting commitments.

Illustration 8 Sonia Landy Sheridan, *The Seeing Box and Its Energy*, 1965.
Hood Museum of Art, Dartmouth College, Hanover, New Hampshire; gift
of the artist. © Sonia Landy Sheridan

8

Sense Data and Bare Bones Content

The last two chapters provide some purchase on what pictorial content is like. First, pictures, as well as other kinds of representations, have bare bones contents. We cannot explain what it is to be a picture solely in terms of bare bones content, as Haugeland (1991) thought we could, but bare bones content is essential to understanding transparency, which is a core part of a workable account of depiction. Pictures also make and fail to make commitments in ways that descriptions and other kinds of representations generally do not. These interesting features of pictorial commitment, however, are facts about the fleshed out contents of pictures only. Bare bones contents make no explicit non-commitments and they make neither explicitly conflicting nor inexplicitly conflicting commitments.

This chapter and the next tie bare bones content to fleshed out content. The interesting features of pictorial commitment only show up in their fleshed out contents, so understanding pictorial commitment involves understanding how we get from pictures' bare bones contents to their fleshed out contents. Now, no one has ever looked at a picture and taken it to have bare bones content. Bare bones content is, perceptually speaking, difficult to notice. In linear perspective, recall, the bare bones content consists of projective invariants and color properties. Margaret Hagen (1986, 54) points out that: 'Those properties that are invariant are not only not obvious perceptually, but remain tricky to visualize even with examples'. Bare bones content, though elusive, is nevertheless that upon which any fleshing out of pictorial content must build. How could bare bones content play such a role if no one ever thinks of pictures in terms of bare bones content?

To put it another way, accounting for pictorial representation is in part providing a theory that jibes well with our intuitions in the neighborhood of depiction. The account worked out in Part I seems to get the extension of the term 'picture' right, despite including auditory and tactile representations. What is counterintuitive, however, is that the account relies on pictures having bare bones contents, which do not have a clear place in the suite of intuitions that surrounds depiction.

This chapter uses an old tool from the philosophy of perception and claims that the relation between bare bones content and fleshed out content is much like the relation between sense data and what we perceptually judge to be the case. Philosophical consensus is that there are no sense data: they were a bad idea in the philosophy of perception. That being said, lessons learned working out a sense datum epistemology can help us understand how we come to know the fleshed out contents of pictures, given that we have more immediate access to their bare bones contents. The point is not to explicate an absolutely strict analogy between sense data and bare bones content. Rather, sense data were supposed to be the basis of our perceptual judgments in virtue of being that of which we were immediately aware, even though we often did not notice sense data at all. This is how bare bones content does its work in relation to fleshed out content. This approach is something of a reversal in that pictures have been used as an example to help explain sense data at least since Berkeley's dialogues (1713/1979). Once this proposal about the role of bare bones content has been explicated, the next chapter goes on to discuss the implications of this for the perception of pictures.

Sense Data

Sense data were quite popular in the first half of the twentieth century, but their roots are as deep as British empiricism. They were supposed to be the things of which one was directly aware and which one knew immediately in perception. They served as the ground for all of our perceptual knowledge. One's perceptual judgment that there is a green chair in the room, for example, was based on awareness of or acquaintance with sense data that had certain shapes and colors. Sense data served as a basis for these judgments in that one inferred claims

about the world at large from acquaintance with sense data. We know our sense data non-inferentially, while all other perceptual knowledge builds by inference thereupon. Just what kind of inference this was supposed to be varied among philosophers.

A Lockean (1690/1975) view has it that we come to know about the world because our sense data are caused by it. We are only ever aware of the effects of the world on us—i.e., our experiences—but these effects justify something of an inference to their causes. We needn't explicitly make such inferences: they happen quite unnoticed. A Berkeleyan view is that we come to know about the world because the world *is*, in some sense, our sense data. This kind of response is by far the one more commonly found in the early twentieth century. The problems with Lockean causal views, as discussed by Berkeley (1710/1982), and later G. E. Moore (1918) and H. H. Price (1950) seemed insuperable. Bertrand Russell (1914), for example, thought the world was composed of minds and sense data alone. Everyday objects like tables, tomatoes, and envelopes were, for Russell, logical constructions out of sense data. Our knowledge of objects on this view might be inferential, but it is not an inference from effect to cause. It is the more secure inference from part of a logical construction to a logical construction. These inferences were supposed to be automatic and natural, just like Locke's inferences.

The fact that we so naturally and effortlessly infer claims about the external world on the basis of our sense data makes it difficult to notice that there are any. G. E. Moore (1953) held an envelope before his class and pointed out that even though everyone judges it to be the same shape—a rectangle—no one has a rectangular sense datum corresponding to the envelope. This sense datum could have been trapezoidal, rhomboidal, or some rather irregular quadrilateral shape, depending on one's position in relation to the envelope. One had to concentrate in the right way on one's experience to notice the data that sense presents. Moore (1903, 450) says for this reason that experience is 'as if it were diaphanous'. Usually we ignore sense data, in favor of the perceptual judgment that the envelope is rectangular. The data do their work, in a way unnoticed even though they are the only things of which we are directly aware.

Explaining this strange state of affairs is easy, as long as one is prepared to use pictures as an example. We often see pictures that are obviously *of* rectangular objects. We immediately judge of the depicted object that it is rectangular without noticing the shape of the picture's region that corresponds to the rectangular thing it represents. This is all the more true when we watch movies. It is easy to notice the shapes of depicted objects, but the shapes of regions on the screen, though they are only things of which we are directly aware, pass by unnoticed. In Berkeley's (1713/1979) second dialogue, Philonous shows Hylas a picture of Caesar to demonstrate the distinction between what we know immediately by sense and what we know only by inference. The reason this analogy between perception and pictures works so well is not because pictures mimic perception or conversely. The real reason is that the point about sense data is better suited to explaining pictorial content and how we come to know it than it is to explaining our knowledge of the external world. This point will become clearer presently. For now, let's take a look at the other features of sense data that make them a useful tool for understanding pictorial content.

Sense data were not the kinds of things that could conflict with one another. When Russell (1914, 77–8) tried to identify the data of sense he asked what the 'hard data' of an experience were. These would be those properties indicated by an experience that one could not come to doubt on the basis of having the experience. Among the hard data were the facts that there were certain colors and shapes instantiated in one's immediate environment. Many experiences exhibit figure/ground ambiguities, or are not clear concerning relative distances or orientations. Ambiguities, conflicts, and the like are not admitted among the hard data of an experience by definition. Russell and the other sense datum theorists were looking for an epistemological ground for our perceptual judgments. 'The problem of our knowledge of the external world . . . is: Can the existence of anything other than our own hard data be inferred from the existence of those data?' (Russell 1914, 80). As the basis of these inferences, sense data could not admit of conflicts. If they did, then the basis of our inferential perceptual judgments could be contradictory, leading to something of a carte blanche when it came to further perceptual judgments.

One way to make this work is to take sense data to be non-intentional. They may be the basis upon which we make our perceptual judgments, but they needn't, in and of themselves, say anything about the world or anything else. It could be that sense data just have properties like colors and shapes, and that we are acquainted with these objects themselves. If the sense data are not intentional *per se* but just things that have certain properties like colors and shapes, then the question of whether they conflict cannot come up. Objects and properties do not have conflicts among themselves; representations can conflict when they ascribe properties to something that no object can have. Bare bones content is nothing if not content, but the claim that pictures must *manifest* their bare bones contents plays the analogous role of preventing conflicts within bare bones contents.

Another feature of sense data is that they make no explicit non-commitments. The origin of explicit non-commitment in pictures, as noted in the previous chapter, is pictures' commitments to spatial features of scenes. To the extent that pictures commit to one object being in front of another they explicitly non-commit to properties of the obscured portions of objects. Berkeley is famous for denying that distance is immediately perceived (1710/1982, 1713/1979), which is tantamount to denying that distance is a 'hard datum' or a property of sense data. Perceptual judgments usually concern the relative distances of objects and what have you, but not because sense data or their parts are located at different relative distances. After all, perceptual judgment usually concerns a lot of properties—being an archbishop, a rainbow, a bulldozer, or what have you—which are certainly not properties of sense data.

The sense datum theorists of the early twentieth century did not quite follow Berkeley in claiming that distance is not immediately perceived. Russell (1914, 80) thought it 'probable that distances, provided they are not too great, are actually given more or less roughly in sight'. Price agreed. When he looked at a tomato, he said 'there is much I can doubt . . . One thing however I cannot doubt: that there exists a red patch of a round and somewhat bulgy shape, standing out from a background of other colour-patches, and having *a certain visual depth*' (Price 1950, 3, my emphasis). Later on, he says 'It is obvious that all visual sense-data have the characteristic depth

or "outness". This characteristic of them is just as much "given" as colour or shape' (Price 1950, 218). Those for whom depth was a feature of sense data were not *eo ipso* committed to sense data making explicit non-commitments. Price's discussion of sense data as an array of 'colour-patches' makes this clear. One may judge the toaster to be obscured in part by the bowl but that does not mean one sense datum is partly obscured by another. Rather, one is acquainted with two sense data, one for the bowl and one for the part of the toaster, neither one obscuring the other. On this way of looking at things, the sense data fill the visual field, at different distances, without gaps, but without overlapping, either.[1]

Problems with specifying just what count as data of sense contributed significantly to the downfall of sense datum epistemology. Distance was a particularly troublesome property in this regard.[2] Consider the supposedly trapezoidal datum at the root of Moore's judgment that the envelope is rectangular. If parts of that datum are at different distances from an observer, then there is a good reason to expect the datum to be rectangular, but oriented oddly, rather than trapezoidal and at no distance in particular. This is but one way in which, when distance is added to the set of properties specified by sense data, the problem of distinguishing what we immediately perceive from what we infer therefrom becomes acute. Is the sense datum trapezoidal or rectangular and oriented obliquely? If the latter, why are we not just immediately perceiving the surface of the envelope, as opposed to some sense datum? This is not a problem, notice, for pictures, since there is a perfectly good sense in which pictures' bare bones contents do not specify distance.

In the end, sense data didn't get very far. We needn't mourn their demise, though. They were a bad idea, albeit a very interesting

[1] Things get more complicated with sense data here than they need to be for my purposes. Price (1950), for example, thought that sense data could have properties that they were not taken to have perceptually. That is, sense data did not need to be fully revelatory of their own properties to the perceivers who were acquainted with them. This raises the question of whether there is a sense in which sense data could make explicit non-commitments. This topic, however, is only interesting if one wants to work out a fully formed sense datum theory, rather than draw an instructive analogy between sense data and the bare bones contents of pictures.

[2] Cf. Roderick Firth (1949-50) on perceptual reduction.

one. Despite not being the best candidates to provide a foundation for our perceptual knowledge, they serve as a useful analogy when considering the role that bare bones content plays in how pictures lead us to their fleshed out contents. In fact, bare bones content serves as a bridge between our knowledge of pictures and our knowledge of their fleshed out contents. Like sense data, they do this in a way unnoticed even though they are that of which we are, in a sense, directly aware when we look at pictures.

Bare Bones Contents and Sense Data

Bare bones content is a theoretical construct that figures in the explication of transparency as a feature of representational systems. That is, it helps to explain the sense in which the Walker Evans and the Sherrie Levine have the same content. Bare bones content and transparency need not be obvious or even terribly salient features of pictorial representation. Our folk conception of pictorial representation may simply have no place for them. It is easy to get in the mood for seeing how transparency and bare bones content help to understand depiction, but these are hardly features that one can read off from our everyday practice with pictures.

The last section made it clear that sense data, like bare bones contents, admit of no conflicting commitments and make no explicit non-commitments. In this respect, bare bones content and sense data are very much alike. In fact, part of the reason why sense data could play the role of an epistemological ground is that they are unable to make conflicting commitments. This turns out to be one of the roles that bare bones contents play in pictorial content. They ground any other ascription of a fleshed out content to a picture, the only condition being that the fleshed out content is consistent with the bare bones content. Since anything is consistent with something that is internally inconsistent, conflicting bare bones content would make trouble for pictorial content more generally.[3] Likewise, though it was

[3] Note that the fleshed out content can itself be inconsistent, as in pictures of impossible figures. In these cases our chosen way of fleshing out parts of the picture are not consistent with one another. See Sorensen (2002) and the previous chapter for more on pictures of impossible things.

controversial whether sense data were located at different distances from the observer, the bare bones contents of pictures do not include distance at all. The Ames chair (Ittleson 1952) shows that the picture of a chair could have been created using a series of line-segments that are not even connected in space. If bare bones content specified distances, examples like Ames chairs could not get off the ground. These points are important because they show the respects in which sense data, somewhat remote in many respects from bare bones contents, are very much like them.

The rest of this chapter explicates the sense in which we have privileged access to bare bones content. How is it that pictures make their bare bones contents available to viewers in a way that is privileged over the way in which their fleshed out content is available? Sense data are the objects of immediate awareness, which is what makes them a candidate foundation for the rest of our knowledge. And bare bones contents are supposed to be the basis upon which we flesh out pictures contents. This is a difficult question to answer because what we are directly aware of seems to be the picture itself and not its content. It turns out that insofar as we are aware of the picture itself, we get special access to its bare bones content, which can then ground our ascription of fleshed out contents to pictures. Chapter 9 goes on to address why we flesh out pictures' contents in the way we do.

Privileged Access to Bare Bones Content

The bare bones content of a picture tells us that certain colors and rather abstract spatial properties, like being a conic section, being straight, and so on, are instantiated at certain relative locations. Bare bones content captures what all of the diverse possible sources of a picture have in common and thus that upon which any precisification of the content to something more fleshed out must build. Pictures are special in part because they *instantiate* the properties that their bare bones contents specify. The perspective invariants, to use LP as an example, are those properties that the picture itself shares with whatever results in the projection. One way in which pictures give us knowledge of their content, on this view, is by instantiating properties of the things that they are about. In that sense, to the extent that one

can be aware of the picture itself, one is aware of an instance of its content. Moreover, the picture has that content in virtue of being an instance of it. By contrast, one cannot come to know about the bare bones content of a description merely by acquaintance with the description itself. Descriptions generally do not describe themselves, so acquaintance with a description is not generally acquaintance with an instance of its content.

Not only are pictures instances of their bare bones contents, one thing that makes pictures in linear perspective special is that they afford us a special access to those features constitutive of their bare bones content. Most instances of pictures' bare bones contents are three-dimensional scenes like the dilapidated rooms of the Burroughs family. One thing about three-dimensional scenes, however, is that they are only instances of bare bones contents from a point of view. That is, only from one point in space vis-à-vis the room does the room satisfy the picture's bare bones content.[4] By contrast, pictures in LP at least are special instances of their bare bones contents because they satisfy those contents *irrespective* of viewpoint. Whether some object or state of affairs is an instance of a picture's bare bones content from a given point depends on whether it exhibits the perspective invariants constitutive of that content from that point. A picture exhibits its perspective invariants from any and all points that are not in the picture plane. Hagen (1986, 104) points out that 'the invariants captured in such pictures [LPPs] are exactly those that remain invariant across *subjective movements of the observer*' (italics Hagen's).[5] This is not to say merely that pictures in linear perspective *have* their bare bones

[4] Calling this a point of view may suggest that there is something particularly subjective about it, but that is misleading. We can often put ourselves, subjects that we are, at those points, but that does not make them subjective.

[5] Hagen (1986) is quite fond of a Gibsonian approach to perception, and the question naturally arises whether I am committed to that as well. Just as I am not committed to a sense datum view of perception, the Gibsonian cards can fall where they may as far as I am concerned. If one is a Gibsonian, one may have an interesting explanation of picture perception ready to hand once one has noticed the facts about bare bones content that this chapter explicates. My point about perspective invariants is a point about pictures and the way they satisfy their bare bones content, not a point about what goes on when we see pictures. That we have perceptual access to the bare bones content of a picture irrespective of viewpoint does not say anything about what that access amounts to. You could be a computationalist, a Gibsonian, or something in-between for all that has been said here.

contents irrespective of viewpoint; they do, of course, but most representations are like this. Rather, unlike most instances of the bare bones content of a picture, a picture is an instance that is not relative to some other point in space.

What does this interesting fact about pictures and their bare bones content have to do with subjects' access to it? Since the picture manifests all of its perspective invariants independently of viewpoint, oblique views are just as good as direct views for perceiving those invariants. In a sense, we have better perceptual access to the bare bones content of a picture than we have to determinate features of its surface. Viewed obliquely, it is quite difficult to discern the shapes on a picture's surface, but the picture, from that perspective, is an instance of its perspective invariants. In that sense, our access to the bare bones contents of pictures is privileged. This does not mean that it is infallible, incorrigible, or what have you. The point is merely that we have a special access to bare bones content in relation both to other features of the picture's surface and to the picture's fleshed out content.

If fleshed out contents are consistent with bare bones contents, and we have privileged access to bare bones contents, it suggests that we come to know of the fleshed out contents of pictures on the basis of coming to know of their bare bones contents. For this reason, bare bones content plays an epistemological role not unlike that supposedly played by sense data in perception. By accessing bare bones content we infer facts about fleshed out content. We may not self-consciously do this, but we do it all the same. The next chapter discusses just *how* this fleshing out is supposed to happen.

To review, two things work together in seeing a picture. The picture is that which one sees, so as long as one is able to see it, one is also able to see an instance of its bare bones content. Furthermore, pictures in linear perspective are instances of their contents in a special, viewpoint-independent manner. This helps pictures to make their bare bones contents available to us, and it goes a long way toward unpacking the analogy between bare bones contents and sense data. Pictures' bare bones contents undergird our ascription of fleshed out contents to pictures, much as sense data were supposed to scaffold our perceptual judgments. We have special perceptual access to bare

bones content because of the way pictures are structured, and every fleshing out of the content of a picture must square with its bare bones content. Though bare bones content and most of the fleshed out contents of pictures are not perceptually salient, the next chapter shows how perceptual access to bare bones content can lead us to the perceptually salient, fleshed out features of pictures' contents.

One theme of this book has been that LP is a rather special and central case of depiction. As a start this view merely seems intuitive, and it is supported by the fact that many pictures at least approach being in linear perspective. But LP helps us to see transparency, which broadens out the class of pictorial representations in a theoretically interesting way. With such a variety of depiction one wonders why LP seemed so special. This chapter suggests that in addition to being a central example of transparent representation, LP makes the bare bones content of its representations available in a viewpoint-independent manner. This is *not* first and foremost a feature of our perception of pictures, notice, but it has direct consequences for the perceivers of pictures. The discussion of bare bones content unpacks Hagen's suggestion that LP is special because its invariants remain the same across differing viewpoints on the picture. The hope, in giving a structural account of depiction, was that once we got clear on their structure, this would reframe the problems of picture perception, and it seems as if this hope has been partially realized. Keeping perception out of the picture has left us in a good position to ask why the perception of at least some pictures seems so special. The next chapter unpacks this idea in some detail by asking how and why we flesh out the contents of pictures, in particular those in linear perspective, in the way we do. Chapter 10 then looks at what the present account has to say about the two most prominent perceptual accounts of depiction.

Once these goals have been accomplished, Part III looks at how we should understand the variety of pictorial systems in light of the fact that LP seems so special by addressing whether 'what Westerners call "realistic" information is pictorial information that is invariant under individualistic, movement-generated change' (Hagen 1986, 105). That is, Part III considers what pictorial realism is and whether pictures in LP, in virtue of being so special, are considered to be particularly realistic.

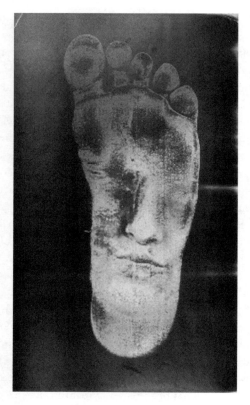

Illustration 9 Sonia Landy Sheridan, *Foot Face*, 1970s. Hood Museum of Art, Dartmouth College, Hanover, New Hampshire; gift of the artist © Sonia Landy Sheridan

9

Fleshing out and Seeing-in

Though we have privileged access to the bare bones contents of pictures, we rarely notice that pictures have such content. We are led right through a picture to its fleshed out content. This chapter considers four problems concerning how and why we flesh out the bare bones contents of pictures in the way that we do, which are, fundamentally, questions about picture perception. First, how and why do we consistently flesh out the bare bones contents of pictures in some ways and not in others? We look at the Ames chair demonstration, and flesh out its bare bones content to a chair, rather than any of the indefinitely many configurations of line segments that are equally consistent with the bare bones content of the picture. Why? This problem is related to three others. In particular, what is the source of explicit non-commitment and implicitly conflicting commitments in fleshed out contents, when bare bones contents exhibit neither? Also, how do we flesh out the content of a picture consistently across multiple viewpoints? The work done in the previous chapter and Part I suggests a new way of accounting for this much-discussed phenomenon. Finally, though we tend to be consistent in the way that we flesh out the contents of pictures despite the angles from which we view them, anamorphic pictures are not like this. Anamorphic pictures are usually intelligible from a set of odd viewing angles and are not generally interpretable as anything but abstractions from normal viewing angles. Understanding this phenomenon helps clarify the view on offer here. Before addressing each of these problems in turn, the next section sets them up by looking at what the special perceptual state evoked by pictures—seeing-in—is supposed to be and how the fleshed out/bare bones content distinction relates to it.

Twofoldness and Manifoldness

Richard Wollheim (1980) coined the term 'seeing-in' for the special perceptual state associated with seeing pictures. When we look at pictures we can see what they are about *in* them. For Wollheim, this means that we see the picture surface, and are aware of it as a colored two-dimensional plane, but we are simultaneously aware of what we see in the picture, which is a fleshed out content. Pictures evoke this special, amalgamated perceptual state, but so does looking at patterns of oil in a puddle or, as Leonardo suggested to his students, dirt on a wall.

Seeing-in is a natural capacity we have—it precedes pictures, but pictures foster it—which allows us, when confronted with differentiated surfaces, to have experiences that possess a dual aspect or 'twofoldness': so that, on the one hand, we are aware of the differentiation of the surface, and, on the other hand, we observe something in front of, or behind, something else. (Wollheim 1993, 188)

Some sense of twofoldness can be found in Leonardo, who says that 'The first intention of the painter is to make a flat surface display a body as if modeled and separate from this plane' (Kemp 1989, 15). He warns against 'forgetting the beauty and wonder of a flat surface displaying relief' (Kemp 1989, 16). Wollheim (1987, 1998) called the aspect of experience that involves the picture's fleshed out content 'recognitional' and the aspect involving awareness of the picture itself 'configurational'. For Wollheim, without twofoldness, there is no depiction: '[I]f I look at a representation as a representation, then it is not just permitted to, but required of, me that I attend simultaneously to object and medium' (Wollheim 1980, 213). Consequently, genuine *trompe l'oeil* paintings or photographs are not pictures at all because one cannot be aware of their configurational aspects.

Opinions vary on the status of twofoldness. Robert Hopkins (1998, 15–17) and Susan Feagin (1998, 236) agree with Wollheim whereas Flint Schier (1986, 207–8), Dominic Lopes (1996, 49) and Jerrold Levinson (1998, 229) think twofoldness is characteristic only of the experiences of some pictures. Ernst Gombrich, by contrast, thought twofoldness is impossible:

But is it possible to 'see' both the plane surface and the battle horse at the same time? If we have been right so far, the demand is for the impossible. To understand the battle horse is for a moment to disregard the plane surface. We cannot have it both ways . . . the better the illusion, the more we see a picture as if it were a mirror. (Gombrich 1961, 279)

The view on offer here does not require, but it permits, twofold experiences when looking at pictures, so it sides with Schier, Lopes, and Levinson. In fact, if what has been said so far is on the right track, there is a *manifoldness* to pictorial content that is often, but not always, realized as a twofoldness in our experiences of pictures. The manifoldness is found in the myriad of pictures' possible fleshed out contents. Indefinitely many scenes could result in the same perspective projection. The bare bones content of a picture generates and holds this wealth of possible contents together, but neither the bare bones nor most fleshed out contents of pictures are ever perceptually salient. This manifoldness does not therefore translate into manifold experiences of pictures. Rather, our experiences are usually twofold because for any picture just one fleshed out content is perceptually salient, along with the picture surface itself.

Fleshing Out

Why do pictures have just one, or very few, perceptually salient contents given the myriad of fleshed out contents they can have? Levinson recently suggested that 'The impression of seeing . . . at the core of seeing–in is one intimately bound up with the registering of the visual data afforded by the picture, whereby the latter in a sense constitutes or realizes the former' (Levinson 1998, 230). This remark sums up the present view rather well. The data of the picture are its bare bones content. A picture 'constitutes or realizes' bare bones content by manifesting or instantiating it. What about the 'intimate' connection between the data and the 'impression at the core of seeing–in'? Gombrich (1961), who had a notion of bare bones content, seems to have gotten that part right. Simply put, seeing a fleshed out content results from deploying concepts as a result of seeing the picture surface—and thus registering its bare bones content—that do not

apply to the picture surface. Which concepts we deploy depends on what recognitionally keyed concepts we have, which determines the perceptual salience of a given fleshed out content.

Those things that can be perceptually salient are in part those things we are wont to judge as being instantiated in our environment. Trees and fire engines are perceptually salient. Fire engines seen at 46 degrees from head-on and trees between 20 and 21 feet tall are not: they do not stand out as such. Moreover, disconnected parts of fire engines and trees would stand out, if we saw them in the right way, but they are not what we expect to find. A depiction of a daring cat rescue is taken to be about fire engines obscured by trees, not about a tree sandwiched between disconnected fire engine parts. We would be very surprised to encounter a jumbled mess of tree and hook and ladder pieces, and it would likewise be odd to interpret the cat rescue picture in that way. The idea is that in viewing a picture, we latch on to perceptually salient, rather ordinary instances of its bare bones content. We do this not because there are no other interpretations, but because we do not have concepts ready at hand to apply to those other, odd instances of the bare bones content. The demands of life and leisure may contrive to make such things perceptually salient, perhaps even more salient than your average whole fire engine, but until that comes to pass, we will not interpret pictures in that way. Changing the stock of concepts that we have ready to hand could be accomplished by a concerted effort on our part, or by changing the world around us and thereby forcing a change in the way we conceive of it.

Gombrich suggests that if Ames chairs were common—as common as, say, Eames chairs—many might regard pictures of chairs as pictures of disjoint collections of line segments in three dimensions:

We are blind to the other possible configurations because we literally 'cannot imagine' these unlikely objects. They have no name and no habitation in the universe of our experience. Of chairs we know, of the crisscross tangle we do not. Perhaps a man from Mars whose furniture was of that unlikely kind would react differently. To him the chair would always present the illusion that he had the familiar crisscross in front of the eye.... Since we know chairs but have no experience of those

crisscross tangles that also 'look like' chairs from one point we cannot see or imagine the chair as a crisscross tangle but will always select from the various possible forms the one we know. (Gombrich 1961, 249)

A world furnished with Ames chairs would force us to acquire perceptually triggered concepts thereof, and thus make them salient in the flesh as well as in pictures. If the surrealists take over the town council, we might get used to hook and ladder pieces rescuing cat parts. As our world or merely our concepts change, we expose different aspects of the manifold possibilities for fleshing out pictures' bare bones. Many figures, often called 'ambiguous pictures', admit of more than one perceptually salient fleshing out, so we regard their content as indeterminate between them. The point here is that all pictures admit of more than one fleshing out, but some make this obvious and others do not.

The sense datum theorists, by the way, worried about a similar problem. In Russell's (1914) terms, how do we sort our sense data into 'logical constructions'? For Russell, illusions and hallucinations were on a par with veridical appearances in that they are all just composed of sense data. Some sense data, however, fit nicely into logical constructions that seem a lot like mind-independent, three-dimensional objects, while others, those we dismiss as illusory or false, do not fit together so well. Likewise, some fleshings-out of pictures comport well with the world we have the conceptual resources for representing readily while others do not.

Commitments Again

Once we have deployed the relevant concepts and fleshed out the content of a picture, it is easy to see how pictures make explicit non-commitments. We see a toaster in the picture and we have a conception of what toasters are like, which concerns their shapes, constitution, and so on. We also see a bowl in the picture, which obscures part of the toaster. It is clear that the bowl obscures the toaster because we know what toasters are like: they usually lack bowl-shaped holes. In that sense, the picture makes an explicit non-commitment to a portion of the toaster's surface. Fleshing out brings

explicit non-commitment into the picture. This all follows from the fact that we deploy concepts on the basis of seeing only proper subsets of objects' properties. We can notice a toaster even if we only see a small part of it. Once we see that the picture commits to a toaster's presence, we see that it explicitly does not commit to certain features of its surface.

Chapter 7 claims, against Lopes (1996), that explicit non-commitment is not a necessary feature of pictorial content. That still seems right, but now we can see why Lopes thought that explicit non-commitment is necessary. The examples used against Lopes are admittedly contrived. We can flesh out a picture's content to a collection of non-overlapping, colored patches, but we are unlikely to do so. In most pictures, concepts we do have—fire engines, toasters, bowls, etc.—trump the application of such odd concepts as a colored patch, resulting in explicit non-commitment, and even conflicting commitments.

Some pictures, particularly photographs, are interesting because they depict an object by committing to a very small subset of its features. A photograph of a part of the top of a toaster can hold one's interest because it captures almost too little to elicit the deployment of our toaster concept. We have to concentrate and at a certain point we can just see the toaster. Another interesting feature of pictures like this is that when they completely resist the recognitional deployment concepts, they are often regarded as abstractions: we focus only on their configurational aspects, which can often be rather impressive in their own right. As we will see below, when we look at anamorphic pictures, the easiest interpretation from a normal viewing angle is often a collection of colored patches.

It is also easy to see how implicitly conflicting commitments arise from fleshing out pictures' bare bones contents. The most perceptually salient fleshings-out of parts of a picture can be mutually incompatible. This is certainly true of the inconsistent picture (Figure 7.1) mentioned earlier. Implicit conflicts arise when different parts of a picture call for the deployment of concepts that do not sit comfortably together when applied to a single object, though they are perfectly good as interpretations of (perhaps large) parts of the picture in their own right. One need not retreat to bare bones content to resolve this conflict. All

that is required is that we read the picture as of two objects, situated next to one another in such a way as to suggest that they form a continuous whole. One the one side we have three round prongs while on the other we have a rectangular arrangement of surfaces. They have been juxtaposed to give the impression that they form one continuous object even though they do not. This in no way retreats to the rather indeterminate bare bones content of the picture: it just chooses another, perfectly consistent, fleshing out of that content.

Viewpoint-Independence

Wollheim (1980) points out that even though what we see in a picture—a certain fleshed out content—is always depicted from a point of view, we are able to see it in the picture almost independently of the viewpoint we take toward the picture itself. He takes viewpoint-independence to support his strong view of twofoldness because the latter can explain the former while weak twofoldness cannot. Being aware of the configurational features of the picture surface allows us to notice that the picture is oblique to our line of sight. We then perceptually *compensate* for this off-center viewing angle, which allows us to see the picture's content in it, regardless of the poor view we have of the picture.

It is not obvious why a twofold experience is what we need to compensate for an odd view of a picture, however. Lopes (1996, 48–9) responds that:

When a picture is viewed from an oblique angle the shapes of the objects represented are not experienced...as distorted. A likely explanation of this constancy of represented shape is that the viewer is aware not only of what is represented but also of the orientation of the surface on which it is represented.... [T]he required information may be processed along with a wealth of other visual information at a 'sub-personal' level.

Psychologists, like Maurice Pirenne (1970) and Michael Kubovy (1986), are also interested in explaining our viewpoint-independent access to pictures in light of the viewpoint-dependent nature of their fleshed out contents. They side with Lopes. 'When the shape and the position of the picture surface can be seen, an unconscious

psychological process of compensation takes place, which restores the correct view when the picture is viewed from the wrong position' (Pirenne 1970, 99). Kubovy, who also cites the Pirenne passage, says: 'Indeed, the robustness of perspective suggests that the visual system infers the correct location of the center of projection' (Kubovy 1986, 86).[1] Information about orientation need not be part of the experience of seeing the picture, since it could be used by our perceptual systems without our awareness.

The discussion from the previous chapter suggests another solution to this problem. Pictures are instances of their bare bones content independently of point of view, while most fleshed out contents essentially involve a point of view. The special access we have to bare bones content allows us to flesh out the content of a picture despite viewing it from various perspectives. Since most fleshed out contents of pictures are only instances of that content from a point of view, however, our access to those contents is mediated by our more immediate access to their bare bones contents. In contrast to Pirenne, Kubovy, Wollheim, and Lopes, the present proposal suggests that we might not need to *compensate* for oblique views if pictures make their bare bones contents available to us independently of viewpoint.[2] The picture is just as good an instance of its bare bones content from oblique views as it is from more standard viewpoints. The perceptual salience of certain fleshings-out likewise endures many changes of viewpoint, though not all of them. This point is a bit subtle and requires some more unpacking. Here again an account of the structure of pictures vis-à-vis what they represent can inform the problem of picture perception.

It helps at this point to consider an analogy with inscriptions. Getting at the content of a representation—any kind of representation—requires at least that one can know what representation it is. We

[1] More recent results, due to Yang and Kubovy (1999), among others, suggest that perspective is not as robust as thought previously, and that an alternative explanation of the phenomenon is called for. In quite the other direction, Busey et al. (1990) found that vertical slants of up to 22 degrees, even in cases where all cues as to the slant of the picture surface were removed, were interpreted as not distorted.

[2] J. J. Gibson (1954, 1960, 1971) held a similar view of pictures and compensation, but he supported a Gibsonian approach to perception. None of my claims commit me to understanding perception in Gibson's terms.

know that 'dog' means dog, but when we encounter an inscription of the word getting at its meaning depends on being able to identify the inscription as an inscription of 'dog'. This does not mean that we notice the syntactic identity of the inscription, in the sense of coming to believe that there is a representation of such and such a type before us. We may not really notice the text at all, which seems like what happens when we read. Without access to the syntactic identity of the representation, and *a fortiori* access to those features constitutive of the representation being of the syntactic kind that it is, however, we have no access to its content. Like pictures, descriptions can be read from many oblique viewpoints, which suggests that one of two things is the case. On the one hand, we may correct for our perspective on an inscription when seen obliquely by virtue of having perceptual access to its orientation relative to us. On the other, perhaps being an inscription of the letter 'a' depends not on having the determinate shape that the letter has on this page, but on having a less determinate shape that it shares with perspective projections of 'a'. In the case of letters the latter option clearly seems closer to the truth. Many distortions of a letter's shape, not limited to those which projective transformations inflict, leave its identity as a letter intact. Alphabets and written languages are not terribly syntactically sensitive. We do not need to 'correct' for many distortions to know what letter it is because a letter's identity is not terribly sensitive to changes in its SRPs.

Like letters and words, pictures are representations in systems, and instances of them have syntactic and semantic identities. Many assume that getting at a picture's content requires coming to know about the determinate shapes and shades of its surface. Our access is compromised if one takes an oblique view of the picture without correcting for it somehow. The suggestion here is that there is nothing to correct for because a picture's syntactic identity does not depend on such determinate details of its surface. Pictures are quite syntactically sensitive, but they are, as noted in Chapter 3, insensitive to changes that do not affect their perspective invariants. So, first, we can come to know what picture something is from many viewpoints without correcting for those viewpoints. And second, pictures are special in part because these viewpoint-independent features constitutive of their

syntactic identities also manifest their bare bones contents. Pictures are instances of their bare bones contents, so as long as we have access to their syntactic identity, we get access to their bare bones semantic identities as well. This is why bare bones contents are so immediately available in pictures. Descriptions fail to be instances of their contents, and thus do not deliver their contents to observers in such an immediate way as pictures do despite the fact that we are good at identifying descriptions independently of viewpoint.

Evidence For and Against Compensation

So, do we compensate for odd views of pictures, or is compensation unnecessary, as the current account claims? Any given picture has a manifold of fleshed out contents: indefinitely many scenes are consistent with its bare bones content. For a while—see, e.g., Hochberg (1972, 55), Halloran (1989), Busey et al. (1990), Yang and Kubovy (1999)—we have known that changes in viewpoint result in changes in how we interpret a picture. One empirical question is therefore whether and to what extent our interpretations of pictures change with changing viewpoints. The other question, however, which has not been asked, is whether the distinct interpretations of a picture when viewed from varying viewpoints are consistent with its bare bones content. Those who have written on this topic in the past seem to assume that the fleshed out content we assign to a picture when we view it head-on in ideal conditions is the only fleshed out content of the picture, the others being 'distortions' of it. This is the wrong way to think of pictorial content and it obscures what the viewpoint-independent access to pictorial content consists in.

As far as the first question goes, the data are inconclusive but some, at least, seem strongly in favor of compensation. Pirenne (1970) was interested in why certain pictures seem to retain their content through massive changes in viewpoint while others, in particular ceiling frescoes, often look lopsided unless viewed from just the right point. In a letter to Pirenne, Albert Einstein sketched a proposal that Pirenne developed. The claim is familiar by now: when looking at a picture, we have perceptual access to the orientation of the picture plane. This allows us to compensate for the oblique view

and thus read the picture correctly. Ceiling frescoes do not give us access to the orientation of the picture's surface simply because the ceilings are so far away: this compromises compensation and results in large distortions. Moreover, conflicting cues for orientation affect picture interpretation. Pirenne illustrates this point with a picture of Nixon standing before one of his campaign posters. The poster is at a rather oblique vertical and horizontal angle to the picture plane. While Nixon looks just fine in the photo, the poster of Nixon looks distorted, and the distortion endures arbitrary changes of viewpoint. We glean information about the picture's orientation, which lets us compensate for oblique viewpoints. In this case, compensating for viewpoint forces us to see the depicted Nixon poster askew, regardless of the view we take on the picture. We cannot compensate for the odd view of the Nixon poster by reorienting the picture, so it always looks distorted. By contrast, if we were viewing the Nixon poster itself from an odd angle, it would not look distorted because we could mobilize our compensation resources.

Three predictions follow from the compensation proposal. First, in the absence of information about the orientation of the picture, our interpretations should be distorted—as with the ceiling—when the picture is viewed obliquely. Second, if information about orientation is available, then interpretations should not distort even given changes in viewpoint. And third, in the presence of conflicting information—as with the Nixon poster—interpretations should be distorted.

Busey et al. (1990) tested something like the first proposal on photographs of faces. Subjects viewed the photos at varying orientations, though the cues that would indicate the orientation of the picture plane were removed. Even under these conditions, subjects experienced no so-called 'distortions' for pictures rotated vertically by up to 22 degrees. Perceived distortions appeared for horizontal rotations smaller than 22 degrees. Given the lack of access to the picture's orientation, the undistorted interpretations cannot be due to compensation via adjusting for the angle of the perceived picture. In general, these data are inconclusive because they involve faces. For a long time psychologists have known that people are specially equipped to perceive faces accurately and rapidly under all sorts of conditions, so this may account for at least part of the lack of perceived distortion.

Both of Pirenne's examples involve faces, but they also involve fairly large angles—closer to 45 degrees than to 22—with fairly large horizontal components. Cutting (1987) noticed that though moviegoers noticed no distortion at 22.5 degrees, distortions were evident at 45.[3] It would be interesting to know to what extent the distortion of the Nixon poster is reduced when the photograph is viewed under Busey's conditions, removing information about the picture's orientation. To my knowledge, this has not been investigated.

Halloran (1989) tested the second hypothesis, to the effect that in the presence of information about surface orientation, there should be no distortions. He found that this is true for small angles, but false for large ones. His study follows up on one by Rosinski and Farber (1980) that argued in favor of compensation. Rosinski found no distortions when surface information was available, but Halloran showed that increasing the angles at which the picture was viewed, among other things, produced distortions. Halloran's data fit well those of Cutting and Busey, who suggest that there is no compensation mechanism at all. There are no distortions for small angles even without knowing the picture plane's orientation, but distortions appear for large angles. It is likely, then, that we just do not notice any distortion for these small rotations and that large angles are sufficient to alter our interpretations. Sheena Rogers (1995, 151) suggests that the data, though in conflict, are overall against compensation. Topper (2000, 119), by contrast, suggests that compensation is 'an experimentally confirmed fact'. He leans almost exclusively on Rosinski's work. Though he mentions Halloran, Rogers, Cutting, and Busey in the footnotes, he does not point out that these papers call compensation into question.

[3] I owe this reference to Sheena Rogers' (1995) excellent review of literature on picture perception. The one frustrating aspect of that review is that it does not mention the specific example that seems most in favor of compensation, viz. the picture of another picture from an oblique angle. I have not found much research on those stimuli, either, with the exception of Koenderink et al. (2004), mentioned below. It is worth noting that Cutting (1988) comes out in favor of compensation for still pictures, following up on results by Goldstein (1979, 1987). In cinema, which was the focus of Cutting (1987), the picture is viewed from a relatively great distance, and information about its orientation is difficult to discern.

Some of Jan Koenderink et al.'s (2004) results test the third pre-
diction, that interpretations should be distorted in the presence of
conflicting information. They found little evidence for compen-
sation even when the conflicting information involves 45 degree
vertical obliques. In this study, subjects observed a computer moni-
tor on which was depicted a picture in an obvious frame on a
brick wall. Subjects viewed the monitor head-on and at a 45
degree angle and were always aware of the monitor's orientation.
The image on the monitor was presented either head-on, in a
plane parallel to the monitor's surface, or at a 45 degree verti-
cal oblique. In the latter case, the picture on the monitor is a
picture of the wall, picture frame, and picture as seen from a
45 degree angle.[4] There was no significant difference in subjects'
interpretations of the oblique presentation while viewing the moni-
tor head-on and the head-on presentation viewing the monitor
obliquely. In both cases, the figure was seen as somewhat slenderer
than the head-on presentation viewed with the monitor head-on,
and the oblique presentation viewed obliquely was, unsurprisingly,
the most compressed of all. Though slightly compressed, it did not
seem distorted, which suggests that conflicting orientation informa-
tion does not thwart our interpretations of the picture, contrary to
Pirenne's hypothesis.

The fact remains that Pirenne's (1970) Nixon example seems skewed
irrespective of the view one takes of it. Koenderink's experiment does
not make use of pictures viewed at horizontal obliques or angles
with both vertical and horizontal components. The experiment is
therefore far from conclusive. The foregoing has also ignored a wealth
of data about how interpretations change as one's distance from the
picture plane changes. Those data conflict much as those for oblique
angles do. Yang and Kubovy (1999) retreat from Kubovy's (1986)
strongest claims favoring compensation because of data concerning
interpretations at different distances from the picture plane. Also, there
seem to be no studies of how interpretations change with distance

[4] There were other, less relevant conditions as well, including one in which the image
on the monitor was distorted so when the monitor is viewed obliquely, the picture presents
the same retinal image as an undistorted version seen head-on.

when pictures are viewed obliquely. There is clearly much more work to be done figuring out how we perceive pictures. For now, the important point is that though there is some support for the compensation hypothesis, it is far from obvious that we compensate. There are data that strongly suggest we do not, and this fits with the current proposal.[5]

Pictures are viewpoint-independent instances of their bare bones contents. So, we have perceptual access to their bear bones content irrespective of the view we take on the picture and independently of whether we compensate for such oblique views. Following Gombrich (1961), the first point made above was that we flesh out pictures' bare bones as we do because some fleshed out contents are more perceptually salient than others. Perceptual salience depends on our recognitional abilities and the concepts we have ready to deploy. The data, plus the account just adumbrated, suggest a way of using that point as part of the story about viewpoint-independence. We flesh out pictures' contents consistently across relatively small oblique angles because the perceptual salience of a given fleshing out does not change as our viewpoint changes. This is a way of unpacking Cutting's (1987) and Busey et al.'s (1990) suggestion that at these small angles there is no need for compensation. In fact the only way in which interpretations change at these small angles is that depicted objects seem to be compressed, or thinned out. Rogers (1995, 138) in fact points out a claim of Gombrich's from *Art and Illusion* (1961, 144): 'if trees appear taller and narrower, and even persons somewhat slimmer, well there are such trees and such persons'. When seen obliquely, the picture occupies a smaller horizontal visual angle. This compression renders a slimmer fleshed out content perceptually salient, but only because we have recognitional abilities and concepts for such slim things. Now, as the angle increases, perhaps in an odd direction, the fleshing out that seems perceptually obvious

[5] Why have philosophers seemed so sure that some form of compensation must be at work given that the psychological data are conflicted at best? Two of the most accessible books by psychologists that address the relevance of their data to art *per se* are Pirenne's (1970) and Kubovy's (1986). Both of them support compensation. For this reason, the close tie between philosophy of pictorial representation and aesthetics may have skewed philosophical opinion adversely.

from fairly frontal angles gets trumped by other fleshings-out. These alternative fleshings-out are, on the current account, consistent with the picture's bare bones content, though they may not comport well with what we usually take things in the world to be like. That is, the fleshings-out that are perceptually salient from oblique angles are odd contents compared to the more ordinary ones seen from head-on. This is a somewhat strange point. If one fleshed out content is perceptually salient, why wouldn't it remain so even at extreme angles when, by hypothesis, it is in virtue of bare bones content that we flesh out pictorial content in the way that we do? This is an important piece of the puzzle, since it shows how the present account accommodates both the consistency of interpretation at small angles and the aberrant ones at large angles. The easiest way to answer the question is to take a look at anamorphic pictures, which seem quite odd viewed head-on, though rather ordinary when viewed obliquely.

Anamorphosis

Pictures made at extremely oblique angles and then viewed at ordinary angles are often very difficult, if not impossible, to interpret. Anamorphosis thwarts interpretation. This is a rather well known phenomenon, but it raises trouble for the account of how pictures make their bare bones content available to us. Bare bones content is all that we require to flesh out a picture. We get bare bones content by viewing a picture from any angle we choose. Anamorphic pictures have ordinary and perceptually salient fleshed out contents, but they often are unintelligible when viewed head-on. This is not what one would expect.

There are many kinds of anamorphosis, but the one that matters here is quite simple. When a picture in linear perspective is made at an extremely oblique angle to the center of projection, the result is a stretched out, often unintelligible mess. (See Figure 9.1.) Such objects count as pictures in LP just as much as the more common ones we are familiar with. What seems odd about such anamorphic pictures is that they have bare bones contents identical to those of more ordinary pictures in LP. Thus, the anamorphic pictures have fleshed

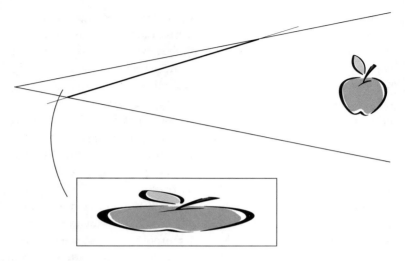

Figure 9.1 Anamorphosis

out contents that are just as (un)ordinary as the fleshed out contents of the non-anamorphic pictures.[6] Despite having such ordinary fleshed out contents, we do not flesh out their contents in this manner when we view them head-on. This is a problem because the account so far suggests that we find the most perceptually salient fleshed out content when viewing a picture. That certainly seems not to happen with anamorphic pictures.

The previous section claims that we flesh out pictures differently depending on viewpoint, even though all fleshings-out are consistent with the picture's bare bones content. This leaves us with two questions about anamorphosis. First, do we flesh out an anamorphic picture when seen head-on in a way that is consistent with its bare bones content? Second, why do we forego a seemingly perceptually salient fleshing out when an anamorphic picture is seen head-on in favor of something else?

The answer to the first question seems to be 'yes'. To the extent that the anamorphosis is so severe as to resist much interpretation at all, the

[6] Other kinds of anamorphosis include distortions that are righted when the picture is viewed in a cylindrical or hemispherical mirror, for example. Those kinds of anamorphosis are not relevant here.

picture seems like an abstraction. If forced to interpret the picture, we will say that it depicts a set of odd shapes at indeterminate distances and orientations. The shapes of the picture surface itself determine just what shapes are depicted, so this forced fleshing out will be consistent with the bare bones content of the picture. When the anamorphosis is not so severe, we often take the picture to depict an oddly stretched or distorted version of the scene. But this stretched interpretation, too, is perfectly consistent with the bare bones content of the picture. A suitably stretched and oriented scene would result in precisely the picture in question. As pointed out above, anamorphic pictures are usually made by orienting the picture plane at an extremely oblique angle to the center of projection. Another way to make anamorphic pictures, however, is to make an ordinary picture of a stretched and oddly positioned scene. To the extent that we interpret anamorphic pictures in that way, we interpret them consistently with their bare bones contents.

Turning to the second question, even though we may flesh out the contents of anamorphic pictures consistently with their bare bones contents, why are we unable to flesh them out to their more *ordinary* contents when we view them head-on? The way in which we flesh out bare bones content is supposed to track the perceptually salient possible contents of the picture. We do not flesh out an Ames chair picture to a disjointed collection of lines because we have no real concept of such a thing to deploy perceptually. Anamorphic pictures have perfectly good, ordinary fleshed out contents, but we nevertheless regard the picture as an abstraction or as a picture of some odd, stretched out scene.

Why does this happen? Fleshing out involves the recognitional deployment of concepts, specifically visual ones in the cases at hand, which is why it is so closely connected with the intuitive notion of seeing-in. Now, one thing about seeing is that under all but exceptional circumstances, we see what is in front of us. To the extent that our recognitional abilities are keyed to the presence of certain things in our environment, they are keyed to their presence in the central portion of the visual field. We can always put an object in the environment in the center of our visual field—'foveate' on the object—and this is exactly what we do when we want to know what

something is since the spatial resolution of our vision is best under those circumstances. When we look at anamorphic pictures *obliquely*, they present bare bones content in such a way that it can be fleshed out to an ordinary scene *right in front of us*. That is, the ordinary fleshing out is to a scene right before one's eyes. When we look at the picture head-on, it is possible to flesh it out to an ordinary scene, but one that is out of our field of vision. The picture seen head-on shares perspective invariants with an ordinary scene that is well off to one side. If fleshing out the bare bones content of a picture essentially involves perceptual concepts keyed to the presence of things in our visual field, it is plausible that these concepts can only be deployed when viewing the picture from certain angles. Another way of putting this is that perceptual salience involves what is right in front of us, which is why seemingly ordinary interpretations of anamorphic pictures are unavailable when the pictures are viewed head-on. None of this suggests that bare bones content fails to undergird our fleshing out of pictures' contents. The point is just that the way in which it is fleshed out depends on the point from which the picture is viewed.

Think of how we interpret the anamorphic picture, if forced to interpret it at all, while looking at it head-on. We do not see a man in the picture, just outside of our field of view, we see a rather abstract configuration of shapes, at perhaps indeterminate distances and orientations, but we see these things as being right in front of us. This is one thing that is right about the window and mirror metaphors discussed in the introduction. We see things through windows and we see things, in some sense, in mirrors, but the things seen are seen as being right in front of the viewer. The interpretation of an anamorphic picture in terms of odd shapes wins out over the reading of the picture when seen obliquely because the oblique reading cannot be perceptually salient when the picture is viewed head-on. Whatever the perceptual concepts are that we deploy in the normal reading, we do not use them when viewing the anamorphic picture head-on because this would result in our seeing something out of our field of view, which never happens. (See Figure 9.2.)

These considerations shed light on Hopkins' (1998) insistence that pictures must depict from points of view, and that any respectable

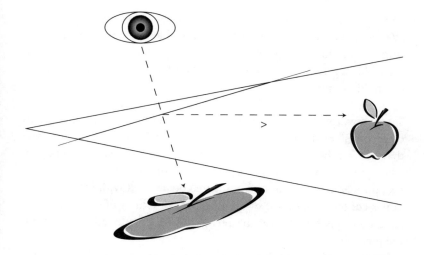

Figure 9.2 We flesh out the content of an anamorphic picture to a stretched out scene because that is the kind of scene that could have resulted in the picture from head-on rather than oblique to one's line of sight. When the picture is viewed obliquely, however, the most plausible fleshing out is to a rather ordinary content

theory of depiction must account for this fact.[7] It is not at all obvious that this is true of pictures generally, even on a pre-theoretic, intuitive understanding of what pictures are. Some pictures seem to depict from a couple of viewpoints (Lopes 1996, 126), and some depict from no point of view at all, such as pictures in orthogonal projection. In the context of Part I, of course, it is false that pictures must depict from a point of view. Some pictures are not even perceptible, let alone visual, and point of view seems like a particularly visual notion, though there are analogs of it in both the auditory and the tactile cases. The question to address is why certain visual pictures, in particular those in linear perspective, tend to depict from a point of view. To the extent that this explanation of anamorphosis is correct, we also have

[7] This is the second of Hopkins' six explananda mentioned at the end of Chapter 5. There we saw that my account accommodates revised versions of his first and third explananda and avoids the fourth altogether. The next chapter shows that my account has something to say about the fifth and sixth explananda too.

an explanation of why point of view is so important for such pictures. We flesh out the content to something that we could see right in front of us, and even when there is a perfectly ordinary fleshing out available, we skip it if it would put the object of the picture out of our field of view.

To review, four points have been made about the fleshed out contents of pictures. First, we flesh out the contents of pictures in the way that we do because certain fleshed out contents are perceptually salient while others are not, given the picture's bare bones content. Indefinitely many fleshings-out square equally well with pictures' bare bones contents, but most of these are not the kinds of scenes that we have concepts for that can be recognitionally deployed upon seeing the picture.

Second, fleshing out the contents of pictures by deploying concepts recognitionally explains how fleshed out contents make explicit non-commitments and conflicting commitments.

Third, we are reasonably good at fleshing out the content of a picture independently of the viewpoint we take on the picture. This results from pictures in LP being viewpoint-independent instances of their bare bones content. In normal cases, we do not have to compensate for anything to flesh out the content of a picture when it is viewed obliquely.

Fourth, anamorphic pictures are odd, but not that odd. Despite the relative viewpoint invariance of our access to the fleshed out contents of pictures, we fail to interpret anamorphic pictures as having normal fleshed out contents when seen head-on. That is to say, the perceptual concepts that we succeed in using when we view the picture obliquely fail to be engaged when we view it head-on. This is what we should expect, given that our perceptual concepts are keyed to things we see head-on. When viewed head-on we take the anamorphic picture to be an abstraction or a picture of a stretched version of the content we take it to have when viewed obliquely. This assignment of content is consistent both with the bare bones content of the picture, and with what one might see head-on, rather than out of one's field of view.

The last two chapters have discussed the perception of pictures quite a bit, and this raises the question of where the account on offer

here stands with respect to perceptual accounts of depiction. The next chapter shows that the account offered so far (1) has natural affinities with the recognitional view of picture perception (Schier 1986, Lopes 1996) and (2) uncovers an unnoticed connection between it and the experienced resemblance view (Hopkins 1995, 1998). After that, Part III justifies the somewhat narrow focus of Part II on linear perspective by providing an account of pictorial realism that makes the focus make sense.

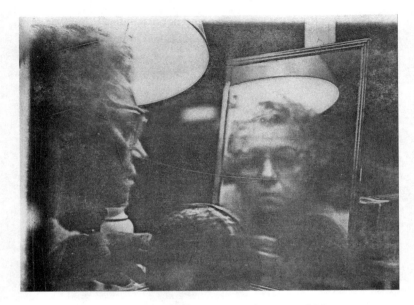

Illustration 10 Sonia Landy Sheridan, *Sonia with Lamp and Mirror*, 1977. Hood Museum of Art, Dartmouth College, Hanover, New Hampshire; gift of the artist. © Sonia Landy Sheridan

10

Perceiving Pictures

Where do the previous chapters' results leave us with respect to current perceptual accounts of depiction? This chapter bridges some of the gap between two popular accounts of picture perception: the recognition view supported by Flint Schier (1986) and Dominic Lopes (1996) and the experienced resemblance view supported by Robert Hopkins (1995, 1998).

Chapter 9 claims that pictures lead to the deployment of concepts for things other than pictures: bowls, toasters, fire engines, and archbishops. This helps explain why we flesh out the contents of pictures as we do. The recognition view has it that pictures invoke our perceptual ability to recognize their objects under different conditions. Pictures form a class of objects that exploits and perhaps extends our abilities to recognize familiar objects.

Hopkins' experienced resemblance account has it that pictures are experienced as resembling their objects in outline shape. Outline shape turns out to be a good way to characterize some features of bare bones content. Since many pictures do resemble their objects in outline shape, on the account offered here, Hopkins may be right to locate experienced resemblance as key to understanding picture perception.

According to the recognition view, any experienced resemblance between a picture and what it depicts follows from the recognition of a picture's object. 'Our experiencing pictures as of what they represent is at least in part a consequence of our grasp of their contents. Rather than explaining depiction, pictorial experience needs to be explained by it' (Lopes 1996, 175). By contrast, Hopkins hopes to account for recognition in terms of experienced resemblance.

There is a danger of landing in the dreaded chicken-and-egg dialectic here, but for perceptual accounts of depiction answering this question is the key to understanding pictorial representation. This debate is rather less dramatic in the present context. We already have an account of what kinds of representational systems are pictorial, and once we have philosophically and scientifically respectable accounts of experience, perceptual representation, and recognition on the table we could answer the chicken-and-egg problem. In that sense, the central debate among perceptual theorists no longer rests on issues specific to depiction.

The last two chapters are more sympathetic to recognition than to experienced resemblance. The problem of pictorial content is in part the problem of fleshing out, which requires deploying concepts recognitionally but not experiencing resemblance. Since outline shape and our perception of it, however, are central to the account of fleshing out, there is room for Hopkins here as well. Without hoping for reconciliation, part of the point of this chapter is to show how the gap between these competing views can be partially bridged.

Recognition

Schier and Lopes claim that what makes a picture a picture *of Xs* is that it invokes our perceptual abilities to recognize Xs. Let's say that we have the ability to recognize fire engines. This means that certain perceptual episodes, which can differ substantially from one another, will result in our tending to believe that there are fire engines present. Under some conditions we can see a fire engine, but not recognize it because it is too obscured by other objects, the lighting is bad, there are odd lenses interfering with our view of the truck, and so on. For the most part, we can recognize fire engines from just about whatever viewpoint we take on them and under many lighting conditions. We can also recognize them when partly or even mostly obscured by other objects.

Schier's claim is that some colored surfaces engage the ability to recognize fire engines. 'If S depicts O that is because an ability to recognize O could be enough, given an initiation into the relevant symbol system, to explain P's getting his interpretation of S right'

(Schier 1986, 49). It may be that we need training with a given system of marking planes with colors and lines in order for our recognitional concept of a fire engine to be so triggered. Once the training is in place, however, we are able to interpret indefinitely many pictures within that system, as long as we are able independently to recognize their objects.

A system of representation is iconic just if once someone has interpreted any arbitrary member of it, they can proceed to interpret any other member of the system, provided only that they are able to recognize the object represented. (Schier 1986, 44)

Schier (1986, 43) calls this feature of pictorial systems 'natural generativity'. Unlike languages, in which the ability successfully to interpret a sentence has few implications for success with other sentences, success with one picture brings along the ability to interpret arbitrarily many other pictures. The only constraint is that one already has in place the ability to recognize the range of objects depicted. With these abilities ready, learning how to deploy them and recognize an object in a given picture results in competence at recognizing other objects in other pictures.

Lopes' view is similar to Schier's:

A picture basically depicts a property or kind of object F if and only if it embodies aspectual information derived from Fs on the basis of which a suitable perceiver is able to recognize it as an F. (Lopes 1996, 152)

The *aspect* under which an object is represented is just the set of properties to which the representation in question commits and explicitly non-commits, as discussed in Chapter 7. For Lopes, what makes systems of depiction different from one another is that they present their objects under different kinds of aspects, i.e. they characteristically represent their objects as having certain 'combinations of properties' (Lopes 1996, 146). A linear perspective picture of a fire engine presents it as having a certain set of spatial and color properties, while an orthogonal projection presents it as having some other set.

Lopes never quite explains what 'embodying' information is, as distinct from carrying information. To embody information is not,

however, to carry information, since the latter involves lawful correlations between instantiations of properties. Some pictures, especially photographs, may very well carry information, but many—pictures of dragons, for example—will not.[1] Chapters 8 and 9 offer some clarification of what embodying information could be. Pictures *embody* their bare bones content in that they instantiate it, and our access to it determines how we can flesh a picture out. The tight link between transparency and mimesis worked out in Chapter 4 ensures that pictures share features with what they depict, and that these shared features are relevant to interpreting pictures. Pictures embody the skeletal commitments that provide the frame upon which their fleshed out contents, including explicit non-commitments, must build.

Making a perceiver *suitable* may involve training, familiarity with the system, and a host of recognitional abilities. Lopes unpacks suitability, and thus eliminates the term from his definition of basic depiction, in the following manner:

A picture basically depicts an F under pictorial aspect A if and only if it embodies information from some F on the basis of which someone who has a recognition capacity for Fs and who is able to recognize pictures under the dimensions of variation to which A belongs is able to recognize an F. (Lopes 1996, 153)

There is a lot going on in this definition. Recall that an aspect is just a set of properties that objects are characteristically represented as having. Lopes requires that we be able to recognize pictures under the dimensions of variation to which the aspect, A, belongs. We recognize pictures, that is, along dimensions of variation characteristic of their *contents*. We recognize 'a design *as* the features making up an aspect of [a picture's] subject' (Lopes 1996, 145 italics mine). Given that we can do this, and recognize Fs, a picture depicts an F just in case we deploy our concept of an F when we see the picture (presumably, under normal circumstances).[2]

[1] The best account of what it is for some state of affairs to carry information about another can be found in Fred Dretske's *Knowledge and the Flow of Information* (1981). Pictures generally do not carry information about what they represent.

[2] Schier (1986) does not require that the recognition of pictures' objects take place in virtue of the recognition of aspects, as Lopes (1996) does. This distinction makes Lopes'

How do we recognize pictures under dimensions of variation characteristic of their contents? It does not suffice to learn a 'design-content correlation' (Lopes 1996, 153) by rote, since that happens in language all the time. We learn to pair 'red' with redness and 'chicken' with being a chicken, which allows us to interpret 'red chicken'. We do not, however, recognize 'red' *as* red; we recognize it *as of* red or redness. Similarly, we do not recognize 'chicken' as a chicken. According to Lopes, given a picture that represents something as red we recognize the picture as red and so on for all of the other properties it represents its object as having. Given this collection of properties that we recognize the picture as having—the aspect under which the picture represents its object—the picture depicts a fine engine if that aspect is one under which we recognitionally deploy our concept of a fire engine.[3] In that case, we recognize the picture as a fire engine, in addition to recognizing it as red, boxy, metallic, of a certain shape, etc. Lopes does not require that we recognize the picture as having the design features that it actually has: the picture of the fire engine may not itself be red. All he requires is that the design features are recognized as features of a certain aspect, which will get us to recognize the picture's subject.

Just what design features can be recognized as what content features depends on the way in which we are built perceptually. It is not that our ability to recognize certain design-content correlations is fully innate, as such things can be learned, but our perceptual apparatuses constrain the kinds of design-content correlations we can

account much more amenable to my discussion of fleshing out than Schier's. Lopes requires aspect recognition and I require that access to the bare bones content of a picture is essential to its being fleshed out.

[3] I am rather uneasy with the use of the term 'recognition' here. To be sure, it is recognitional *abilities* that get us to see a fire engine in the picture, but to say that we recognize the picture as a fire engine grates against the success-laden use of 'recognize'. We only recognize something as an F if it is in fact an F. This is not a fundamental problem with Lopes' account, but it suggests that there is a better way of putting things in terms of genuine recognition. Perhaps something like 'recognize in' would work better. Since a fire engine is part of the content of the picture, we do succeed in recognizing it *in* a picture, even if we fail to recognize the picture as a fire engine. The terminology just marks the fact that the recognitional ability is deployed in a reliable way, and the fact that in a sense it is accurate to do so even though no genuine recognition takes place.

learn. Gombrich (1961) was fond of Constable's claim that pictures are experiments, investigations into how we can perceive the world. We generally cannot, before actually trying, know whether a certain scheme of pairing designs with contents is one that will lead to the deployment of the appropriate perceptual abilities. Artists like Constable experiment with the boundaries of this perceptual ability. Gombrich points out, for example, just how odd Constable's landscapes were taken to be, in part because they were green. Despite the fact that Constable, like those before him, was painting lush landscapes, the practice at the time privileged the use of yellows and browns to pick out green expanses. What struck so many as being odd about Constable's paintings was, somewhat ironically, their greenness, not the greenness of what they depicted. It was, in Lopes' terms, difficult to recognize Constable's green pictures as green in the content sense, and a bit jarring to recognize the picture itself as green.

To sum up this section, something like the recognitional deployment of concepts is relevant to fleshing out pictures' contents. Schier and Lopes realize that just what features of the environment trigger a recognitional ability for something can vary with time and training, and can be very difficult to articulate. This book claims that bare bones content triggers this recognitional ability. Fleshings-out of a picture's content are consistent with its bare bones, and this would be a minor miracle if the latter did not provide the materials for triggering the relevant concepts. Because bare bones content includes objects' outline shapes, however, the recognition view must tarry with outline shape in a more significant way than one may have thought.

Outline Shape

For Hopkins, pictures have the contents they do because we experience them as resembling their objects in outline shape: 'Something O is seen in a surface P iff P is experienced as resembling O in outline shape' (Hopkins 1998, 77). We experience a picture as resembling something in outline shape, which leads to the deployment of a concept of what the picture depicts.

Outline shape is a relational, spatial property.[4] Objects have outline shapes relative to points, so imagine an object and some point external to it. Project rays from the point in all directions. Some do not intersect the object at all, some pass through it, and some just catch a point on the object's surface as they pass by. The set of all rays that just touch the surface of an object without passing through it trace something like an outline of that object from that point.[5] They form a cone-like solid with its apex at the projection point. The surface of this cone may be rather irregularly shaped, depending on the shape of the object whose outline the rays trace. This solid angle subtended by these rays is an outline shape. Two objects share an outline shape from a given point if they both fit exactly into that solid angle.

Some interesting features of outline shapes are worth noting. First, outline shapes are not two-dimensional in any interesting sense. Both portions of planes and three-dimensional solids may fit without remainder into one of these cones. For this reason, pictures can genuinely share outline shapes with their objects regardless of whether those objects are two-dimensional or three-dimensional. Second, an object can have indefinitely many outline shapes, corresponding to the indefinitely many points from which rays are projected. A penny's outline shape, for example, differs depending on its orientation relative to a given point. Third, the fact that outline shape is relative to a point in no way implies that there is anything subjective about it. Outline shape is relative to points in space, not observers, though observers can occupy points in space from which objects have different outline shapes.

Fourth, outline shape is something we can perceive (Hopkins 1998, 59 ff.). Seen from an oblique angle, there is a sense in which a penny

[4] This paragraph and the next follow Hopkins (1998, ch. 3, section 3).

[5] Alberti expressed a similar idea in *On Painting*, though he does not develop the idea in the way that Hopkins does: 'Let us imagine the rays, like extended very fine threads gathered tightly in a bunch at one end . . . they are like a trunk of rays from which, like straight shoots, the rays are released and go out towards the surface in front of them. But there is a difference between these rays . . . for some reach to the outlines of surfaces and measure all their dimensions. Let us call these extrinsic rays, since they fly out to touch the outer parts of the surface' (Alberti 1435/1991, 40). The extrinsic rays are what together form the outline shape of the object from the projection point. Alberti never spoke of outline shape *per se*, but he gives us the tools for working out such a notion.

looks elliptical. This fact has bothered philosophers of perception for quite some time because there is a sense in which the penny also looks circular when seen obliquely. Certainly, nothing could be circular and elliptical at once, but it is also odd that it could look circular and elliptical at once. The sense datum theorists would say that the penny, from that viewing angle, results in an elliptically shaped sense datum, just as Moore's envelope results in differently shaped sense data depending on the perspective. Similarly, a picture of the penny from that viewpoint would itself be elliptical in the region corresponding to the penny. The sense datum theorists did not have a very promising theory of perception, so their explanation of this phenomenon is suspect. Those who wanted to replace the sense datum theory had to explain the sense in which the penny looks elliptical without appealing to shapes of sense data. Hopkins' outline shape could, perhaps, have done just that, and it is closely related to David Armstrong's proposal for handling the phenomenon.

In *Perception and the Physical World* (1961, 12–13), Armstrong argued that we have perceptual access to at least two shape properties when looking at an object: intrinsic shape and 'square shape'. Square shape—unfortunate as the terminology is—is the shape an object would project onto a screen interposed between a point and the object at right angles to a line connecting the object to the point.[6] The point in question is just a point in space, which could be a point of view, if a subject were to occupy it, but the notion of a square shape is a perfectly good objective, albeit relational notion of shape.

[O]bservers will be able to see the spatial relations that their own bodies have to the object perceived, and this means they will also be able to see what is the 'square' size and shape of the object relative to their own body . . . the 'square' shape will differ according to the angle from which the thing is being viewed. (Armstrong 1961, 13)

A penny has an elliptical square shape in the sense that it projects onto an elliptical portion of a screen between it and many points in space.

[6] Armstrong calls this shape a 'square' shape because he imagines the screen to have a grid on it, much like Alberti (1435/1991) recommended to artists who wanted to paint in perspective.

Likewise, a penny has an elliptical outline shape if the solid angle it subtends is like the solid angle an elliptical object would subtend seen head-on.

Square shapes and outline shapes are odd because they are objective, relational properties which can seem to be intrinsic and subjective. This intuition is what can lead an otherwise mild-mannered philosopher into the den of sense data. Berkeley's Ideas, for example, are candidates for the bearers of subjective, intrinsic properties since they depend for their existence on being perceived, though the properties they have are not relational but intrinsic, like shapes and colors. When we look at the penny obliquely, there is a sense in which it just looks elliptical. It doesn't look as though it would project an elliptical shape onto a screen or as though it fills a solid angle into which an ellipse would also fit, or what have you.

We fail to notice the objective, relational nature of such properties for two reasons. First, outline shapes and square shapes are rather difficult to see. We only see these relational properties when we occupy the point from which objects have them, which contrasts with many other spatial properties. We can, for example, see that the George Washington Bridge is closer to Columbus Circle than it is to the Empire State Building without being *at* any of those locations. Perhaps some artists develop the ability to see outline shapes and square shapes, as it were, from without. They can see what outline shape an object has from some point across the room. Objects don't usually seem to have such shape properties except from the point from which we *view* them, so it is likely that we will consider such properties essentially to involve subjects in some sense or other. This is an understandable intuition, but it is false, since this fact is just an artifact of how we are able to track such properties perceptually.

Second, because we always *occupy* the point from which an object has the outline shape or square shape we see, we cannot see the point with respect to which an object has such a shape. Outline shape seems intrinsic, not relational, because the way we manage to perceive it always renders one of the relata imperceptible. In a different context, Sydney Shoemaker (1994, 1996) points out that we often misjudge relational properties because we leave our own locations out of the mix. For example, we take being to the right of to be a two-place

relation even though it is a relation between two objects given another point in space and a direction. Moreover, the expression 'to the right of' only takes two arguments, with the third suppressed. It seems as though we are better at noticing relations like to the right of even if we do not occupy the point from which the judgment is made than we are at perceiving outline shape from without.

Hopkins, like Armstrong, is trying to answer a challenge in the philosophy of perception: how is it that objects seem to have two shapes from any given point of view? This is only a problem in the theory of depiction if one's account appeals to the phenomenon. Both Hopkins' view and the view on offer here view do this, albeit for different reasons. For Hopkins, experienced resemblance between a picture and some other object makes the picture about that object. We deploy a concept of what a picture is about on the basis of seeing it, and he thinks that the explanation of this is that we experience the picture as resembling its object in outline shape. He therefore needs to convince us that we perceive outline shape. On the current account, perceptual access to bare bones content allows us to flesh out the contents of pictures in the way that we do and, as we will see, outline shape is closely related to bare bones content. This does not require that we experience a picture as resembling its object. We may do so, but to the extent that we do, it is in the service of fleshing out the contents of pictures. That is, it is in the service of the recognitional deployment of concepts for pictures' fleshed out contents.

The relation between outline shape and perspective invariance is somewhat tricky. On the one hand, outline shape is more specific than perspective invariance. A picture is a viewpoint-independent instance of its perspective invariants, but the outline shapes of regions of its surface change with viewpoint. On the other hand, any pictures that share perspective invariants share outline shapes from some point of view. Viewed head-on, pictures alike in respect of perspective invariants can differ in outline shape, but one can always rotate the pictures with respect to one another so that they share outline shape from a given point. One picture's being a perspective transformation of another amounts just to this. So outline shape, because it is defined in terms of cones of rays, much like a perspective projection, is intimately linked to bare bones content.

In the previous chapter, we saw that the way in which we flesh out a picture is sensitive not only to perspective invariants but to viewers' orientations with respect to the picture. The idea was that our recognitional capacities are keyed to things when they turn up right in front of us, which is why an anamorphic picture viewed head-on is not interpreted as having a normal content. Viewing normal pictures askew can have a similar result, while viewing anamorphic pictures from sharp angles results in rather ordinary fleshings-out. The present discussion helps to refine our understanding of this phenomenon: our recognitional abilities are cued to outline shape as well as perspective invariance. Viewed head-on, a picture in linear perspective has the same outline shape as its object viewed head-on. Viewed at extreme angles, the picture's outline shapes depart substantially from those of the ordinary scene when seen head-on, so we flesh out its content differently. Seen at more subtly oblique angles, the outline shapes, while different from the scene viewed head-on, still render the ordinary reading perceptually plausible. As noted in Chapter 9, this does not require compensation, since the aberrant readings at these mildly oblique angles are overridden by the perceptually salient ones.

Varieties of Priority

The intuitive appeal of both approaches sketched above can be traced to a phenomenon noticed by the sense datum theorists. Moore said that our experience is diaphanous because, though sense data were supposed to undergird all perceptual judgment, they do so unnoticed. Without making a special effort, we see right through our sense data to the world our perceptual judgment describes. Moore took the odd duality in shape perception to be but one road to noticing sense data, which were the only things of which we were immediately aware. Look at the envelope, and notice that it seems to be both rectangular and an odd quadrilateral shape. Armstrong shows that this duality can be explained even if we do not appeal to the shapes of sense data, since objects have relational shape properties that we perceive and that fit the bill for the odd properties cited by Moore and others in defense of sense data.

But the sense datum theorists are, as argued in Chapter 8, at their best when it is pictorial content they are discussing, not perception. When we look at pictures we often do not notice their bare bones contents, but are led directly to their fleshed out contents. This is the root, it seems, of Lopes' claim, cited earlier, that 'Our experiencing pictures as of what they represent is at least in part a consequence of our grasp of their contents. Rather than explaining depiction, pictorial experience needs to be explained by it' (Lopes 1996, 175). Conceptually or *psychologically* speaking, our access to pictures' fleshed out contents is prior to our access to their bare bones contents. Often we avoid bare bones content altogether in thinking about the pictures we see, and this is no doubt in part because we often do not even have concepts ready to hand for such things as projective invariants, outline shapes, or what have you. This is doubtless why it seems reasonable to begin explaining depiction by appealing to pictures' fleshed out contents.

Hopkins notices that there is something rather basic and low-level going on in our perception of pictures—which he explicates as experienced resemblance in outline shape—that explains why pictures have the contents that they do. Outline shape is hardly something we usually regard pictures or objects in general as having, but for Hopkins it is an experienced resemblance in that regard that gets us to deploy our concepts in the first place. Even the recognitional account must claim that there is something about the perception of basic and perhaps abstract features of pictures that gets us to deploy our perceptual concepts. It may not need to be an experienced resemblance that gets us to do this—which is a prime worry about Hopkins' account—but *something* along those lines must be going on. On the current view, access to these abstract features of pictures is precisely what, epistemically speaking, undergirds our ascription of fleshed out contents to pictures. Access to bare bones content is *epistemically*, though not psychologically or conceptually, prior to access to fleshed out content.

Overall, then, these competing perceptual accounts of depiction differ in focus. Lopes looks to the psychologically salient, fleshed out contents of pictures and explains them by appeal to the recognitional deployment of concepts. Hopkins hopes to unpack just what the basic mechanism is that allows us to flesh out pictures' contents in the way that we do. In that sense he focuses on the epistemically prior source

of our grasp of pictorial content. Perhaps neither Hopkins nor Lopes thinks of their views in these terms, but then again it is the machinery introduced herein that makes the comparison salient. The current view of fleshing out appeals to the deployment of recognitional abilities, and there is reason to suspect that such deployment is beholden to outline shape to some extent or other. Nothing in the current view, however, suggests that outline shape is important insofar as one experiences pictures *as resembling* their objects in outline shape. Perhaps psychological research will point to a connection between experienced resemblance and the deployment of recognitional abilities. If it does, then we will need to sort out just what that research says about the relation between these two accounts of picture perception.

Explaining Depiction? (Again)

The end of Chapter 5 reviewed the six features of pictorial representation that Hopkins thinks any reasonable theory must explain. Chapter 5 dealt with the first four, but left the last two:

(x5) General competence with depiction and knowledge of the appearance of O . . . suffice for the ability to interpret depiction of O.

(x6) General competence with depiction and knowledge of the appearance of O . . . are necessary for the ability to interpret depiction of O. (Hopkins 1998, 36)

Hopkins claims that experienced resemblance in outline shape explains (x5) and (x6), while the recognition view merely takes these explananda for granted. In the present context, both (x5) and (x6) are strictly speaking false, since a variety of things count structurally as pictures without being easily interpreted or even perceptible. If we focus on central cases of depiction and read 'the ability to interpret' as 'the ability to flesh out', however, then both of these claims are true on the current view and explained by it.

What does knowledge of the appearance of O consist of? First, one needs a concept of O. Second, one needs a *conception* of what O looks like. That is, one needs a conception of the properties that one is apt to perceive O as having. For example, we have a concept of fire

engines and a conception of fire engines as being metallic, red vehicles, with certain shapes, and so on. Presumably, having a conception of what something *looks like* entails having recognitional abilities for the features in question, if not for the object as well. So, we should expect that we can recognize redness, being metallic, having a certain shape, etc. General competence with depiction presumably amounts to familiarity with depiction as a means of representation, and perhaps some familiarity with particular depictions.

Why is all of this sufficient for being able to flesh out pictures' contents? First, pictures instantiate their bare bones contents. Second, we can perceive their bare bones contents. Third, fleshed out contents are consistent with bare bones contents, and it is on the basis of the latter that we flesh out in the way we do. So, bare bones content of a picture provides enough to our perceptual systems to elicit the deployment of concepts for things like fire engines and some of their properties. As long as we have such recognitional abilities, then, we are in a position to understand pictures. Pictures are considered special because of the uniquely perceptual nature of our access to their contents. On the current view, this results from the fact that pictures instantiate their bare bones contents, with which fleshed out contents are consistent. This gets us to mobilize our perceptual resources in recognizing fleshed out content. We do not need to learn what Lopes calls 'design-content correlations' by rote, the way we need to learn that the inscription 'fire engine' picks out fire engines.

On the other side of the coin, if we lacked a stock of recognitional abilities, life would be difficult for many reasons, but we would certainly not be in a position to flesh out pictures' contents. Without recognitional abilities, we would hardly be able to recognize features of the pictures themselves, let alone their fleshed out contents. For this reason, knowledge of the appearance of O is necessary, and not just sufficient, for understanding depictions of O.

Variety

Though it does not make the list of explananda, both Hopkins and Lopes are concerned to account for the variety of depiction. Many different kinds of colored surfaces can be experienced as resembling

other objects, just as many kinds of surface can provoke our recognitional abilities for other things. At the end of Part I, the structural account seemed problematic because it included some representational systems that are not intuitively pictorial. Pictures are not essentially visual, they do not essentially depict what can be seen, they do not need to depict from a point of view, and so on. We use audio pictures, on this view, almost as often as we use visual pictures. The challenge, then, was to show that, despite this uneasy inclusiveness, the account captures a special kind of representation that we can identify as pictorial. Part of answering that challenge is showing that the pictures we *can* see, the things we ordinarily regard as pictures, form a special perceptual kind. Hopefully Chapters 8 through 10 have convinced the reader of that.

There is, however, an apparently chauvinistic aspect to Part I, which reappears in Part II. Chapter 3 introduces transparency by using linear perspective as an example. It turns out that LP is not just an example, but one of a few central cases of depiction. Even though non-visual representations can be pictorial, among the visual ones, linear perspective seems special. It is not unique in satisfying the four structural constraints on being pictorial, since odd systems like oblique parallel projections and reverse perspective satisfy them quite well. LP takes pride of place in part because of how we can perceive representations in that system. Pictures in LP make their bare bones contents available in a viewpoint-independent manner, while many other pictorial systems do not. The variety of pictorial systems suggests that we need to broaden the account of pictorial content before it is to be convincing. Part III addresses this concern in the context of pictorial realism.

PART III

Realism and Variety

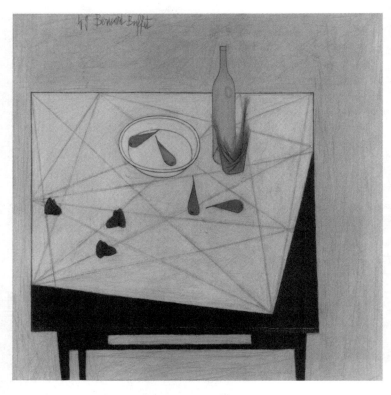

Illustration 11 Bernard Buffet, *Geometry*, 1949. Hood Museum of Art, Dartmouth College, Hanover, New Hampshire; gift of Julian J. and J. Jean Aberbach. © 2005 Artists Rights Society (ARS), New York/ADAGP, Paris Photography: Jeffrey Nintzel

11

Verity

A theory of depiction should say something about the variety of things that count as pictures and about what makes some of those things more realistic representations than others. These two problems are intimately related, even though they are strictly speaking independent. When accounting for the extension of the term 'picture' one invariably winds up including some cases that are, intuitively at least, not pictorial and excluding some intuitively pictorial representations. In the latter case the task is to explain away the intuitions in favor of the system or representation being pictorial. In the former, one needs to explain away intuitions to the effect that the system is not pictorial. One way to do this is to insist that though the system is pictorial, it is not a particularly *realistic* system of pictorial representation.

We saw in Chapter 1 that the set of syntactically dense, semantically dense, and relatively replete systems is much larger than what we ordinarily take to be the class of pictorial systems. Goodman (1976) addresses this problem by claiming that, while being a pictorial representation depends on satisfying his structural constraints, being a *realistic* picture depends on the familiarity of the system being used. Realistic representations are those that we are suitably comfortable with using. The plausibility of an account of depiction, therefore, can depend on the plausibility of one's account of pictorial realism. Since many do not agree that realism 'is a matter of habit', as Goodman (1976, 231) says it is, many doubt that density and repleteness capture the essence of pictorial representation. Irrealism thus serves as a home for a theory's misfits. Any good home must be both humane and secure: it is with good reason alone that systems are so consigned or set free. In this way, realism avoids being merely what Bill Wimsatt calls a 'wastebasket explanation', whose only motivation is clearing the clutter.

Realism is also a topic of interest in its own right, of course. The concept is doubtless a bit of a mongrel, and sorting out what makes its many uses alike and different might be fun. The hope here is to capture a couple of forms of realism and to relate them to claims about the variety of artifacts that count as pictures. One kind of realism, verity, applies most fruitfully *within* a system of representation, and not between systems, but it helps with handling the variety of depictive styles that do not constitute systems unto themselves. Verity also shows that two notions of realism are really just variations on a single theme. Realism is often taken to pick out the sense of verisimilitude some pictures can evoke regardless of what they happen to be pictures of, but realism also tracks the idea that some pictures *accurately* represent their objects. Both of these sorts of realism fall comfortably under verity. In fact, verity works so well that it undercuts much, though not all, of the motivation for an *inter*-systemic notion of realism. Chapter 12 discusses the nature and value of inter-systemic realism.

Variety

Chapter 5 shows that the structural account of depiction on offer here accommodates a rather vast variety of pictorial representational systems. Audio recordings, tactile pictures, and visual pictures in many kinds of projective systems, analog and digital, all count as pictures. They are all instances of the theoretically interesting structural kind of representation that Chapters 2–5 explicate. A vast array of imperceptible representations also, despite being rather useless as artifacts, meet the conditions for being pictorial. These pictorial systems relate systematically to other kinds of representations like diagrams, non-pictorial images, and languages along the dimensions of repleteness, sensitivity, richness, transparency, mimesis, and so on. This is the source of pictorial diversity, and with so many systems fitting under the tent, one wonders whether the problem is not including too few, but including too many.

Nevertheless, there is good reason to be worried that the account is overly chauvinistic. Specifically, in the visual case the focus has been squarely on projective systems, and linear perspective in particular. It seems possible that a pictorial system may not be projective.

And second, it seems as though many pictures fail to fit neatly into any system at all, transparent or otherwise. Pablo Picasso's *Old Guitarist* is not in linear perspective or parallel projection and it is doubtful that Picasso was trying to approximate such a system with his painting. Van Gogh's paintings of his room in Arles are neither in linear perspective nor a systematic approximation thereto. They are unsystematically uneven in ways that prohibit them from fitting into such a scheme, but they do thereby foreground features of that technique. Similarly, Bernard Buffet's *Geometry* has the look and feel of systematicity while stubbornly refusing systematization. These works are all pictures, however.

The focus on projection is largely harmless for visual pictures as long as it is understood in the right light. Projections are just a way of establishing systematic spatial relationships between pictures and what they depict. Different projections do this in different ways. Since visible pictures depict visible things, and spatial layout is a visible feature of scenes, pictures in any system will exhibit semantically significant spatial relationships to what they depict. Projections just try to capture those relations.

Now what of the thought that many pictures do not fit within any such system? Recalling the discussion from Part I, taken by itself a token representation can fit into indefinitely many representational systems. Some marks on paper can be an instance of an inscription or a picture of an inscription. This affects how we treat the representation. A small smudging of the marks results in a picture of a different, smudgy inscription. The marks treated as an inscription endure many more alterations. Leave your letter in the rain and up to a point it will say the same thing that it did before the soaking and despite the smudging, but not so for your watercolor painting of the letter. The moral of this story—and it is really Goodman's (1976) moral and story—is that whether something counts as a picture depends on the kind of representational system one fits it into. Treating a token as a picture means that you inherit commitments concerning its syntactic and semantic identity. None of this dispels the question posed at the beginning of the paragraph, but it reframes it a bit. Pictures that do not seem to fit into systems can be interpreted as members of such systems, but at the price of constraints on what they are about. It

seems as if this is a price that we are all willing to pay, at least very often.

To get a feel for why we do seem to interpret these representations as members of projective schemes, consider Picasso's *Old Guitarist*. It depicts a man playing a guitar, but the man is particularly, rather unrealistically, emaciated, with particularly long limbs that are rather unnaturally folded up. Van Gogh depicts his room in Arles as being rather oddly shaped. The floor seems to slope, the bed does not seem rectangular, and so on. A cubist portrait depicts what seems like a shattered complexion, and much of Matisse is notable for its odd use of color and the indeterminate, childlike borders between things. Buffet's painting is flatter than a Cezanne and the obscure lines along the table recall Renaissance tiled floors without suggesting depth. When we interpret these paintings in this way—and we do, although that's not *all* that we do—we are interpreting them as belonging to pictorial schemes of a rather familiar sort. A linear perspectival projection, for example, from an exceedingly thin, long-limbed, folded man would result in Picasso's *Old Guitarist*. An oddly shaped and colored room would result in van Gogh's portrait via such a projection, and a cubist world is a rather fractured world indeed. It makes sense to claim that we fit these representations into pictorial schemes because of the way we are apt to interpret them. This is true even if the artists did not self-consciously decide to work within a given system of interpretation for the pictures. If we fit these odd representations into something approximating a linear perspectival interpretive scheme, the results are depictions of rather unrealistic states of affairs. This notion of 'unrealistic states of affairs' needs unpacking, which it will get in the next section.

In setting the stage it is crucial to note another fairly convincing way in which one can interpret these odd representations. On this view, the Picasso belongs to a different kind of representational *system* than, for example, pictures in linear perspective or parallel projection. The content of the Picasso is a man playing a guitar. It is not an unnaturally thin, folded, or emaciated man, but an ordinary, quite vanilla instance of a man strumming along. What makes the Picasso interesting is not its content, *per se*, but the way in which the painting manages to have that content. Picasso blue period paintings have their own set of

'design-content correlations' (Lopes 1996, 153). The features of the painting that allow it to be about a vanilla guitar player are rather different from those in virtue of which a photograph depicts such a scene. According to this approach, the blue period paintings, with their characteristic design-content correlations, constitute a system of pictorial representation in their own right. An account of depiction needs to show how the particular way in which the blue period paintings manage to represent vanilla states of affairs is a *pictorial* way of representing vanilla states of affairs. Similarly, the van Gogh paintings—or perhaps just those painted from 1888—form their own system, alongside the cubist system(s), the Matisse system(s), and so on. Each of these artists and schools hit upon extraordinary ways of representing rather *ordinary* states of affairs. We can group these ways of representing into sets of stylistic systems. A theory of depiction must show how each of these systems, with its own rules for interpretation, is pictorial. Without doing so, the account fails to accommodate the requisite degree of pictorial variety and should therefore be rejected.

We shouldn't be too eager to treat stylistic distinctions as distinctions in systems of representation, however. There is this tendency, which Goodman (1976) rightly warned against, to think that objects, in and of themselves, are representations of certain sorts. Masaccio's *Trinity* is a good approximation to linear perspective, while Duccio's paintings are not. Normal photographs are in linear perspective, or something close enough, while photos taken with an anamorphic lens are not. This is true, in a sense. Masaccio's *Trinity* is a fairly good example of linear perspective, given some sense of what Masaccio was trying to depict. The fresco counts as a linear perspective rendering of Christ on the cross, framed by a certain set of columns and a ceiling with a certain concavity. If we have a representation *and* a specification of some content, then we can ask whether the representation depicts that content and whether it does so in a linear perspective system. It is easy to walk through an art gallery and point, after quick surface inspection, at the linear perspective pictures, the cubist pictures, the surrealist pictures, and so on. But that is not to say that it is merely features of the surface, the colors and shapes on the canvas, that determine what system of representation the paintings belong to. The Masaccio can be interpreted as belonging to a reverse perspective

system, but this has consequences for its interpretation. The marks themselves do not determine their representational system. It's how we interact with them that counts.

None of this suggests that we always fit flat planes into one standard pictorial system. On the one hand, we have a tendency to fit representations in many styles into a privileged set of pictorial systems and make judgments of realism within those systems. On the other, we often treat different pictures as belonging to different systems and make judgments of realism between the systems themselves. Black and white photos are not taken to depict things as being black and white, for example. We just treat them as belonging to a system that is silent concerning color. However, very often noticing how a picture must have been made—via anamorphic lenses, while in a cubist mood, etc.—does not trump the interpretations that result from treating the picture as if it belonged to a more ordinary system of representation. People in the anamorphic pictures seem stretched and the cubist subjects seem shattered. Once we recognize our tendency to fit many kinds of pictures into a single interpretive scheme, it opens up the possibility of accounting for realism *within* such a system and not between systems.

Realism as Verity

Within a system of representation, pictures are realistic when the situations that they depict are rather realistic, and they are not to the extent that the situations they reveal are unrealistic. Pictures depict situations in the sense that they have fleshed out contents rich with detail that include objects, their properties, and relations. Those situations are realistic when the things, properties, and relations in them comport well with our conception of what such things are like.

An account of realism must involve a picture's fleshed out content, which is usually rather rich and complex. Many concepts are deployed recognitionally as one investigates a picture. People, rocks, rooms, lions, tigers, and bears are parts of pictures' contents. So are qualities of those things. Brown, furry, metallic, fuzzy, matt, bright, yellow, bent, and burned, over, under, near, and far are ways in which a picture can depict its objects as being. Each of these objects, qualities,

and relations is the kind of thing that we notice perceptually, and we notice these things when we look at pictures.

Not only do we have concepts for these things and their qualities, we have *conceptions* of what those things are like. Bears are furry and not metallic. A burnt tree is not bright yellow, though a burning tree may be. Most things, clouds and kiwis excepted, are not fuzzy. Pictures get us to deploy concepts, and their deployment calls to mind a myriad of features included in our conception of what those recognized things are like. This is not to say that recognizing a bear requires recognizing properties that are constitutive of bearness. Our concept for bears may be simple, or atomistic, in that it is not composed of recognitional concepts of other things like furriness, bear-shapedness, and so on.[1] However, when we recognize bears—in pictures or in perception more generally—we also tend to notice some of their properties like their color, shape, and size.

Given all of this, we wind up with two things to compare once we come to know a picture's fleshed out content. First, we know what the picture depicts. And second, we have our conceptions of what it depicted. That is, we know what the picture says about its subject and we know what our conception of the subject is like. Bears are neither metallic nor bald—this is just something we know about bears—but it is possible for the fleshed out content of a picture to be a bald, metallic bear. Guitarists may be old, but they rarely exhibit the exaggerated proportions and composure of Picasso's. Van Gogh may have depicted a bedroom and its standard accoutrements, but we also know that rooms and furniture are not standardly shaped in the way that his portrait suggests. This contrast holds for anything of which we have a conception, be it a particular like the Parthenon, a kind, like ancient Greek ruins, or a property like being a mottled off-white color. Often a cartoon can depict furriness, insofar as it gets us to recognize that the thing depicted is furry, but it does so in such a way as to conflict with our conception of furriness, which is a property, not an object. Perhaps just a few strokes of the pen indicating hairs

[1] For the distinction between atomistic and complex concepts, see Fodor (1990). The properties we perceptually register that lead to the recognitional deployment of a concept are those that, in Fodor's terms, 'sustain' the lawful connection between our concept of a bear, say, and bears.

are what get us to recognize furriness, even though furriness is not generally constituted by a few hairs scattered about. At this point, we have the tools to explicate pictorial realism as a kind of verity.

Within a given system, a picture *realistically* depicts something as being *q* for some observer if (a) it depicts its object as being *q* and (b) some other quality that the fleshed out content of the picture ascribes to this thing matches the qualities included in the observer's perceptual conception of things that are *q*.

Within a given system, a picture *unrealistically* depicts something as being *q* for some observer if (a) it depicts its object as being *q* but (b) some other quality that the fleshed out content of the picture ascribes to this thing is not included in the observer's perceptual conception of things that are *q*.

How does a perceptual conception depart from an ordinary conception? Since visible pictures depict visible states of affairs, judgments of realism are made with respect to those properties in one's conception of an object that one can perceive it as having. We can leave somewhat open the question of just what is included in a perceptual conception of an object. It is reasonable, however, to include not just a list of properties one could perceive an object to have, but also collections thereof that one is apt to perceive an object as having all at once. That is, it is not part of our perceptual conception of most objects that we can see every patch of their surfaces at once. Seeing someone in profile usually requires that we cannot see half of her face. To the extent that perceptual states seem to provide access to suites of objects' properties, such collections are included in our perceptual conceptions of them. This does not presuppose that all of the properties included in a picture's fleshed out content are strictly speaking perceptible properties. We cannot see archbishop-ness in the sense that being an archbishop requires standing in the right relation to the proper church authorities. A picture can depict something as being an archbishop if its bare bones content triggers a recognitional deployment of our concept thereof. The realism of this representation depends, however, on the perceptible features we associate with archbishops: jewelry, tattoos, clothing, etc.

Some more clarifications help to flesh out the idea of realism as verity. First, the definitions allow that a picture can be both realistic and unrealistic. One could depict a tomato as having both properties that match well with our conception of it and properties that we usually do not associate with it. A color reversed image depicts tomatoes as having unrealistic colors but realistic shapes, while anamorphic pictures distort shape, leaving color intact. Second, we can say that within a given system, a picture is realistic *simpliciter* when it realistically depicts something and it does not unrealistically depict anything. Perhaps few pictures are realistic *simpliciter*. Third, we tend to *call* a picture a realistic depiction of some object when it is both realistic enough—i.e. with respect to enough properties in our perceptual conception of the object—and not too unrealistic. So, pictures do not need to be realistic *simpliciter* in order for us to *call* them 'realistic'. Fourth, pictures can at least in theory fail to be either realistic or unrealistic if they depict something as being *q* but do not depict it as having any properties that are in or not within our perceptual conception of things that are *q*. Robert Hopkins (1998) thinks that in order to depict something as being *q*, a picture must represent it as having at least some of the properties we conceive of such things as having. This certainly seems true in many cases, but it is unlikely to be true across the board, and Hopkins does not claim that it is. If the claim holds generally, though, then all pictures are realistic in some sense. Fifth, verity says nothing about how *many* properties a picture represents its object as having, so it remains possible that another kind of pictorial realism that tracks the relative informativeness of pictures awaits explication. That will have to wait until the next chapter. And sixth, since verity depends on truth to one's perceptual conceptions of things and since perceptual conceptions can vary between subjects and over time, whether a representation is (un)realistic will vary that way as well. This seems exactly right. After all, our perceptual conceptions, just like conceptions of things generally, should aim at the truth of the matter, so though there will be variety, things will not vary willy-nilly. There will be occasion to discuss this point in the last section.

What of comparative judgments of realism, to the effect that one representation is more realistic than another? This is complicated, but not in ways that seem to raise deep philosophical puzzles. It is easy

to compare two pictures of corvettes with respect to realism because we have one perceptual conception to which both are beholden. The picture that is realistic with respect to more of the properties in our perceptual conception of a corvette is the more realistic picture. Realism and irrealism come apart on this account, however, so one may also turn out to be more *un*realistic than the other. Both of these judgments seem relevant to our overall comparative assessment of a picture's realism, but just to what extent they do, and whether they do so consistently across pictures and contexts of viewing, is hard to say. Pictures of different things submit to the same kinds of comparison, though with respect to properties common to our conceptions of each of the things depicted. On the present account, such comparative judgments are rather complex, but this seems right. Such judgments *are* complicated, and when we discuss a picture's realism, we are more apt to discuss respects in which a picture is realistic than to compare two pictures with respect to realism overall. Again, there is likely another kind of realism that tracks the informativeness of systems of representation. This sense may capture, for example, the way in which cartoons are less realistic than photographs, but it does not do justice to the judgments that are made within a system of interpretation, like the ones we have been discussing here.

Flint Schier (1986) proposed a notion of pictorial realism that is related to verity. He claimed that 'a depiction is iconically realistic$_1$ when its subject has all the properties it is depicted as having' (1986, 176). This version of realism, like verity, does not say anything about how *many* properties a picture depicts its object as having. The point is that in realistic depictions things are depicted as having only those properties they really have. Schier's account is weak, though, because of the way it focuses on truth. A picture is realistic just in case there is some particular that has all of the properties the picture says it has. Or, if there is some particular that the picture is supposed to depict, it is realistic just in case that particular has all the properties the picture says it has (Schier 1986, 177). There at least seem to be realistic and unrealistic depictions of dragons even though there are no dragons to depict. For Schier these pictures are not realistic in the above sense. The only sense in which they are or are not realistic is that some of them represent dragons as having *many* properties while others do

not (Schier 1986, 176–7). To the extent that a picture of a dragon represents it as having a lot of properties that picture is realistic$_2$, but no picture of a dragon can truthfully represent dragons (there are none), so no picture of a dragon is realistic$_1$. There is a place for something like Schier's realism$_2$ in a full account of realism, but the next section will show why the motivation for it is not that pictures cannot be truthful to dragons because there are none. Verity concerns truth to our perceptual conceptions of things, dragons included, and not truth to the world represented. The next chapter will discuss proposals like realism$_2$ in some detail.

Though there are many kinds of realism, verity captures a central one. A depiction is realistic to the extent that it depicts things as being the way we generally take them to be. It is unrealistic to the extent that it depicts things as being different from how we take them to be; hence the name 'verity'.

Worries About Verity

First, there seem to be at least a couple of kinds of realism that this notion conflates. To be specific, a photo-realist depiction of the Cheshire cat turns out to be, in a sense, an unrealistic depiction of a cat, but a Matisse painting of the Cheshire cat would also be unrealistic, though in a different sense. The photo has the verisimilitude mentioned at the outset of the chapter, even though it depicts a fantastic being while the Matisse-Cheshire lacks verisimilitude. Likewise, a blurry photo is unrealistic in a different way than an anamorphically stretched photo is. Verity, however, says that all of these unrealistic representations are unrealistic in the same sense, so it is not up to the task of capturing the richness of realism in representation.

This worry does not so much force a revision of the definition of realism, as it forces an explication of the varieties of verity. Pictures can be realistic or unrealistic in different respects because there are many features which pictures can represent objects as having. Some properties in our conception of a given object are properties peculiar to objects of that kind and some of them are peculiar to objects more generally speaking. Cats have pronounced whiskers and a specific body shape. They are furry, too, but this is something characteristic of

mammals in general, not just cats. Most objects—animal, vegetable, or mineral—have fairly definite boundaries and have surfaces that are rich with spatial detail. The photo-realist depiction of the Cheshire cat is an unrealistic depiction of a cat because it depicts the cat as having properties that are not in our conception of a cat, such as a big, grinning, human mouth and other physiognomic oddities. It is, however, a realistic representation of a human mouth, and a realistic representation of a furry body. It is a realistic representation of a body more generally, in that it has relatively definite boundaries between it and the rest of the world and it is represented with a wealth of spatial detail. The Matisse-Cheshire is an unrealistic depiction of a cat, but it is also an unrealistic depiction of a body more generally, of a mouth, of a furry body, and what have you.

The intuition, it seems, is that the Matisse-Cheshire is unrealistic in a more profound way than the photo-realist one is. In a sense, this is right. The former is unrealistic with respect to properties of objects *qua* material objects while the latter is only unrealistic with respect to cats *qua* cats, and it may very well be a realistic representation of the Cheshire cat. Blurry pictures differ from anamorphically stretched ones in this respect as well. The latter depict objects as having shapes not normally associated with them, but they do depict objects as having clear boundaries. Blurry pictures mess up the boundaries but manage to suggest rather normal shapes for objects, unless the blurry picture is also anamorphically stretched. John Currin's painting is interesting for a number of reasons, among which is the way in which he combines painting styles that differ in respect of their realism. What is a realistic depiction of a human being does not turn out to be a realistic depiction of a person's face in Currin's work.

A second worry is that the account classifies certain pictures as unrealistic when in fact they are not. There is a difference between a realistic picture of a dragon and an unrealistic picture of a dragon. In both cases, however, the account claims that the picture is unrealistic. Our conception of the world is of a world without dragons, after all, so any picture depicting dragons is *eo ipso* unrealistic.

There is certainly a sense in which any picture of a dragon is an unrealistic depiction of our *world*, since encounters with dragonish things are uncommon at best. It makes perfect sense, though, to

distinguish realistic depictions of dragons from unrealistic pictures of dragons, since we have a perceptual conception of dragons with which a picture can comport well or poorly. Dragons come with wings, they breathe fire, and look rather reptilian. They have the sharp boundaries and rich spatial detail characteristic of most physical objects, which makes them rather different from most ghosts. There are no ghosts, of course, but that doesn't prevent us from having a reasonably clear conception of them as being diaphanous and somewhat fuzzy. As mentioned earlier, it is an advantage of this approach to realism as verity over Schier's (1986) that it can say in what respects pictures of dragons or ghosts are (un)realistic.

The first two worries are worth considering, but it seems as though the intuitions behind them are captured best by this third objection. Intuitively at least, realism involves features of the representation itself as well as features of the representation's fleshed out content. That is, when we want to know whether a picture is realistic, we are asking whether there is something like the right relation between the picture and what the picture is about. Richard Wollheim's (1987) discussion of pictorial realism focuses on this comparison, informed by what he takes to be the twofold nature of picture perception. And this is why imitation and illusion make Goodman's (1976, 38) well-known i-list of features related to realism: 'Realistic representation, in brief, depends not on imitation, or illusion, or information, but upon inculcation.' To the extent that the canvas imitates its object, or gives the illusion of seeing the object, the painting is a realistic one. We cannot ignore content when assessing realism, but somehow the picture itself must also fit into the equation.[2] This is the sense in which the Matisse-Cheshire differs in its irrealism from the photo-realist Cheshire, and it is the sense in which realistic pictures of dragons are realistic. The definition of realism as verity says nothing much about the picture itself, focusing instead on the fleshed out content of the representation

[2] Some accounts of realism, such as Lopes (1995), actually focus on the content of representations as a measure of their realism. Lopes specifically compares the characteristic kinds of information that representations in such a system can carry with the purposes to which such representations are put. Hopkins (2003) suggests that what makes linear perspective special—though he avoids the term 'realism'—among representational systems is the amount of certain kinds of information that representations in the system can carry.

in relation to our conception of the content's elements. Painting, at least from the late nineteenth century onward, calls attention to the picture surface in a way that no photo-realist picture can (Danto 1997). Any account of realism should accommodate the differences between these cases but verity fails to do so.

This worry does not require refashioning the definition of realism as verity, but it calls for yet more unpacking. Recall the discussion of anamorphosis in Chapter 9. Our access to a picture's bare bones content is independent of the point from which we view the picture, but the way in which we flesh out its content is not. In particular, some anamorphic pictures like the famous portion of Holbein's *Ambassadors* are such that, when viewed head-on, they look rather more like splotches of paint than like skulls. Whether viewed head-on or sideways, we flesh out the picture's content in a fashion consistent with its bare bones. When it's all splotches, however, the fleshed out content we take the picture to have is more consistent with our perceptual conception of things like painted canvases than it is with our perceptual conception of most other kinds of object. Apply this thought to the Matisse-Cheshire. The bare bones content specifies colors and shapes that result in the recognitional deployment of our cat concept, but the features of the cat and grin are not those we usually associate with such things. For example, the colors are odd, the boundaries between the parts of the object are odd, and the spatial relations the parts bear to one another are odd. They are odd, that is, for a cat, and even for the Cheshire cat, so we have an unrealistic painting of the Cheshire cat. The features that the picture ascribes to the Cheshire cat are perfectly ordinary features of splotches of pigment, oil in a puddle, or the pattern of dirt on a wall, however. This draws our attention to the canvas itself when we are looking at the Matisse-Cheshire. In the photo-realist Cheshire, the properties unrealistically ascribed to a cat, such as a realistically rendered, human grin, are not features that fit well with our perceptual conception of a colored canvas, so we are less apt to notice the picture plane in its own right.

Many have praised Cézanne's work for drawing the viewer back from what the painting represents to the picture surface itself. It is easy to say that Cézanne depicts ordinary things in an extraordinary way.

The challenge is to explain how this happens. The current proposal is that we look at the Cézanne and come to know its fleshed out content, which is a three-dimensional world of ordinary things that bear mind-jarring spatial relations to one another. Since we have a very clear perceptual conception of such ordinary things—part of the value of Cézanne's work is its depiction of the ordinary—it is easy for us to compare that conception with what the picture tells us about it. As far as verity goes, the picture is rather unrealistic. However, odd features for fruit are quite ordinary features of colored planes and the like. So the Cézanne draws us out to the fruit, via the recognitional deployment of concepts, and then we are drawn back by the very same process. We recognize the depicted objects as having features incongruous with our perceptual conception of them and indeed of objects in general. These features are not, however, incongruous with our perceptual conception of patterns of pigment, so we are drawn to look at the painting in those terms as well. On this view, it is precisely an exploitation of the representational resources of depictive systems and not some other way of emphasizing non-representational features of the painting that draws us back to Cézanne's canvas.[3] Something similar happens with Buffet. Claiming that the painting is flat is saying something first and foremost about the way its objects are depicted. Tables seen obliquely, bowls, fruit, and the like, however, are not flat: what is flat is the picture plane. So features of the picture's content draw us back to the picture itself.

[3] This is close to Flint Schier's (1986, 174–5) view of what goes on when we look at Cézanne, but I cannot for the life of me figure out how this squares with his definition of realism₁ as truthfulness discussed above. For Schier (1986, 174), the point of such paintings is that the 'medium is the message', in that 'the main point of the picture is to draw attention to itself'. He thinks that the point of the subjects being simple, like fruit and trees, is to indicate to us that we should not focus on the content of the picture but the picture plane itself. This doesn't seem right, at least if we are to take most still life painting up until Cézanne—Chardin, for example—seriously. Schier admits that though 'How the painting depicts the object is more to the point than what the painting ascribes to the object . . . there is no suggestion that we can easily separate these matters . . . But of course to see the way the apples are depicted is precisely to see them as depicted in a certain way' (Schier 1986, 174–5). I think that the notion of realism that I have been working with explicates these matters in a more satisfying fashion than Schier does. The simplicity of the subjects in still life means that we have a rather robust perceptual conception of such things to compare with what the picture says about them, which can lead us back to the canvas via the route sketched above.

None of this requires revising the definition of realism as verity, but it brings to light how some subspecies of verity have different effects on the viewers of pictures than others. Since the effects of irrealism in these different respects explain what might seem to be two kinds of realism, we have no reason to insist that there are two kinds of realism here. Verity does a nice job of accommodating the intuition that judgments of realism involve comparing the picture itself to what it is about, without grounding pictorial realism in such comparisons.

Also, the way in which we are drawn back to the canvas relies on the fact that the canvas itself is an instance of the picture's bare bones content. That is, the features that a picture unrealistically ascribes to a cat are features that are realistically ascribed to the representation itself, in part *because* the representation itself is an instance of its own bare bones content. This explains, therefore, the role that the picture itself seems to play in our judgments of pictorial realism and why this seems unique to pictorial realism. We may not expect other kinds of representations, such as descriptions, to exhibit this range of effects when they unrealistically represent their objects, though descriptions can be unrealistic as far as verity goes. Well, sometimes linguistic representations can be unrealistic in this sense, as in Paul Auster's novels, but in general it is only pictures that exhibit it. The fact that irrealism, in the sense of verity, can shift our focus to the representation itself for pictures, but not generally for other kinds of representation, suggests why pictorial (ir)realism *per se* is aesthetically interesting and why philosophers care so much about it.

Revelatory Realism

Realism can be surprising. Giotto's frescoes, no paradigm of realism today, were surprisingly realistic at the time. Linear perspective followed on Giotto's heels and more than four centuries thereafter daguerreotypes and photographs had a similar effect. An account of pictorial realism should shed some light on these revelatory moments. What do they reveal? Why is this aesthetically interesting or valuable? If the account of realism as verity is on the right track, revelatory realism should amount to a way of making pictures that are veritable in respects that previous pictures were not. Since verity allows for

this, verity allows for revelatory realism. Moreover, verity suggests an analysis of a puzzle about changing standards of realism.

First, how can realism be surprising if realism is verity? When we manage to depict objects veritably in respects that we had not been able to depict them before, the result is surprising. Giotto was able to depict faces and hands as having features that no one had depicted them as having before. His subjects seemed particularly lifelike because those features they were depicted as having fit well with our perceptual conceptions of the people we see. The same is true of daguerreotypes and photographs. In a sense, these pictures raised the bar, and verity captures the sense in which this is so.

A puzzle lurks just here, however. Verity is an intra-systemic notion of realism. When we claim that one picture is realistic in respects that another is not we are making a claim within a given system of interpretation. Without this, verity fails to account for the respects in which many pictures like the *Old Guitarist* fail to be realistic. The problem is that for Giotto's revolutionary realism to be understood in terms of verity, he had to paint people as having features no one had painted them as having before. It seems odd at best to claim that people had all along understood pictures as fitting into an interpretive scheme that included features they had never before taken to be represented. If anything, it seems as though Giotto raised the bar by changing the rules, or at least by detailing and unpacking them. He introduced a new system of representation with more expressive power than its predecessors. This system in turn was superseded by many linear perspective constructions, daguerreotypes, and photographs. Revelatory realism strongly suggests some *inter-*systemic approaches are on the right track, while verity does its best work when understood intra-systemically, or so it seems.

What the foregoing misses is that new interpretive schemes do not make trouble for verity, since verity says nothing about how and under what circumstances such systems change. All it claims is that judgments of realism are made within systems of interpretation and not between them. Let's say that Giotto opened people's eyes to a new system of interpreting images. That is, he produced pictures that admit of different kinds of interpretation than those preceding them. We need not demand an account of just how interpretive schemes change,

and in particular how exposure to a new set of images could change them. For present purposes, we can just insist that the interpretive scheme changes. Supporters of an inter-systemic view and the current view can agree so far.

Now consider what happens to our interpretation of past pictures in light of a revolution in realism. Giotto's paintings were taken to be amazingly lifelike at the time, but they are not anymore. More importantly, they seem downright unrealistic. In fact, they are unrealistic in ways that parallel the senses in which, say, Picasso's work can be unrealistic. The shapes of the hands and face, the texture of the skin and so on, are not rendered realistically. It is easy to say that we view Giotto through the lens of subsequent revelatory moments, like linear perspective and photography. But why do these subsequent moments make what was once lifelike so unreal? The intra-systemic approach to realism suggests a nice answer, though at this point the answer is somewhat speculative. Giotto introduces a new interpretive scheme for pictures. Pictures can now represent features of their subjects veritably that they could not represent before. We then recruit past representations into this new interpretive scheme. That is to say, we interpret them armed with the standards to which Giotto's work holds up well. In a similar fashion, these days we fit Giotto's work into an interpretive scheme influenced by photography and linear perspective constructions. This is why Giotto no longer seems terribly realistic.

This highlights one of verity's virtues: it characterizes both realism and irrealism in positive terms. Every failure of realism is a twofold representational success. One manages to represent a dragon, for example, and manages to represent it as having properties that do not fall within our perceptual conceptions of dragons. This helps to explain why past pictures can go from seeming quite realistic to seeming rather unrealistic when one's system of interpretation changes. Paintings pre-Giotto had a set of features that were relevant to their semantic interpretation and a set that were not. This is always true with painting. Some perceptible features of the surface matter to what it is about while others are safely ignored. Giotto makes some features matter that did not before. Shading and coloration, for example, are recruited more effectively to help with the representation

of shapes and light sources. Now, if one cleaves to Giotto's standards while interpreting earlier paintings, one treats features that may not have mattered to those who produced the painting as mattering to its interpretation. Faces seem to lack depth, their shapes are odd, and it is not clear how they are illuminated. Before Giotto the features suggesting flatness were not taken to suggest that at all. They might not have suggested much of anything. With humbler ambitions a picture can seem realistic without seeming positively unrealistic because it just keeps quiet about certain things. With a new, perhaps richer, interpretive system on line, features that were ignored take on semantic significance. What was once silent now speaks, but awkwardly and hence unrealistically.

In this way, revolutions in realism open the door to creative irrealism. Whenever certain features of a picture's surface are recruited into semantic service, they can be used to suggest properties of the depicted object that do not match our perceptual conception of it. Once techniques develop to allow veritable representation of certain properties, they allow for representation of such properties that is not veritable. Though there have been few revolutions in realism since photography, there have been myriad developments of irrealism in the work of Cézanne, Matisse, and Picasso to name but a few. At least part of a recognizable pictorial style is a syndrome of realistic and unrealistic representation. John Currin's work is particularly interesting because it mixes varieties of irrealism in unexpected ways. This helps one to recognize the manner in which different pictorial styles relate to one another.

The foregoing is admittedly speculative, and we have come some way from trying to account for revelatory realism. The main point is that realism understood in terms of intra-systemic verity can accommodate revelatory realism. Secondary is the claim that revolutions in realism are best understood as taking past pictures and including them within a new system of interpretation, which is why past pictures can go from seeming positively realistic to positively unrealistic. Partly because our current interaction with pictures suggests that we fit them into a single interpretive scheme, it seems plausible that this is what happens once the dominant interpretive scheme changes as well. The first section of this chapter did make it clear that we also are able to

interpret different kinds of pictures as belonging to distinct interpretive schemes, like black and white versus color photography. Michael Baxandall's excellent *Painting and Experience in Fifteenth-Century Italy* (1988) is an example of how hard one must sometimes work to interpret pictures within their original interpretive scheme. The fact that we do both is relevant to understanding pictorial realism, no doubt, but this chapter has focused on intra-systemic notions because they have been rather neglected.

Realism and Discovery

Scientists use pictures too. In their hands, pictures reveal much about everything from the state of the cosmos to the structure of cells. Very often, the scientists do not know just what they are looking for. The new cell promises to be interesting, but beyond that they are without a clue. The developed film changes their view of what this little piece of the world is like. Does this revelatory photo realistically depict the cell? On the present account it does not. Nor does it unrealistically depict it. Without a perceptual *conception* of the cell, it makes no sense to compare what the picture tells us about the cell with our perceptual conception of it. This is counterintuitive at best.[4]

It is tempting to claim that, though we cannot strictly speaking say that the picture is realistic, photography is realistic in general, and the photo in question inherits its realism from the system to which it belongs. This gives up the game early. Verity is an intra-systemic kind of realism. Whatever kind of realism photography as a system possesses, it cannot be verity. Though verity may not be the only kind of realism, without giving an account of the other kinds, this suggestion is at best unhelpful. And there is more to verity than this response suggests.

Perhaps this example reveals a problem with the definition of verity in terms of truth to conception rather than truth to the world. We have reason to believe the picture accurately represents the cell. In that sense, it is a veritable representation. Why not insist that verity

[4] Julia Driver raised this concern and convinced me that the point deserves a section to itself.

is truth to the particular depicted? This quick fix to the problem at hand undercuts all of the advantages of verity as truth to conception. It leaves us in need of an explanation of the sense in which pictures of dragons are realistic, with the most plausible avenue blocked.

The account of realism as verity, and verity as truth to conception, should be left alone. Examples from science show that some pictures have a special epistemological status. They can inform us about particulars because we have reason to believe they are generally accurate, or veridical. Scientists use such representations as tools for discovery. As sources of knowledge, these representations allow us to form perceptual conceptions of the things depicted. Before seeing the picture, we had no idea what the cell would look like. The picture lets us know. This situation virtually guarantees that the picture will be considered realistic once we have taken in what it has to tell us about the cell. In virtue of their special epistemological status, scientific images will score high on verity, in the sense of truth to conception, once they have informed our conceptions. None of this requires refashioning verity in terms of truth to depicted particulars.

Just to drive the point home, let's say we started with a limited perceptual conception of the cell, and the picture winds up contradicting it. Is the picture realistic? The jury is out. On the one hand, our prior perceptual conception suggests that the picture is not. On the other, the picture is a reliable informant. We are left with a mess. We do not know what is true of the cell. Since we try to keep our perceptual conceptions of things in line with what things are like, our uncertainty about the cell means an uncertainty in our conception of it. This means that it is not obvious which pictures fit well with it and which do not. Resolving this problem amounts to figuring out which source of our conception was faulty. If the culprit is the picture, then the picture is unrealistic; if not, not. By contrast, if the picture had no such epistemological status—say it was drawn by an unreliable illustrator—we would not hesitate to call it unrealistic. This is true even if the illustrator, by chance, got it right and veridically represented the cell against the weight of scientific evidence. Realism does not track veridicality so much as truth to our conceptions of things. Our conceptions of things, however, aim at the truth. This is why making realism relative to observers does not mean judgments of

realism will vary haphazardly. Evidence can revise our conceptions, and thereby our judgments of realism. The rapacious T-rex of old textbooks has been replaced by a scary scavenger. In its day, the former was a realistic depiction of the dinosaur while the latter was not, but times have changed, for most of us at least.

Illustration 12 Stanley W. Hayter, *Astyanax; from the portfolio Death of Hektor*, 1979. Hood Museum of Art, Dartmouth College, Hanover, New Hampshire © 2005 Artists Rights Society (ARS), New York/ADAGP, Paris. Photography: Jeffrey Nintzel

12

Information, Imitation, and Inculcation

Verity applies to representations within a system of representation, but there are inter-systemic kinds of realism as well. It is absurd to suggest that we always force pictorial representations into a single, linear perspectival interpretive mold. Suggestions for inter-systemic kinds of realism abound. Plausible candidates include the fact that some systems are more informative than others, that some are perceptually special in a way that others are not, and that some are just those we have become used to using. There is something or other right about each claim, though sorting out just what that is can be tricky.

Realism as Informativeness?

Many have insisted that at least one notion of pictorial realism involves the informativeness of pictures. The realistic pictures are the ones that go into the appropriate detail vis-à-vis what they depict. Cartoons, line drawings, stick figures, and even black and white photos are less realistic than true, color linear perspective pictures, in part because they just refuse to go into details from which pictures in perspective do not shrink. Flint Schier's second dimension of realism, which adds to his notion of realism as truthfulness discussed above, is a nice example of how to work informativeness into one's account of realism.

S is realistic with respect to a feature F when S depicts O, F is a potential visually recognizable feature of O, and S either depicts O as F, depicts O as lacking F (by depicting O as having some G incompatible with O's

having F) or S depicts O as having some property H which makes it impossible to tell whether O is F or not. (Schier 1986, 176)

Given this definition, S is a realistic depiction of O to the extent that it goes into a lot of detail concerning the visually recognizable features of O. The pictures Schier has in mind are realistic, but not for abstaining from commitments. These are the bold pictures that do not avoid saying something false merely by saying very little. Schier needs this version of realism because his view that pictorial realism is just truthfulness to the particular depicted leaves him wanting for an account of realistic pictures of dragons. What counts as a realistic picture of a dragon, for Schier, is just a picture of a dragon that goes into a lot of detail. The detail need *not* comport well with one's perceptual conception of a dragon. It may seem as if Schier builds verity into the above definition when he claims that 'F is a potential visually recognizable feature of O'. That, however, is not the case, since a picture is realistic with respect to any property that it depicts its object as *lacking* in the sense that it depicts its object as having some property incompatible with it. So, a veritable depiction of a dragon and one that is not, but equally detailed, can be realistic in Schier's sense with respect to the same properties. For example, in addition to a lot of other detail, one picture represents the dragon as being bright orange with purple polka dots while the other just goes for reptile green. The former is realistic with respect to both greenness and purple-polka-dottedness. Insofar as it represents the dragon as having the latter, it represents it as having some feature incompatible with being reptile green.

It is difficult to tell whether this definition really captures a notion of realism. Dali's paintings did not shrink from detail, but they did manage to be rather unrealistic, both intuitively and with respect to the definition of verity above. Likewise, anamorphically stretched pictures, and pictures in reverse perspective, are quite detailed, but they are rather unrealistic. That being said, intuitive uses of 'realism' seem to favor pictures that go into great detail over those that say rather little, so it is tempting to say that there are two dimensions to realism. Verity captures one and informativeness the other. The problem is that the realism of these rather informative depictions

seems to fall back on their truth to our conceptions of what they depict. It is not their going into detail, but their doing so while remaining true to our conceptions of things that makes them realistic. Still, informativeness has an appeal that is not diminished by problems with Schier's explication of it. What is the source of that appeal?

The key to this puzzle is remembering that pictures relate to other kinds of representations along many structural dimensions, among which are repleteness and sensitivity. Because pictures are mimetic, but also replete and sensitive, they will tend to have quite detailed contents. What seems to be going on with realism and informativeness is that we judge relatively uninformative representations as unrealistic because they seem only to approach being pictorial. That is, they do not count as realistic examples *of pictures* because they say so little about their subjects. This has little to do with their being unrealistic depictions of their subjects. The latter irrealism falls under verity, while the former concerns the extent to which the representations fit into a system that exemplifies a *pictorial* system.

When we treat a representation as pictorial we treat it as being rather informative by default. Pictures are relatively replete, in that many features of a picture's surface are relevant to its being the picture that it is. Because pictures are instances of their bare bones content, their repleteness means that the bare bones content, though a bit more abstract than fleshed out content, is nevertheless rather rich with detail. We flesh out the content of a picture to something even richer in detail than the relatively rich bare bones content. Moreover, pictures are relatively syntactically sensitive, which means that small changes in the features constitutive of a picture's bare bones content—its syntactically relevant properties—result in changes to the picture's syntactic, and hence semantic, identity. Not only do pictures convey a lot, in the sense of specifying *many* properties of their objects, they do so at a fine level of detail.

Sometimes we encounter a representation that doesn't fit comfortably within such a system, like Hayter's *Astyanax* reproduced at the beginning of the chapter. We can certainly interpret such a representation as being part of, say, a replete, sensitive, linear perspective system of representation, but doing so results in a content that is at best odd: flat, colorless outlines which are much less dramatic than

Astyanax taking one for the team. Rather than take the content to be such an odd state of affairs, we presume that the representation just does not go into detail with regard to depth, color, and the like. To the extent that we excuse a representation from going into detail, however, we excuse details of the representation from having the syntactic and semantic significance characteristic of pictorial representations. The print suggests a fall from a wall without going into much detail. We attenuate and desensitize the representation, the remainder being a pictorial, but relatively speaking uninformative, representation.[1] Attenuation and desensitization move a representation away from the pictorial and toward the diagrammatic, so when we encounter a representation that most reasonably fits into such a system it counts as an unrealistic instance of a picture. That is, the system into which we fit the representation is not an exemplar of the pictorial but an outlier at best. In this way, informativeness is a kind of pictorial realism that contrasts sharply with verity.

This analysis of informativeness as a kind of inter-systemic realism makes some sense out of the odd representational systems discussed in Chapter 3. One virtue of transparency was that it could show the respects in which the color-complement system and the shuffled up picture system are, given their standard interpretations, non-pictorial. Both systems fail to be transparent: the first with respect to determinate colors and the second with respect to relative spatial locations. However, these systems are transparent with respect to many other properties. In addition, the color complement system is transparent if we take it to represent not determinate colors but disjunctions of complementary pairs of color. Likewise, the shuffled up system could be transparent if we take it to represent spatially disjunctive states of affairs. Judicious disjunction saves transparency, and thus pictorialness, but at a cost of diminished repleteness and sensitivity. If the color complement system is made transparent, for example, then changing the colors to their complements does not alter the syntactic identity of the representation. Similarly, one could treat the color complement representations as pictorial by ignoring

[1] Goodman proposed using 'attenuation' as the opposite of 'repleteness', but he did not, as far as I can tell, actually use the term in *Languages of Art*.

color as an SRP of the system altogether, but that system is less replete than the one in which color is an SRP. To the extent that we make these systems more pictorial along one dimension, they move away along others. One interesting virtue of linear perspective, parallel projections, and the like is that these systems are both quite replete and sensitive while being transparent. A virtue of the present account of depiction is that it clarifies the dimensions along which these troublemaker systems differ from the central cases from which they are derived. These structural conditions thus track one respect of pictorial realism—informativeness—even if they do not track verity.

Informativeness compares systems of representation and not, like verity, representations within a system. It makes perfect sense to compare cartoons with respect to verity, even though, as far as informativeness goes, they are on a par. Since informativeness applies inter-systemically and verity intra-systemically, it seems inaccurate to call them two dimensions of realism. These notions do not, strictly speaking, apply to the same things. We may say of a token cartoon that it is unrealistic in terms of informativeness, but this is, on the present account, an elliptical claim about the cartoonish system to which the token belongs.

Waltonian Mimicry

Kendall Walton has an account of pictorial realism that is an amalgam of verity, informativeness, and a third ingredient, related to the first two, which we can call 'mimicry'. Walton thinks that we can distinguish kinds of representation in terms of the kinds of play, or imagining, that they occasion. What Walton calls 'depictions' are special because in perceiving them we imaginatively perceive what they are about (Walton 1990, 293–6). So, we see a picture of a tree and that seeing is, imaginatively, seeing the tree. Hearing a vivid description of a tree could occasion rich imagining, but it would not be the *hearing* of the description that is treated, imaginatively, as seeing the tree. The games we play with pictures involve treating our actual perception of the artifact as though it were a perception of something else, the latter being the content of the representation (Walton 1990, 297). Pictorial realism, for Walton, amounts to the extent to which our perceptual

engagement with a picture mimics our perceptual engagement with what it depicts.[2] Pictures are realistic when perceiving them is just like perceiving what they are about in terms of the kinds of information we glean and the way in which we obtain the information.

By visually inspecting a scene we learn about colors, shapes, relative distances, textures, relative sizes, and so on. These are just the kinds of information that we glean from inspection of a picture of that scene. It is obvious that we can learn about shapes, colors, etc. of the picture surface by visual inspection, since looking at a picture surface is just like looking at anything else. The interesting point is that visual inspection of a picture surface is, imaginatively, visual inspection of a depicted scene, from which we glean the same kind of information that we would from visual inspection of the scene itself.

Moreover, the way in which we imaginatively acquire information by visual inspection of a picture is just like the way in which we acquire it more generally. To be more specific, the order in which we acquire information, the relative difficulty of acquiring such information, and the kinds of mistakes we are prone to make when visually inspecting a scene are mimicked by the visual inspection of a picture. In discussing Hobbema's *Mill*, Walton notes that, on the one hand, 'A quick glance at the painting may reveal that fictionally the mill has a red roof' (Walton 1990, 305). On the other hand, 'Perhaps only after careful and extended scrutiny of the picture will Peter discover knots in the wood of the mill, subtleties of the woman's facial expression, or warts on her hand. The sequence is "realistic."' (Walton 1990, 305). In addition to the sequence in which we notice things, information difficult to discern in a scene is also difficult to discern in a picture of that scene. 'It is because the red roof in the painting is more obvious, more striking visually than the knot in the wood, that it is likely to be noticed first' (Walton 1990, 306). It may be, as Walton suggests, that difficulty of noticing things explains at least some of the order in which we notice them. Red barns jump out from a background of green trees so we notice them before we notice, say, specific trees.

[2] Walton and I agree that pictures are not necessarily visual, contra Hopkins (1998), and we agree that visible pictures are pictures of visible states of affairs, auditory pictures depict audible states of affairs, and so on.

That is not to say, and Walton does not suggest, that we always notice what is easy to see before noticing what is more obscure. In similar fashion, it may be difficult to tell whether the barn is crimson or scarlet, and one thus may make a mistake about that, but it is not likely that one will make a mistake about whether the barn is red or green. Similarly, the barn is not just one fifth the height of the trees around it, though it is certainly shorter than most of them.

One final feature of pictorial representation for Walton is that perceptual investigation of a picture is open-ended in a way that the perceptual investigation of other kinds of representations is not. Walton (1990, 307–9) points out that pictures are the kinds of things that we visually contemplate. Thomas Bernhard's beautiful novella *Old Masters* (1992) centers on a man who for years spends a few hours, every other day, contemplating Tintoretto's *White-Bearded Man* in the Vienna Kunsthistorisches Museum.[3] It would be odd, at any given point, to declare that one had seen all that there is to see in a given painting, though it is undoubtedly odd to stare at a single Tintoretto for years. There is a sense in which we do this with novels, too. Many are happy to make time for Joyce's *Ulysses* at least once a year, and many more are willing to contemplate their favorite haiku over and over again. The difference here is not in the time spent with a work of art, but in how that time is spent. Pictures support a searching, perceptual investigation not unlike that supported by a scene of any other kind. This kind of perceptual investigation helps us to learn what the picture is about, so a picture's content unfolds as we continue to inspect it. Only lovers of typography perceptually investigate books in this manner.

It is easy to see that the kind of realism isolated by Walton is related to both verity and informativeness. To the extent that a picture of a cat depicts it as having a human grin, the kinds of information that we glean from the picture will differ substantially from the kinds we glean from perceptual investigation of a cat. Whenever a picture lacks verity, it says things about its object that we do not conceive its object as being like, and will thus run afoul of Walton's condition concerning

[3] Thanks to George Streeter for calling my attention to Bernhard's work and for giving me a copy of *Old Masters*.

the kinds of information a picture provides. Moreover, our perceptual interaction with a picture that is veritable can be unrealistic to the extent that the picture is silent regarding features of the things it depicts. We can typically come to know much about the spatial detail of objects when we see them, so any picture that refuses to commit to such details will *eo ipso* seem unrealistic. For Walton, departure from perceptual mimicry results in irrealism, and there seem to be at least two points of departure: verity and informativeness.

There is more to mimicry than verity and informativeness, however. Walton's insight concerns not just the content of pictorial representations, but the character of our interaction with them. It is not just that pictures represent certain features of their depicta as being more difficult to notice than others, but that it is more difficult to notice that feature of the depicted object, when looking at the depiction, than it is to notice other features of it. Our perceptual interaction with a picture mimics our perceptual interaction with the depicted object, which is something that neither verity nor informativeness on its own accounts for. It turns out, however, that given the account of pictorial representation articulated here, we should expect a veritable picture within a particularly informative pictorial system to be realistic in the Waltonian sense as well. This shows that the structural account sheds some light on the features of pictures that motivate Walton's pretense account.

Pictures, recall, are instances of their own bare bones contents, and a fleshed out content is just a precisification of bare bones content. We learn about colors and shapes, relative to a point of view, both when we look out onto a field and when we view one of Constable's landscapes. Moreover, fleshing out consists in the deployment of concepts that are triggered by the picture's bare bones content. These recognitional abilities are keyed to the things we encounter in our everyday perceptual engagement with the world. It is no surprise, then, that the information we glean from a visual perusal of pictures is much like the information we could gain from visually inspecting the world. This is all the more so in pictures that score high on informativeness and verity.

For similar reasons, the way in which we come to know the content of a picture is similar to the way in which we come to

gather information from the world more generally in terms of order, difficulty, and the mistakes we make. The picture, being an instance of its own bare bones content, is sufficient for the deployment of our concepts of things in the fleshed out content of the picture. In addition, particular features of the bare bones content are responsible for features of the fleshed out content. The patterns of color toward the picture's upper-left corner tell us about features of the fleshed out content that are above and to the left of the rest. The orange pigment toward the center of the canvas lets us flesh out the content to a red-roofed mill seen on a sunny day. The wood's knots are picked out by the swirls of paint in the patterns that depict the barn's boards. This suggests a simple link between Walton's account of our imaginative engagement with pictures and the account of their structure vis-à-vis their contents. The order and relative difficulty of noticing aspects of a picture's fleshed out content, and the mistakes that we make identifying it, are explained by the order, difficulty, and mistakes associated with perceptually registering features of a picture's bare bones content. We notice the roof before we notice the trees, so we should perceptually register the red expanse that stands for the roof before noticing the patches of green that stand for the trees. It is more difficult to register the swirls that stand for the knot than the orange expanse that stands for the roof. We are more prone to mistake the swirl for shadow than for a flower, and the roof for orange than for green.

It would be a mistake to explain how we *notice* certain aspects of fleshed out content in terms of how we *notice* aspects of bare bones content since part of the account on offer is that we tend not to notice bare bones content as such at all. The proposal concerns the features of bare bones content that lead to the recognitional deployment of concepts. Certain aspects of bare bones content draw attention to themselves, such as patches of red on an otherwise greenish-yellowish background.[4] In addition, our visual acuity varies vastly from the central field of view on out to the periphery. Therefore, we perceptually represent much more spatial detail of the portions of the

[4] Just what features in the environment draw our attention is a matter of dispute among scientists, but an active area of research.

picture that we view directly than we do for those areas a few degrees out of our direct line of sight, even if we do not notice the patterns of pigment as such. If we do not perceptually represent the swirl in the paint, it is not clear how we could flesh it out, since in that case, we do not notice the knot because we do not perceptually register the swirl at all. When we are in a position to register the swirl's presence, we are also in a position to notice the knot. This relates to the point about outline shape and bare bones content vis-à-vis recognition of a picture's fleshed out content made in Chapter 10. Our access to the fleshed out content of a picture is mediated by perceptual representation of features constitutive of a picture's bare bones content, but psychologically speaking we are aware first of a picture's fleshed out content.

Finally, the open-ended, perceptual investigation to which pictures submit is just what we should expect if (1) coming to know the content of a picture amounts to using our recognitional abilities, and (2) this requires attending to regions of the picture surface. We can keep inspecting the picture in the way we inspect any scene.

Empirical research may reveal that features characteristic of picture-viewing are not *exactly* those characteristic of scene-viewing in general. This seems likely and Walton (1990) accepts the point. As far as we can tell, our perceptual engagement with pictures is a lot like our perceptual engagement with the world at large, and that is enough for present purposes. It may even be that what counts as sufficient mimicry, or the right kind of mimicry, can change over time and depend at least partly on the standards of the day. The next and final section looks at the significance of such standards for understanding realism.

Standards and Inculcation

Verity applies to representations within any pictorial system, and informativeness applies to any representational system, so we should expect any veritable representation within an informative system to be considered realistic along these dimensions. This is not the case, however, and it raises some worries about the account of realism, as well as the account of pictorial content, presented so far. For example,

reverse perspective is an informative system: it is just as replete, sensitive, and rich, not to mention transparent, as linear perspective. Also, many pictures in reverse perspective are veritable as far as the definition of verity goes. Perceptual and pretense theorists of many stripes can easily relegate reverse perspective to the periphery or banish it from the pictorial altogether, because they identify pictorial representations as those which allow certain kinds of perceptual engagement.

Part II sought to explain what seems so special about the perception of some pictures in light of the structural account in Part I. But Part II focused rather closely on pictures in linear perspective as a special kind of pictorial representation. Part III's task is, in part, to account for the variety of pictorial practices, given the seeming centrality of certain kinds of pictorial representation, like linear perspective. Verity suggests that certain representations that do not seem to fit into a system fit into one of perhaps a few standard systems for interpreting pictures, with something approximating linear perspective being one of them. Our interpretation of pictures in reverse perspective, however, suggests that we fit them into a system approximating linear perspective as well, despite the fact that reverse perspective is an informative system with veritable representations. So, veritableness and informativeness cannot suffice for a picture to seem realistic.

The reason reverse perspective pictures seem unrealistic is not for lack of detail in their contents or lack of verity in each individual representation, but for difficulty in discerning those contents in the first place. Such pictures do not trigger our recognitional abilities as well as pictures in linear perspective or parallel projection do, so they fail the test of Waltonian mimicry. Hopkins (2003) has pointed out that reverse perspective is not the kind of representational system that permits viewers to discern fine spatial detail. A picture of your average room in reverse perspective will not be the kind of thing whose content we can flesh out to the spatially detailed state of affairs that resulted in the picture. This is a fact about us and our perceptual concepts not unrelated to the fact that anamorphically stretched pictures often look like pictures of blobs. Our recognitional concepts are keyed to things right in front of us, which present certain characteristic patterns to our eyes. Reverse perspective and anamorphic perspectives

systematically distort these characteristic patterns. Naturally, if we interpret a reverse perspective picture as a member of ordinary linear perspective, the result is a rather odd state of affairs and thus the picture winds up unrealistic with respect to verity. This is not to say that reverse perspective, as a system unto itself, is uninformative or that its representations generally fail to be veritable, however.

What it is to be a pictorial representation can be accounted for in structural terms, but what it is to be a useful, comprehensible representation cannot. Some pictures are the kinds of things whose bare bones contents we can flesh out, some are not, and this depends on how our stock of concepts and recognitional capacities works. Some systems of depiction are just useless to us because, despite their transparency, repleteness, sensitivity, and richness, we cannot use representations within those systems effectively. Representations within a useless system may nevertheless score high on verity, and the system itself may be rather informative, but these systems will fail the test of mimicry. They simply do not support the kind of perceptual interaction that makes some pictures so useful to us.

All of this suggests the proper place for Goodman's (1976) claims about familiarity's tie to realism. If we easily, more or less naturally, fit representations into a system quite different from the current standard, then standards of realism would change. Just how malleable our pictorial abilities are, and thus just how much standards can change, how quickly they change, and by what means they can change are empirical questions. This is why Walton's discussion of mimicry is essential to any account of pictorial realism, but why we are also left wondering whether what seems like good mimicry can change with the times or between cultures. Since realism says something about how we relate to pictures, it would be shocking if our abilities and standards did not come into play in accounting for it. This is a far cry from claiming that realism is *merely* a matter of habit (Goodman 1976, 38, 231). Realism is verity, informativeness, and mimicry too. What may be a matter of habit is the system that sets the standard. Goodman didn't so much give an account of realism in *Languages of Art* as point out something upon which any account of realism should depend. If we encounter a representation in a rather non-standard system, we will either regard it as unrealistic insofar as it is part of

such a system or we will fit it into a standard system, within which it will likely score low on verity. Goodman would have said that the Matisse-Cheshire is unrealistic because it does not fit within a standard system of depiction. That may be the way we treat such a representation. Even though the Matisse-Cheshire was not produced within a standard system like linear perspective or parallel projection, however, we seem to interpret it as if it were part of such a system. In this case, then, its irrealism stems from its *inclusion* within a standard system of representation. It will often be tricky to say for a given case whether claims about its realism or lack thereof are inter-systemic or intra-systemic.

Understanding the varieties of realism helps with accommodating the varieties of depiction. Our interpretations of pictures in different styles suggest that we fit them into interpretive schemes much like the one for linear perspective. This makes room for verity as an intra-systemic standard of realism. When we fit pictures into distinct interpretive schemes, we judge the systems based on how good they are as exemplars of pictorial schemes. Any exemplar of the pictorial is rather informative, which is why informativeness seems related to realism. There are plenty of systems that we cannot readily interpret, so when we encounter a representation produced within one of them we either insist it is not a picture at all, that it is a distortion of a picture, or we fit it into a familiar interpretive scheme. The structural account of depiction suggests that these difficult representations can very well be pictorial even if we do not have the perceptual resources for interpreting them readily. If we fit such a representation into a familiar system of interpretation, it will likely score low on verity. The standards that we bring to picture interpretation can certainly change, but it is really an empirical question how much they can change, and along what dimensions.

References

ALBERTI, L. B. 1435/1991. *On Painting*, trans. C. GRAYSON. London: Penguin Books.

ARMSTRONG, D. 1961. *Perception and the Physical World*. London: Routledge & Kegan Paul.

BACH, K. 1970. Part of what a picture is. *British Journal of Aesthetics* 10: 119–37.

BAXANDALL, M. 1988. *Painting and Experience in Fifteenth-Century Italy*, new edn. Oxford: Oxford University Press.

BERKELEY, G. 1710/1982. *A Treatise Concerning the Principles of Human Knowledge*. Indianapolis: Hackett.

———1713/1979. *Three Dialogues between Hylas and Philonous*. Indianapolis: Hackett.

BERNHARD, T. 1992. *Old Masters*, trans. E. OSERS. Chicago: University of Chicago Press.

BLOCK, N. 1983. The photographic fallacy in the debate about mental imagery. *Noûs* 17/4: 651–61.

BROAD, C. D. 1953. The theory of sensa. In Swartz 1965.

BUSEY, T. A., BRADY, N. P., and CUTTING, J. E. 1990. Compensation is unnecessary for the perception of faces in slanted pictures. *Perception & Psychophysics* 48/1: 1–11.

CARNAP, R. 1958. *Introduction to Symbolic Logic and its Applications*. New York: Dover.

CASATI, R. and VARZI, A. 1999. *Parts and Places*. Cambridge, MA: MIT Press.

COURT, E. 1990. Poster presented at the IVth European Conference on Developmental Psychology, University of Stirling, Scotland, August 27–31.

COXETER, H. S. M. 1993. *The Real Projective Plane*. Springer-Verlag.

CUTTING, J. E. 1987. Rigidity in cinema seen from the front row, side aisle. *Journal of Experimental Psychology: Human Perception and Performance* 13: 323–34.

———1988. Affine distortions of pictorial space: some predictions for Goldstein (1987) that La Gournerie (1859) might have made. *Journal of Experimental Psychology: Human Perception and Performance* 14: 305–11.

DANTO, A. 1997. *After the End of Art*. Princeton: Princeton University Press.

DRETSKE, F. 1981. *Knowledge and the Flow of Information*. Cambridge, MA: MIT Press.

ELKINS, J. 1994. *The Poetics of Perspective*. Ithaca: Cornell University Press.

FEAGIN, S. 1998. Presentation and representation. *Journal of Aesthetics and Art Criticism* 56/3: 234–40.

FIRTH, R. 1949–50. Sense-data and the percept theory. *Mind* 58/232: 434–65, 59/233: 35–56. In Swartz 1965.

FODOR, J. 1990. *A Theory of Content and Other Essays*. Cambridge, MA: MIT Press.

GIBSON, J. J. 1954. A theory of pictorial perception. *Audio-Visual Communication Review* 2: 3–23.

—— 1960. Pictures, perspective, and perception. *Daedalus* 89: 216–27.

—— 1971. The information available in pictures. *Leonardo* 4: 27–35.

GOLDSTEIN, E. B. 1979. Rotation of objects in pictures viewed at an angle. *Journal of Experimental Psychology: Human Perception and Performance* 5: 78–87.

—— 1987. Spatial layout, orientation relative to the observer, and perceived projection in pictures viewed at an angle. *Journal of Experimental Psychology: Human Perception and Performance* 13: 256–66.

GOMBRICH, E. 1961. *Art and Illusion*, 2nd edn. Princeton: Princeton University Press.

—— 1972. The mask and the face: the perception of physiognomic likeness in life and in art. In M. MANDELBAUM (ed.) *Art, Perception, and Reality*. Baltimore: Johns Hopkins University Press.

GOODMAN, N. 1972. *Problems and Projects*. Indianapolis: Bobbs-Merrill.

—— 1976. *Languages of Art*, 2nd edn. Indianapolis: Hackett.

GOODMAN, N. and ELGIN, C. Z. 1988. *Reconceptions in Philosophy*. London: Routledge.

GREENBERG, C. 1960. Modernist painting. In O'BRIEN (ed.), *Clement Greenberg: The Collected Essays and Criticism*, vol. 4. Chicago: University of Chicago Press.

HAGEN, M. (ed.) 1980. *The Perception of Pictures Vol. 1. Alberti's Window: The Projective Model of Pictorial Information*. New York: Academic Press.

HAGEN, M. 1986. *Varieties of Realism*. Cambridge: Cambridge University Press.

HALLORAN, T. O. 1989. Picture perception is array specific: viewing angle versus apparent orientation. *Perception & Psychophysics* 45: 467–82.

HAUGELAND, J. 1983. Analog and analog. *Philosophical Topics* 12: 213–26.

—— 1991 Representational genera. In W. RAMSEY, S. STICH, and D. RUMELHART (eds.) *Philosophy and Connectionist Theory*. Hillsdale, NJ: Lawrence Erlbaum. Reprinted in Haugeland 1998.

——— 1998. *Having Thought*. Cambridge, MA: Harvard University Press.

HECHT, H., SCHWARTZ, R., and ATHERTON, M. (eds.). 2003. *Looking into Pictures*. Cambridge, MA: MIT Press.

HELLER, M. A. 1989. Picture and pattern perception in the sighted and blind: the advantage of the late blind. *Perception* 18: 379–89.

HOCHBERG, J. 1972. The representation of things and people. In M. MANDELBAUM (ed.) *Art, Perception, and Reality*. Baltimore: Johns Hopkins University Press.

HOPKINS, R. 1995. Explaining depiction. *Philosophical Review* 104/3: 425–55.

——— 1998. *Picture, Image, and Experience*. Cambridge: Cambridge University Press.

——— 2000. Touching pictures. *British Journal of Aesthetics* 40/1: 149–67.

——— 2003. Perspective, convention, and compromise. In Hecht, Schwartz, and Atherton (eds.) 2003.

ITTLESON, W. H. 1952. *The Ames Demonstrations in Perception*. Princeton: Princeton University Press.

KEMP, M. (ed.) 1989. *Leonardo on Painting*. New Haven: Yale University Press.

KENNEDY, J. M. 1993. *Drawing and the Blind*. New Haven: Yale University Press.

KENNEDY, J. M. and FOX, N. 1977. Pictures to see and pictures to touch. In B. LEONDAR (ed.) *The Arts and Cognition*. Baltimore: The Johns Hopkins University Press: 118–35.

KOENDERINK, J., VAN DOORN, A., KAPPERS, A., and TODD, J. 2004. Pointing out of the picture. *Perception* 33: 513–30.

KUBOVY, M. 1986. *The Psychology of Perspective and Renaissance Art*. Cambridge: Cambridge University Press.

KULVICKI, J. 2003. Image structure. *Journal of Aesthetics and Art Criticism* 61/4: 323–40.

——— 2004. Isomorphism in information-carrying systems. *Pacific Philosophical Quarterly* 85: 380–95.

LEDERMAN, S. J., KLATZKY, R. L., CHATAWAY, C., and SUMMERS, C. 1990. Visual mediation and the haptic recognition of two-dimensional pictures of common objects. *Journal of Experimental Psychology, General* 114: 33–49.

LEVINSON, J. 1998. Wollheim on pictorial representation. *Journal of Aesthetics and Art Criticism* 56/3: 227–33.

LOCKE, J. 1690/1975. *An Essay Concerning Human Understanding*, ed. P. NIDDITCH. Oxford: Clarendon Press.

LOPES, D. 1995. Pictorial realism. *Journal of Aesthetics and Art Criticism* 53/3: 277–85.

LOPES D. 1996. *Understanding Pictures*. Oxford: Oxford University Press.

—— 1997. Art media and the sense modalities: tactile pictures. *Philosophical Quarterly* 47/189: 425–40.

—— 2002. Vision, touch, and the value of pictures. *British Journal of Aesthetics* 42/2: 191–201.

MESKIN, A. 2000. Comments on John Kulvicki's 'What's so special about linear perspective?'. American Philosophical Association, Pacific Division, Albuquerque, NM.

MOORE, G. E. 1903. The refutation of idealism. *Mind* 12/48: 433–53.

—— 1918. Some judgments of perception. *Proceedings of the Aristotelian Society* 19: 1–29. In Swartz 1965.

—— 1953. Sense data. In *Some Main Problems in Philosophy*. London: George, Allen & Unwin.

NEANDER, K. 1987. Pictorial representation: a matter of resemblance. *British Journal of Aesthetics* 27: 213–26.

NEWALL, M. 2003. A restriction for pictures and some consequences for a theory of depiction. *Journal of Aesthetics and Art Criticism* 61/4: 381–94.

NICHOLLS, A. L and KENNEDY, J. M. 1992. Drawing development: from similarity of features to direction. *Child Development* 63: 227–41.

PEACOCKE, C. 1987. Depiction. *Philosophical Review* 96: 383–410.

PIRENNE, M. 1970. *Optics, Painting, and Photography*. Cambridge: Cambridge University Press.

PRICE, H. H. 1950. *Perception*, rev. edn. London: Methuen.

PRING, L. 1992. More than meets the eye. In R. CAMPBELL (ed). *Mental Lives*. Oxford: Blackwell.

ROGERS, S. 1995. Perceiving pictorial space. In W. EPSTEIN and S. ROGERS (eds.) *Perception of Space and Motion*. San Diego: Academic Press: 119–63.

ROSINSKI, R. R. and FARBER, J. 1980. Compensation for viewing point in the perception of pictured space. In Hagen 1980.

RUSSELL, B. 1914. *Our Knowledge of the External World*. London: Routledge.

SCHIER, F. 1986. *Deeper into Pictures*. Cambridge: Cambridge University Press.

SCHOCH, R., MENDE, M., and SCHERBAUM, A. 2001. *Albrecht Dürer: das druck-graphische Werk*, vol. 1. Munich: Prestel.

SHOEMAKER, S. 1994. Phenomenal character. *Noûs* 28/1: 21–38.

—— 1996. *The First Person Perspective and Other Essays*. Cambridge: Cambridge University Press.

SMART, J. J. C. 1975. On some criticisms of a physicalist theory of color. In C. CHUENG (ed.) *Physicalism and the Mind-Body Problem*. Honolulu: University of Hawaii Press.

SOBER, E. 1976. Mental representations. *Synthese* 33: 101–48.

SORENSEN, R. 2002. The art of the impossible. In T. S. GENDLER and J. HAWTHORNE (eds.) *Conceivability and Possibility*. Oxford: Clarendon Press.

SWARTZ, R. J. (ed.) 1965. *Perceiving, Sensing, and Knowing*. New York: Anchor Books.

THOMPSON, L. J., CHRONICLE, E. P., and COLLINS, A. F. 2003. The role of pictorial convention in haptic picture perception. *Perception* 32/7: 887–93.

TOPPER, D. 2000. On anamorphosis: setting some things straight. *Leonardo* 33: 115–24.

VAN CLEVE, J. and FREDERICK, R. (eds.) 1991. *The Philosophy of Right and Left*. Dordrecht: Kluwer Academic Publishers.

WALTON, K. 1973. Pictures and make-believe. *Philosophical Review* 82: 283–319.

——— 1990. *Mimesis as Make-Believe*. Cambridge, MA: Harvard University Press.

WILLATS, J. 1997. *Art and Representation*. Princeton: Princeton University Press.

——— 2003. Optical laws or symbolic rules? In Hecht, Schwartz, and Atherton (eds.) 2003.

WOLLHEIM, R. 1980. *Art and its Objects*, 2nd edn. Cambridge: Cambridge University Press.

——— 1987. *Painting as an Art*. Princeton: Princeton University Press.

——— 1993. *The Mind and its Depths*. Cambridge, MA: Harvard University Press.

——— 1998. On pictorial representation. *Journal of Aesthetics and Art Criticism* 56: 217–26.

YANG, T. and KUBOVY, M. 1999. Weakening the robustness of perspective: evidence for a modified theory of compensation in picture perception. *Perception and Psychophysics* 61/3: 456–67.

Index